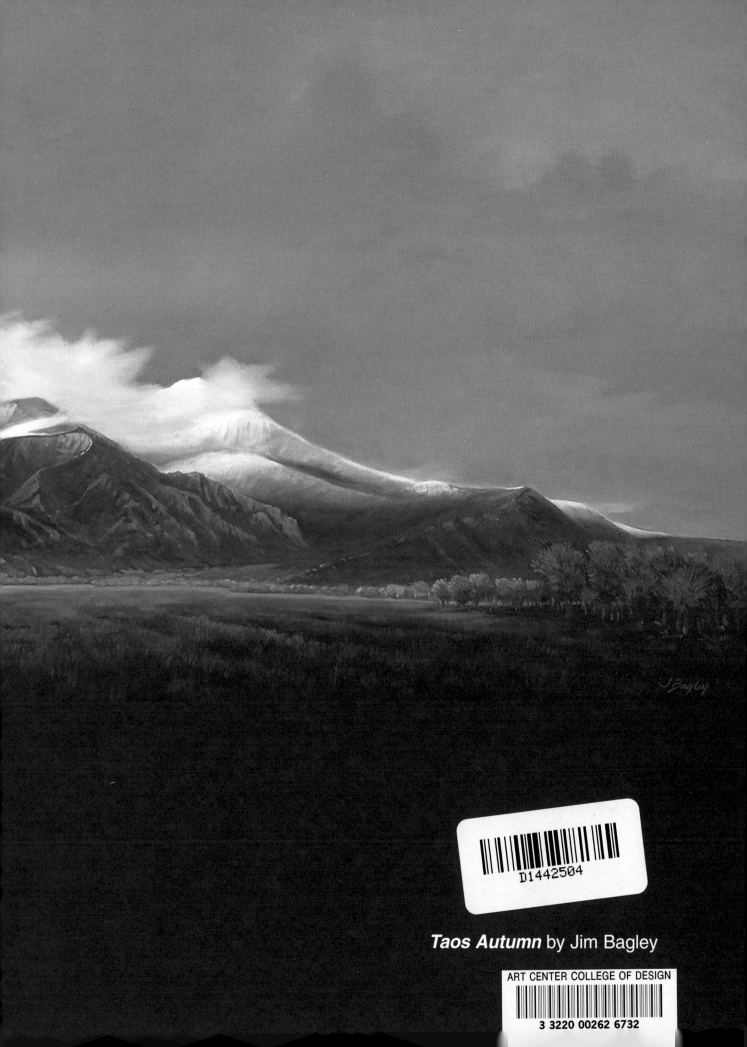

Taos Autumn by Jim Bagley

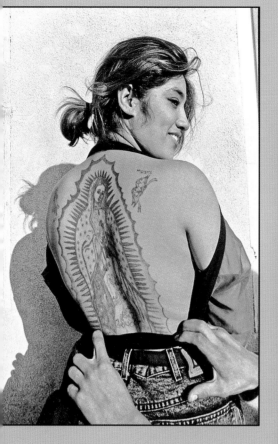

100
Artists
of the
Southwest

Douglas Bullis

Schiffer Publishing Ltd

4880 Lower Valley Road, Atglen, PA 19310 USA

*This book is dedicated
to all those who gave their best,
and for so many their last,
in honor of their country.*

Library of Congress Cataloging-in-Publication Data

Bullis, Douglas.
 100 artists of the Southwest / Douglas Bullis.
 p. cm.
 ISBN 0-7643-2414-4 (hardcover)
1. Art, American—Southwest, New—20th century—Catalogs. 2. Art, American—Southwest,
New—21st century—Catalogs. I. Title: One hundred artists of the Southwest. II. Title.

N6527.B85 2006

709.79'0904—dc22

2005029435

Book production by Atelier Books Ltd. Co., 2810 Plaza Rojo, Santa Fe, NM 87507;
artbookssantafe@yahoo.com, artbookssantafe@aol.com

Covers designed by Bruce Waters
Type set in Arial, Arial Bold, and Palatino

ISBN: 0-7643-2414-4
Printed in China

Published by Schiffer Publishing Ltd.
4880 Lower Valley Road
Atglen, PA 19310
Phone: (610) 593-1777; Fax: (610) 593-2002
E-mail: Info@schifferbooks.com

For the largest selection of fine reference books on this and related subjects, please visit our web
site at www.schifferbooks.com
We are always looking for people to write books on new and related subjects. If you have an idea
for a book please contact us at the above address.

This book may be purchased from the publisher.
Include $3.95 for shipping.
Please try your bookstore first.
You may write for a free catalog.

In Europe, Schiffer books are distributed by
Bushwood Books
6 Marksbury Ave.
Kew Gardens
Surrey TW9 4JF England
Phone: 44 (0) 20 8392-8585; Fax: 44 (0) 20 8392-9876
E-mail: info@bushwoodbooks.co.uk
Free postage in the U.K., Europe; air mail at cost.

Spilt by Roxanne Swentzell

Contents

Mixed Blood by Jaune Quick-to-See Smith

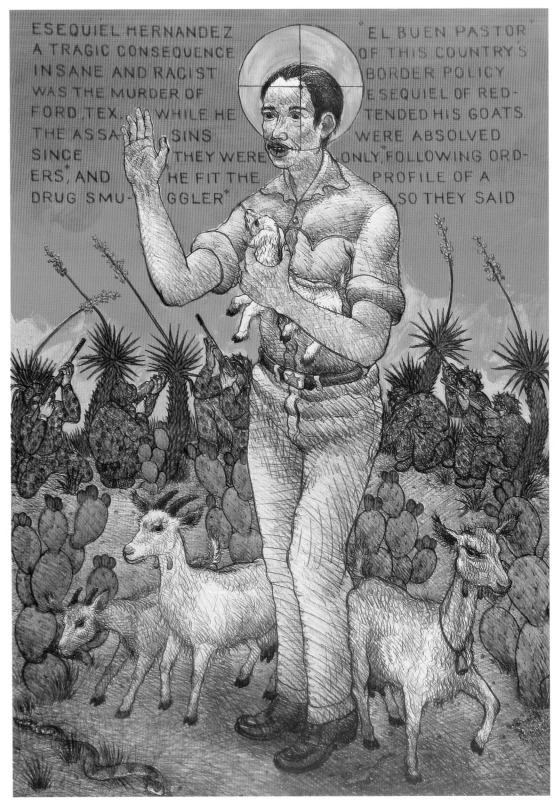

El Buen Pastor by Luis Jiménez

Introduction

A timeless work of art needs two qualities: roots and wings. When you come across an artwork that so distills moment and place and feeling and meaning and wish, one that makes you part-owner in the reality to which it introduces you, whose presence nudges you to lose all track of yourself until the only thought remaining in your mind is, "What use is a life full of stuff when I can feel like this," that's when a work of art transfers you into itself.

Art says what words cannot. It helps us feel, intuitively understand, see into the dream world within wide-awake life that the day blots too brightly for us to see. It is what words, no matter how enamoring their string, cannot make clear. There's no admission fee to understanding a work of art, but in good art there can be a steep climb into its stratosphere of clairvoyance. If a work of art moves you in a direction you didn't know you could go, then go there. You'll find the most interesting truth in what you find: the worth of enigma in a too-managed world.

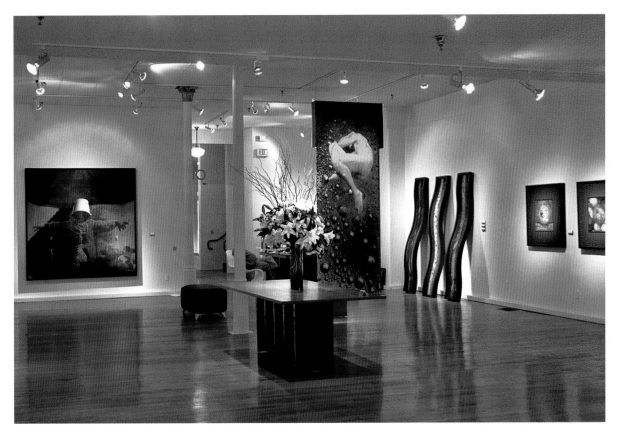

Artworks by Carol Coates at tadu downtown Gallery, Santa Fe, June 2005

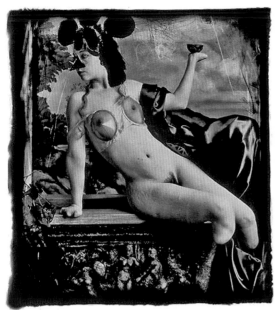

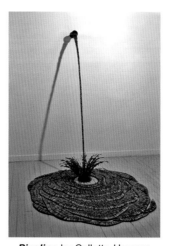

Pipeline by Collette Hosmer

Broken Hearts, Broken Bowls
by Roxanne Swentzell

Humor and Fear by Joel-Peter Witkin

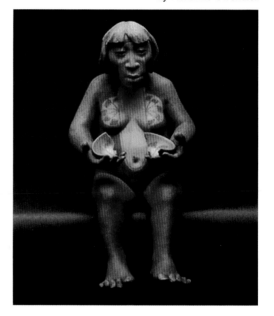

Matisse once infamously said, "Artists should have their tongues torn out." Leaving aside the brass-plated self-contradiction in that statement (to say nothing of the fact that he remained notably voluble to the end), why do so many people assume artists haven't anything intelligent to say about their own work?

The linger of the rose remains on the hand that gives it. For those who make art, the hand is a garden.

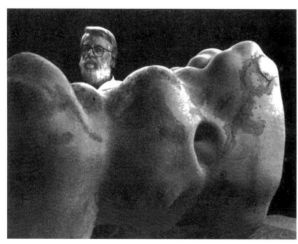

Ken Price in his studio

Trying to understand the interior of another's mind is like trying to explain fuchsia to a pony. Take as evidence our own experience. Given the countless times others have got it so wrong about who we really are and what we really think, why do people defy all evidence to the contrary and believe they can "explain" somebody else—least of all someone so lyric and fractal as an artist? Trying to explain an artist is like trying to dissect a raindrop. Someone who hasn't experienced the blinding white of the moment of creation, or the bittersweet sting that accompanies turning light's infant into a child, is about as qualified to write about art as a bird in a cage is qualified to describe where to find food in the trees. Our cages of unknowing are huge, impenetrable, bricked with the mortar of Self. Hence this book skips the cage and listens to the birds. Our guide is not merely that the artist creates, but that the artist thinks. The words following this intro are by, about, and for the artists themselves. We waste no ink on what somebody else thinks of them. Save for two who preferred that someone else do the job, everyone speaks for themselves. (Albeit with a tidying swiff of editorial peskiness. Artists have wondrous ideas but they're not always good grammarians.)

Why these artists and not the hundreds of others who also could be here? Three more books like this would still not empty the fount of deserving New Mexicans and Arizonians. So why these particular artists? Why not others?

Any with-it art local will instantly notice the absence of certain famous names herein. There are several reasons for this.

Several internationally reputed names opted not to be included—or rather their galleries did it for them. A few we very much desired declined for their own reasons. And a certain number have fallen into repeating past successes to such an extent that their work no longer lives up to their name. Nothing so fascinates as what a good artist invents next, and nothing so depresses as talent slogging the furrow of what sells.

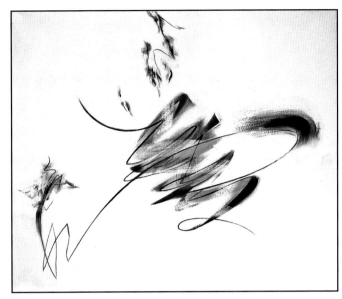

c13 Apr 04 by Jane Barthès

Another reason is that the Top 40 approach ("You've seen these people before, so here they are again") does no one any favors, least of all the highly inventive but lesser known or recently arrived artists forced to live in the penumbra of spotlights directed higher upstage. Our spotlight looks around a bit.

box elm by Chadwick Dean Manley

dawn island clouds
and the astounding sun
the everyday world is enough
 =Kim Rawdin

And too, the word "craft" has been far too often used to dismiss creativity that doesn't fall within an artificially narrow band of what is deemed officially acceptable. Art forms such as jewelry or furnishings, which strive consciously towards the idealized, which embody high levels of finish and workmanship, which appeal to a design sense more than the imagistic or abstract, and which raise those emotions stirred by "beauty"—all these are usually labeled with the word "craft" in books like this and exiled to the Siberia of personal and domesic ornament. Put another way, "craft" doesn't fit into the code-conscious confines of an academic and critical establishment preoccupied with the clog boots of analysis (left foot) and the Official Line (right foot).

This book takes a streamlined approach to the matter of aestheticism: If you don't like something, is the problem it, or you? Compared with good art, criticism lasts about as long as the dust on a table, and is just about as relevant. Read the reviews of the first works of art deco's use of *pochoir*—about as "craft" a technique as one can find—and then ponder the strangling effect of Official Approval. Dismissal didn't work then and age hasn't improved it.

The artists appear alphabetically. It's as democratic as you can get (alas for those born U through Z) and it also minimizes clustering genres together. Everybody gets two pages; no one is favored over anyone else. The next page is always a surprise, hence any page you open to is a good one.

And to set the record straight, this book is not a subsidy affair. Nobody—artist, gallery, or good friend—paid anything to anyone for anything.

3

We also give due recognition to a few arts institutions whose nurturing of talent has produced such notable results that their ideals and methods are tantamount to an aesthetic in itself, the art of nurture. A perfect example is the Capitol Art Collection (CAC) in Santa Fe. It is the result of civic planning so long-term it amounts to a gift to the state's great grandchildren yet to be. In 1991 the New Mexico Legislature foresaw the need to preserve the best of the state's visual and cultural identity as it is interpreted by the extraordinary number of artists who live here. The CAC is the equivalent of the Guggenheim Foundation redoing the Senate Office Building, then filling it with artists whose mediums reflect the diversity of the region—painting, sculpture, devotional *santos* and *retablos*, photography, weaving, works on paper, ceramic, glass, video, basketry, and handcrafted furniture. Tradition, experiment, social criticism, craft, vision, the abstract and the real— all these are guided by the hands of the CAC's Executive Director and Curator Cynthia Sanchez.

A stroll around the circular rotunda's several floors (and new Annex in an adjoining building) treats the eye to a fireworks show of modernist color; the grave, graceful, measured formalities of Spanish Colonial utilitarianism; the muted symbols of today's Native Americans turning ancient into future while not losing sight of the present. The serenity of face and form in Roman Catholic iconography extends in a single line to Byzantium, offshored to the chapels amid our mesas from the cargo holds of the Spanish galleon. To these add the seemingly limitless interpretations of New Mexico's seemingly limitless nuances of cliff and color and cloud and light. Emerging artists, established artists, self taught, academically trained, wildly inventive, meticulously preservationist, and all honored for their value as visionaries in our often unvisioning times.

What lifts the art one finds in Santa Fe's Roundhouse and so many Southwest galleries and museums above something whose subject simply pleases? Good art takes your breath away. Its svelte and elegant balance knows no boundaries of spirit and imagination — least of all the clip-clop haste of time. Art doesn't picture life, it is life. When you see it you pass like a migrant bird through the hour's trivialities into lifetime significances, and you grasp all this without words getting in the way.

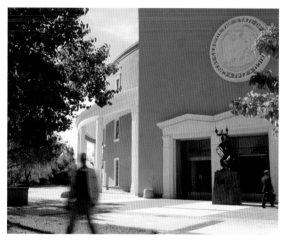

The Roundhouse, Santa Fe

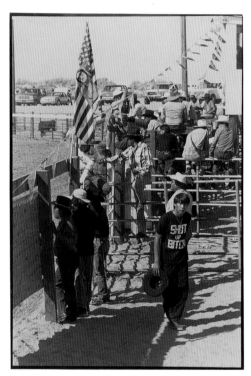

Shut Up Bitch by Carm Little Turtle

Ms Sanchez is hardly alone as a woman shedding the mission statement strait jacket that so strangles the typical institution. Southwestern women in the arts are in the forefront of a significant social shift in the region. Be they painters, photographers, gallery owners, mentors, instructors, or curators, women here are cheerily demolishing the superannuated ethos of the cowboy hat. The hats haven't noticed this yet.

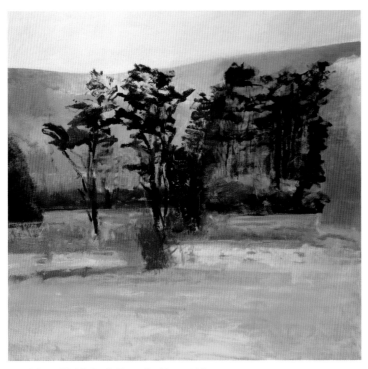

Yellow Field, Dark Trees by Forrest Moses

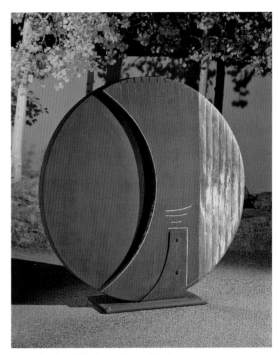

Elusive Ripple by Karen Yank

And what, when the paintings are all down, the gallery walls again bare, the wine scents faded, the unremarked *gellage* of the messy cheese and crackers plate tossed out, the thump and thunder of opinion slipped to silence like the tick of a clock in a locked-away room—what does art actually do?

When you see a white feather on the water, do you really need to see the egret to know it is there?

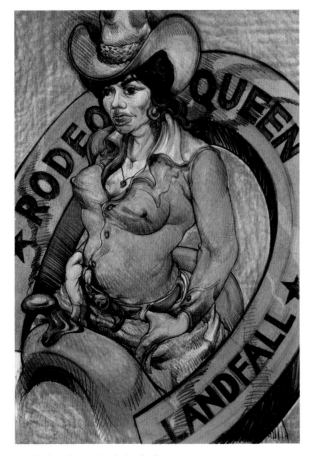

Rodeo Queen by Luis Jiménez

Bird by Barbara Zusman

If that is the hand, what of the land? What is it about the Southwest's topographical sonority that inspires so many artists who move here— competent enough to be assured a lifetime buyer base where they came from—to commence as radical a shift in art style as they do in lifestyle within a week after arriving, and then go on to create things they never imagined they could, would, or even should do?

Every locale has its subtleties—things felt more deeply than words can describe—and the Southwest contributes a sense of meaning found nowhere else in the world. Meaning that flows its own way, independent of the arrow of time and the mood of the self; meaning in touch with the earth, the sky, life, the thousand directions of wind. Its rivers our blood, rock our bone, hours our eyes, cirrus our hair, myth our ghost, legend our wind. The sky is our sea and its incoming swells flash lightning. The rain conjures scented flowers of soil after a dry time. Gem glints of moon off countless facets of fresh snow. The dance of the raindrops as they ballet off a flat surface. Hopes made of dawns. The somewhere in the wind that the monsoon's tendrils of rain let fall their veils. Phorescent sky on a midnight of no moon.

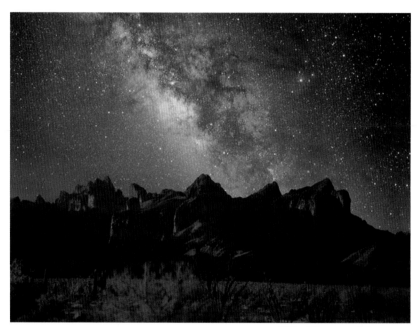

The immense tremor of galactic reach which we can all but pick and taste from the shimmer of creation's sky.

Milky Way over Arizona

The eye with which we see the world is the eye with which the world sees us. Realities other than the visible thrive in this eye-filling sky and nose-filling land. Enormous fields of color make imperceptibly different details and shapes. Every spot on which we stand becomes a place from which the imagination refers to all the other places we've stood— glyphs of wind worn upon the rock, memes of desert said in sun-sanded shapes, time writ small on the withering slabs of epoch. Things of the earth and things of the sky become one in the same as twilight turns turquoise into cerulean into whispers of black. Turn late twilight upside-down but leave the colors what they are, and only the horizon knows which side is up out there in that sky.

Our homage to the land is to move over it, feel its needs and truths, shunt aside our vehicles and banks and hitch to the heat, the height, to the basalt, the layer of eons that is the mesa and the mount, cut an arroyo into our crusted externalities, bathe in the river that abrades our dust to the sea.

The Southwest is a paradise for synesthesics, whose perception in one sense transfers without thought into the feelings and imagery of another. Surroundings of event become suggestion then archestrade—the skrawk of the crow is the flying of the spirit, the tiny clatter of aspen leaves is the lilt of passing finches. The sere day's heat is the same sere about to be removed from the worries of a woman lighting a candle before her mountain shrine *milagro*. The Native who hears yet again from intruders that peace comes from power says instead, "People who let me be who I am don't need either one." As with what lies behind the face caught in a snapshot second, beneath the surface of the jutting rock is a personality. What it says to the mallet and chisel is not what the chisel hears in other parts of the world. In Carrera the marble slab says, "Within me is something beautiful and powerful. Release it." Here the eon-pressed slab says, "See my beauty without? It is also my beauty within. To see my surface is to be my depths. Learn."

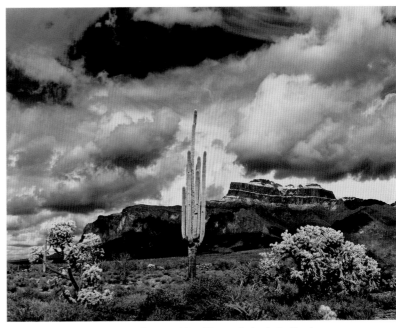

Winter Storm Clearing, Superstition Mountain by Jody Forster

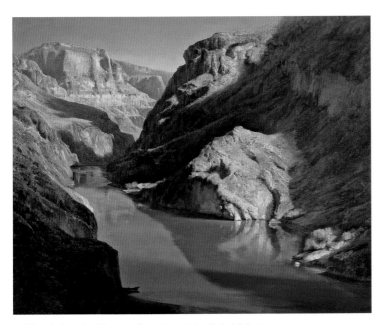

The Colorado River at Deer Creek by P. A. Nisbet

In a landscape as distinctive as the Southwest's, where does the inner landscape of the eye end and the outer landscape of reality begin? What supplies the nudge that ends in a work of art as distinct from the mere prettily pictorial?

"Regional style" isn't quite the phrase to describe what happens here. "Spirit of place" is closer to the mark. Lawrence Durrell once titled an essay about the Eastern Mediterranean with those words. In it he described the wild potpourri of emotions that locale can elicit, evoke, distill, inspire, impassion, enthrall, energize, purify—things like the serenity or vivacity of light, heat and haze, the myriad tints of each color as the day awakens with first light and slips into nothingness at twilight's end. Cloud, wind, hill, cliff, slope, tree, shrub, insect, animal. The oneness with all when self is silent.

Our landscape is the surrogate energy for words not robust enough to capture what we feel. If heaven is people who think there's a heaven, those who live here glimpse it every day.

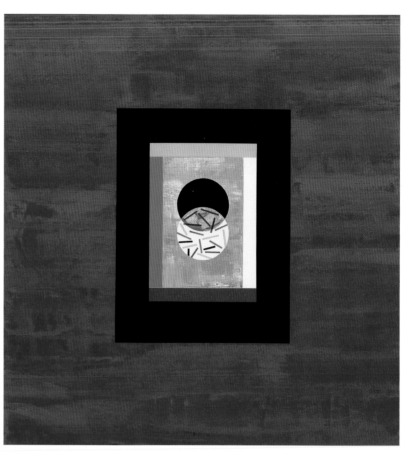

Horizon XIX by Dan Namingha

Timeful as life lived and timeless as afterlife thought, this art is the slow draw into focus that comes with a lifetime love.

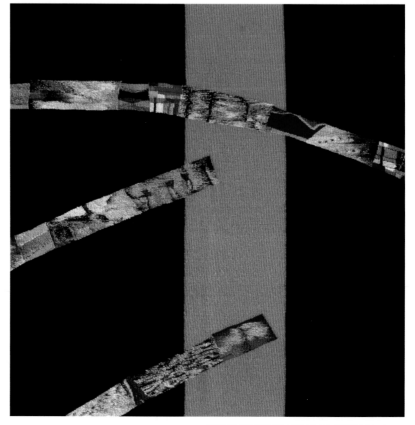

Urban Galaxy by Ramona Sakiestewa

Seek this land mindfully and you too are the artist, quietly sitting and holding steady a brush as the canvas paints itself beneath your meandering tread.

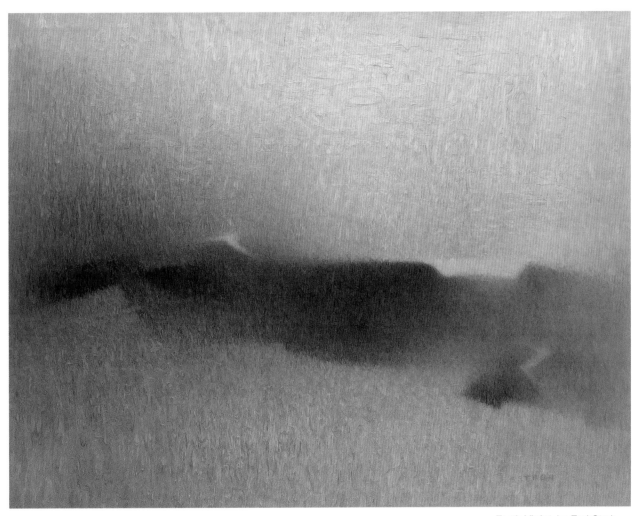

Earth Violet by Earl Stroh

The Hopi have a word for all this, *powaqqatsi*. Life in transformation.

Powaqqatsi is very very quiet here. Listen.

Tony Abeyta
Blue Rain Gallery, Taos and Santa Fe

Painting is a remarkable pursuit, yet it has always been challenged amidst film, performance, music, and poetry. We as painters have always competed against these ephemeral arts. The mainstays in easel painting know why it works and recognize its strengths and its potential weaknesses.

That said, painting remains a traditional art form with mysterious potential. To remain a painter I have to reinvent myself regularly — a system of checks and balances that allows me to see myself revising images and techniques regularly, while still working on sixteen to twenty paintings simultaneously. Complex yet functional.

I relish the moments of inspiration, and also in the frustrations of laborious duties involved in art. Yet when the sun sets, I have to remember that I have a wonderful relationship with a blank canvas. I never know what can happen. When it occurs successfully then I know it is all worth it.

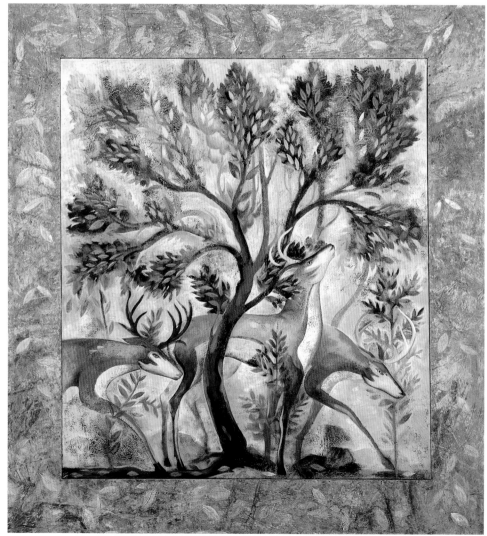

Deer Among the Trees 2004
Oil on canvas, 80" x 74".
All photographs courtesy of
Blue Rain Gallery.
My images are realized through aggravation, trial, and errors. When I get too familiar with any process, I know it's time to move on. Consistency and a concise body of familiar works don't apply here. There are too many bases to be covered in discovery.

Orbit 2004
Oil on canvas, 62" x 50".
I'm not much interested in chasing the good life. I want to develop my responses to what surrounds me — the feel of the water in the river and the rain from the sky, the difference between the Sangre de Cristo mountains above Taos and the Alps above Italy. The spiritual grace of my people the Navajos, and the spiritual grace of Leonardo da Vinci and Piero della Francesca.

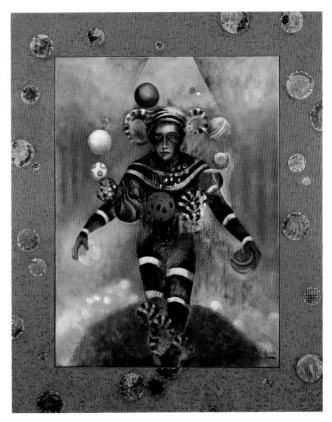

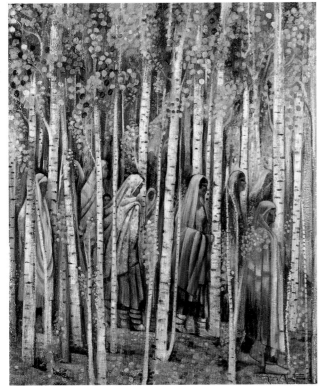

Aspen Journey 2004
Oil on canvas, 72" x 60".
We should never forget that we are also students of the world and its vast information and inspiration. Distinguishing value in an honest image becomes an art in itself; paint can't cover all the bases.

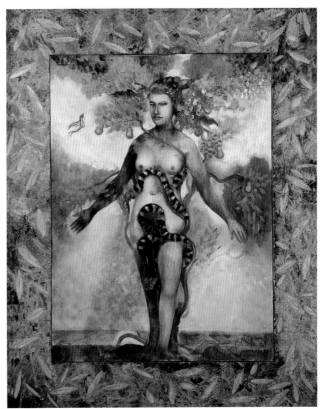

Daphne's Laurels 2004
Oil on canvas, 62" x 50".

Ron Adams

LEWALLEN CONTEMPORARY, SANTA FE

As a youngster I went through the same trials as every other aspiring draftsman of my day. I spent hours copying Donald Duck and Mickey from cartoons and comic books and learning how to draw. Later I studied, had some formal training and got some experience that allowed me to pursue a career as an artist and printmaker.

After working for several years as a hand lithographer with G.E.L., Gemini, Edition Press, and eking out a living as a technical draftsman, I moved with my wife to Santa Fe. In partnership with Robert Arber we opened Hand Graphics, the first professional print making establishment in the region. I was fortunate to immediately meet most of the successful artists in the community and began, almost at once, to print for them and for other national clients.

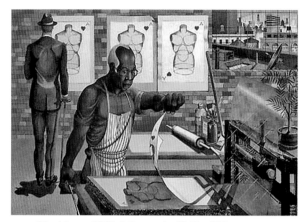

Blackburn 2002. Lithograph, 29.5" x 39".
All images courtesy of LewAllen Contemporary.

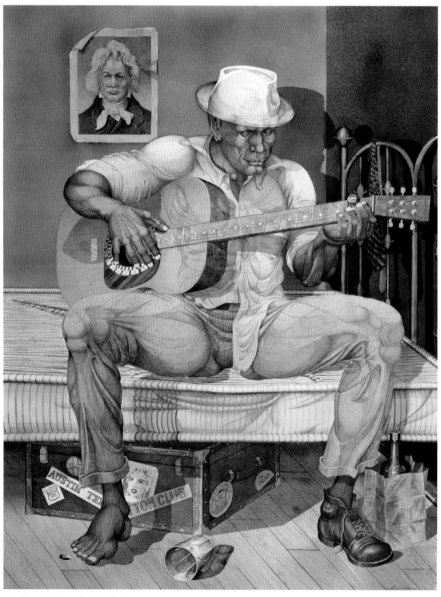

Dandelion Wine 1996
Photo etching, edition of 60, 21" x 16".

Hand Graphics became not only a successful print shop but a local meeting place where people were always welcome to drop in, have a cup of coffee, and get the latest news (but don't distract the printers!).

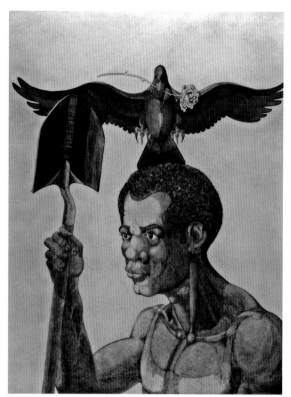

Endangered Species 1994
Etching, edition of 60, 34.5" x 28.5".

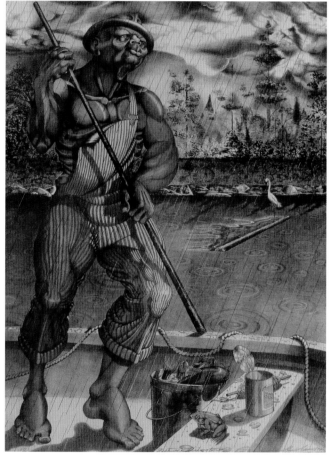

Neptune Washington 1997
Lithograph, edition of 70, 30" x 22".

Today I no longer work as a print maker. I have returned to my first love, making my own original art. I spend more time fishing than before. And you know what? I don't care if I catch anything or not!

Profile In Blue 1997
Lithograph, 53" x 39".

Elizabeth Alderman
NEW MEXICO STATE UNIVERSITY, LAS CRUCAS

Karen Bucher

As a young child, I made books before I knew how to write. I dictated stories to my mother and created images to match the words. The finished work was a codex whose pages were bound with string. Illustrations on the thin spine contained visual codes that revealed the stories. That first effort has become a lifelong interest in creating images that simultaneously record and reinterpret reality. The leap into the gestalt of processing memories and language is fascinating and exhilerating.

To me, the mind's neural pathways fold into creases analogous to the pages of a book. Our thoughts open new chapters and return to older ones, the myriad themes of human experience such as love and loss endlessly repeat themselves in our own lives and the lives of others we meet. I am fascinated with the relationship between the world and our minds. To me the relationship is an endless complexity of linkages, which in turn shape the boundaries of what we know and the role of causality in what we do with that knowledge. My *Artist Books* are ideal narrative terrain of text and image, on which I can devise sequences rather like neural pathways. The structure of the books intentionally gives readers room for personal interpretation. The books unfold, unravel, come apart, and in so doing hint at the contradictions between the printed page and the digital simulation. The nonlinear character of screen-based art and video allows me to model and visualize abstract space. In my works like *Geomantia* and my similarly nonlinear *Scroll Pieces*, the computer is my artist's tool to explore the complex and seemingly limitless interaction between intellectual text and emotive image.

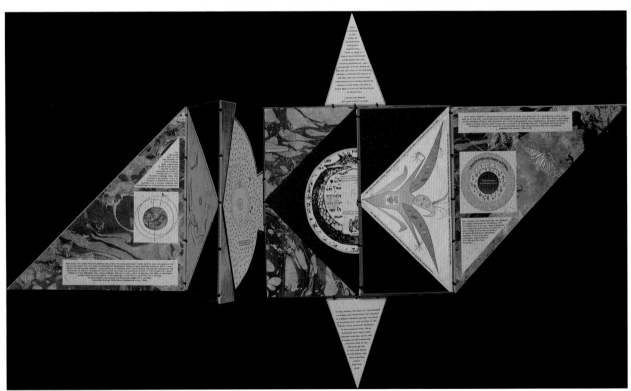

Geomantia 1996
Unfolding hand-made artist book that explores the evolution of scientific thought with texts drawn from the writings of Kepler, Copernicus, Jorge Luis Borges, and Oliver W. Sacks.
Inkjet and paper, 2" x 12" base unfolding to 5'.
Geomantia is an older form of map making that uses the earth's surface, rock, and earth as a guide for spatial navigation. The structural models for the book are seventeenth century navigational tools.

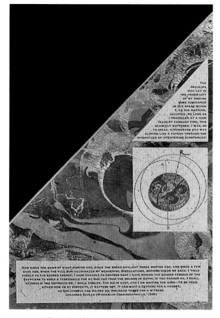
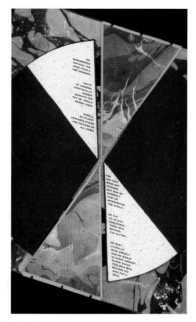
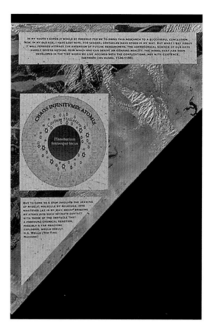

Detail of three fold-out sections from the six fold-outs comprising *Geomantia*.

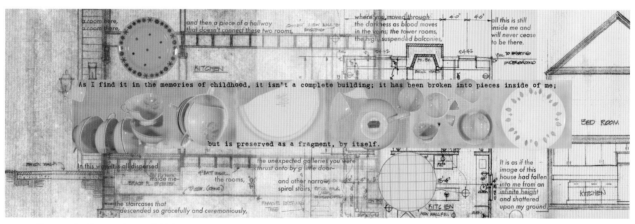

Domestic Excavations 2001
Digitally manipulated scroll book with text by Rainer Maria Rilke.
Polaroid transfers, slides, and objects; archival pigment ink on acid-free
dual-sided matte, 12.5" unfolding to 6'.

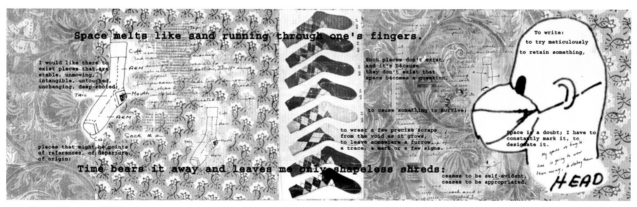

Sock Monkey 2001
Digitally manipulated scroll book with text by Georges Perec.
Archival pigment ink on acid-free dual-sided matte, 12.5" unfolding to 6'.

Page Allen

OWINGS-DEWEY FINE ART, SANTA FE

My childhood in Maine and Illinois, in a family that loved art, showed to me the wonder of the world as well as the pain of it. My family gave me the knowledge that art and life should mingle. Art could be lived as well as made.

Then one fall afternoon in my college studio I looked out the window at the forests and fields. Then I looked at the palette knife in my hand and the white, atmospheric painting in front of me. The thought came to me, "I could do this all of my life . . . I could work as an artist!" Art could engage my intellect and my spirit. Perhaps, in wondering what was most important each day, I could offer that precious question to others. I was filled with sudden energy. I put down the knife and went out for a long walk in the late afternoon light. The red sweater I wore became the emblem of my insight.

Tesuque Road 2000
Oil on linen, 46" x 62". Private collection. Photo by Dan Morse.
My lineage is in the morality of art: the affirming of beauty, hope and creation, in ferment with doubt and destruction. I work to reconcile the ever-present conflicting forces in the world: darkness and light, motion and stillness, depth and height, distance and immediacy. Within these come the images, the symbolic content: a solitary journey; a magic vehicle to take me away; an embracing destination. I give myself and the viewer stepping stones through the world.

Ascent 2001
Watercolor, 30" x 32". Collection of the artist.
Individuality is a wound each one of us receives at birth. When seeing, hearing, reading an artist, we each know we can, via creation and love, heal. I make something that extends to others. I may enhance the world or I may not; there is no certainty. But simply in holding a peaceful concentration in my studio, I enhance the world.

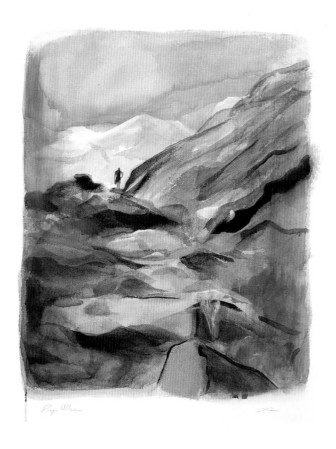

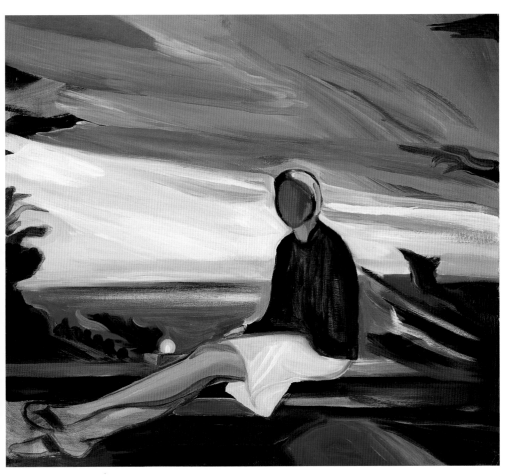

Pink Skirt 2003
Oil on linen, 16" x 18". Private collection. Photo courtesy of Owings-Dewey Fine Art. My fascinations have changed over the years. They used to be invitations to a distant promise. Now they are immediate and intimate. My images lift out of my own story to slip into other stories, other lives.

17

Carol Anthony
Gerald Peters Gallery, Santa Fe

Where a painting
comes from is where I am.
In me, at that moment,
in place
and without time

I have a new dream
and now
the courage and vision
to take it on

I want to feel the
dust of the ancient ones
and their wide skies
and their light
and stones

I need to be part
of this western landscape
its mysteries
its sacred magic

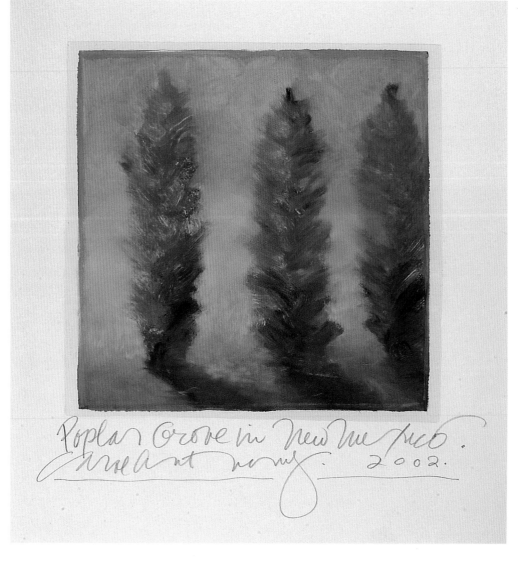

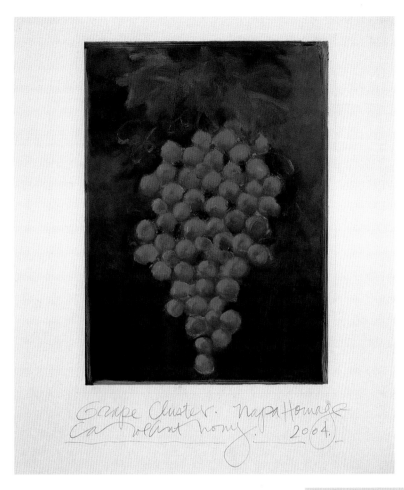

Each painting is a small moment
given theater
a piece of timelessness
given dimension
a passion redefined

Each is a room
a rite of passage
which becomes
a self-imposed landscape
carefully negotiated

Each is quiet, strong, and gentle
hints and traces of the breakdown
and build-up of learned systems
architectural and intellectual
religious and traditional

All are attempts
at solutions and celebrations
of candles and humor
of self wonder
of the mystery
of light and paint
of the capacity to be touched
by the unknown
and be spared

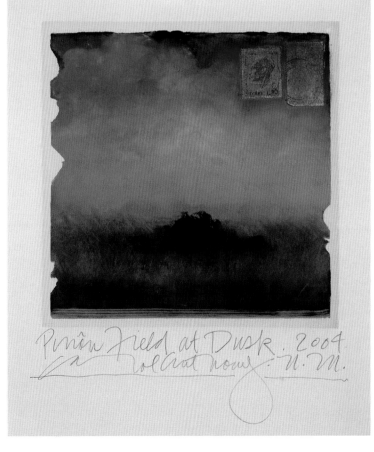

opposite page
Poplar Grove in New Mexico 2002
Monotype, 8.675" x 8.875".
All photographs courtesy of Gerald Peters Gallery.
art is not about doing, it is about being

above
Grape Cluster — Napa Homage 2004
Monotype, 11" x 8".
the rest is MAGIC and a SECRET

right
Piñon Field at Dusk 2004
Monotype, 6.875" x 7".
my house is memories with a roof over them

Diane Armitage
STUDIO OF DIANE ARMITAGE, SANTA FE

Detail of the project *When Fire Becomes Mirror*, 2002
Original portrait of the artist by Leah Douglas.

What draws her into space, toward
the frontier of these altered states,
toward a new resonance of the self?

She singles out in her mind points
of history and memory and desire
and says, Now and forever I choose
this but not *that*. I move toward
this but not *that*. It is my will
and my right to investigate the
limits of my own skin. And she
adds, *I keep my shape by burning.*

They lifted off at dawn into the deep,
immense, black-velvet void — controls
set and machines tracking every pulse.
She thinks, I will spend months in
this cocoon, in this weightless world.
Inactivity will be hard to bear,
but the Man from Mars is a strange
attractor. Around that ancient theme
my mind flickers like the stars —
those nuclear reactors made of noble
gases shedding into outer space.

Onto this infinite, clean dark slate
I project my thoughts and all the
data, and *I keep my shape by burning.*

The frontier is that space between the self and the world . . .

text from the project
Uncontrolled Mosaic — A Martian Chronicle

Watershed — A Video Series
Watershed is a work in progress about the presence
and absence of water in our world and the
possibility of its existence elsewhere in the cosmos.
Water is the most enigmatic of fictions, the most
natural of facts—and with each search for it there
is the illusion that I might come to know some part
of the secret life of water.

Watershed — *The Great River* 2002
Digital video, 5 minutes. All video stills courtesy of the artist.

Watershed — *Anatomy of a Storm* 2003
Digital video, 5 minutes.

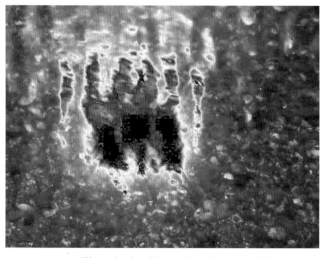

Watershed — *Under the Influence* 2005
Digital video, 5 minutes.

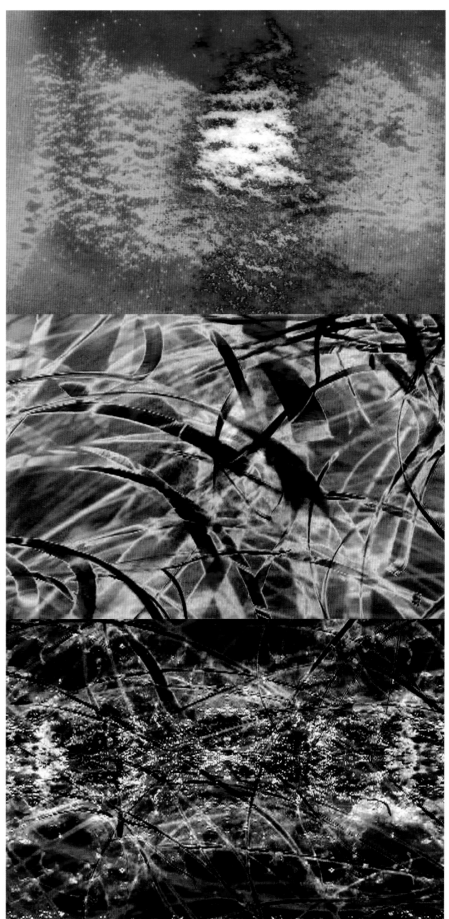

The Language of Fields — A Trilogy 2004
This stacked image represents three separate, though related, videos. *The Language of Fields* is a series of visual approximations of real forces in Nature, but the pieces of information contained in the videos are only simulations of the real.

Grounds for Divination: the cellular field
Digital video, 3 minutes.

Ground Lines: the electromagnetic field
Digital video, 3 minutes.

Ground Zero: the gravitational field
Digital video, 4 minutes.

Cathy Aten
TADU DOWNTOWN, SANTA FE

Jennifer Esperanza

Not long ago I thought competence was the Holy Grail. I am somewhat of a perfectionist and care deeply about presentation; these were part of a carefully constructed identity to which I was extremely attached. It was a fine creation, but not entirely true.

Life began to erode my foundation. The painstakingly crafted sense of self crumbled to reveal the Self. I began exploring unknown and awkward territory. My art changed, my values rearranged themselves, and I found solace only on the earth.

Today I am more interested in feeling my heart and seeing how others open when in relationship to a sense of place. I am drawn to the raw grit of the earth and the elegant play of light and shadow in relation to object. Noguchi inspires me, as does Carl Jung.

I love the quality of enigma that finds its way into my work. In a sense I have used myself up. Now, the state of not-knowing intrigues me. In my work I try to leave room for the viewer to discover their own personal mythology. If I have done my job well, the essence of the piece should speak to our collective consciousness so we feel less separate, more whole.

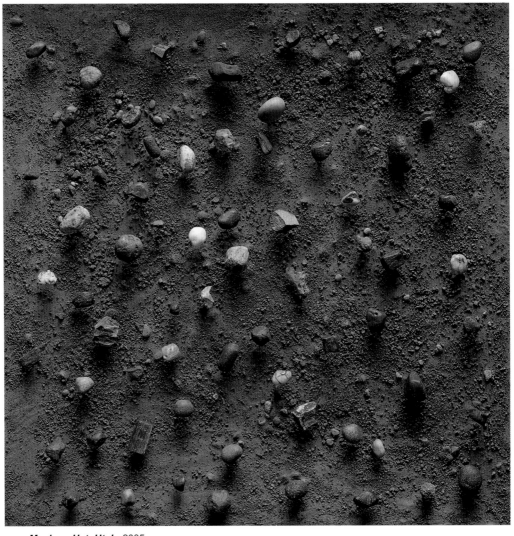

Mexican Hat, Utah 2005
Earth and rock, 35" x 35".
All photos by James Hart.

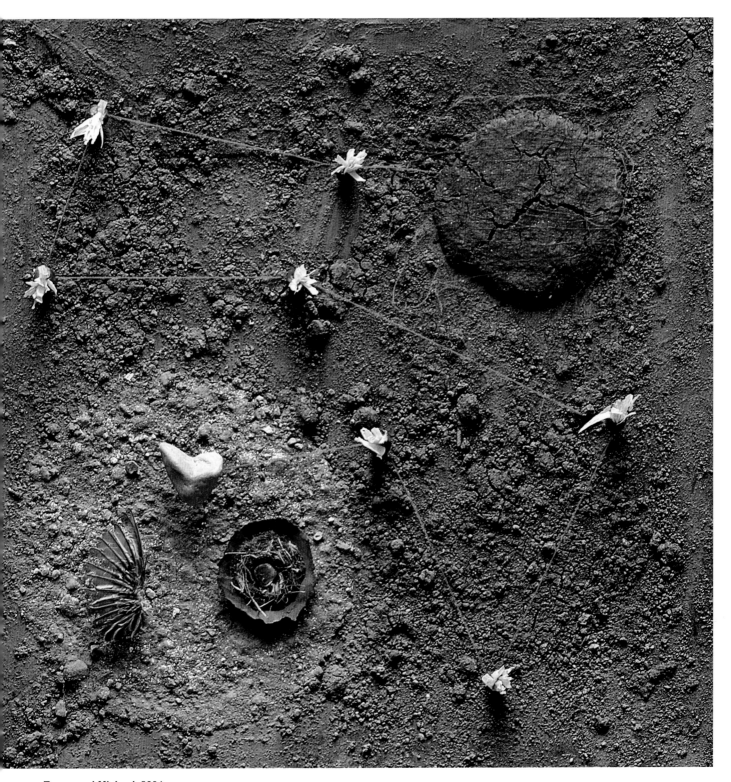

Tonya and Michael 2004
Earth, ceramic, thread, cornhusk, birdwing, rock, mica, 22" x 22".
Collection of Tonya Turner Carroll and Michael Carroll, Santa Fe.
I work on a commission basis to create an energetic portrait of a
client using earth they have gathered from their birth place, travel
destinations and where they now call home. They also collect
special objects such as rocks, shells, feathers and the like. I often
add small ceramic sculptural objects. Essentially, our conversation
together is the medium. I try to get out of the way.

Jim Bagley

Dartmouth Street Gallery, Albuquerque
Charlene Cody Gallery, Santa Fe

I've always been passionate about art and the out-of-doors — fly fishing, exploring, canoeing, hunting, and camping. Eventually art and nature merged through landscape painting.

My paintings are as much about "being there" as anything else — spending time out in the seasons and elements. The more time I spend getting a real feel of any given location, the better the image that comes from it.

Each year I try to make at least one major road trip through the West, camping, photographing, and sketching along its back roads. I tend to avoid crowds and the obvious or romanticized locations and seek out the more remote, understated places that most others ignore. I travel around, through, and over, not merely painting a picture but putting "being there" in the work as well.

Thunder Over the Mesa 2001
Oil on canvas, 36" x 36". Private collection. All photos by Pat Berrett.
A quiet sky over a no-name mesa can turn into a commanding presence on a July afternoon. It blows in, makes a fuss, then is gone. The challenge is being there at the right time and then trying to capture its essence in a single image.

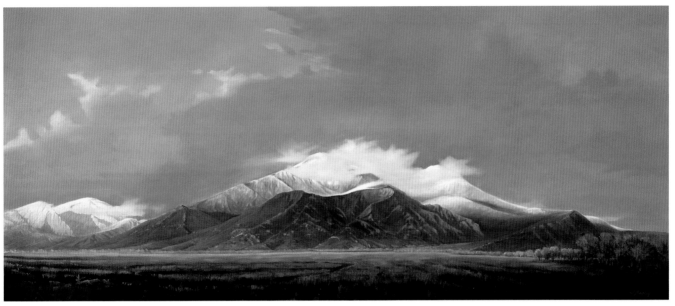

Taos Autumn 2004
Oil on canvas, 34" x 83". Corporate collection.
One of the few "popular" subjects I like to paint—Taos Mountain, which can appear flat at mid-day, then come alive in the dramatic evening light when the clouds move in and the shadows lengthen, giving it a mood and color unique to New Mexico.

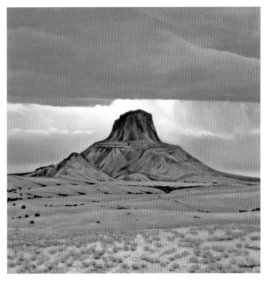

Cabazone 2002
Oil on canvas, 34" x 34". Private collection. A lone, rugged, and odd shaped landmark in Central New Mexico, often overlooked as a painting subject, revealing its subtle beauty when the weather and light cooperated this late autumn day.

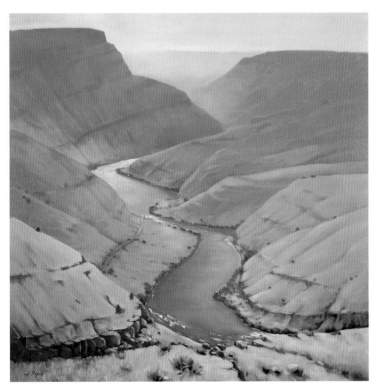

Deschutes 2003
Oil on canvas, 34" x 34". Collection of the artist. My favorite river in Central Oregon where I grew up fly fishing my summers away. It is a unique place full of history, mood, and memories, and always changing light.

Barbara Barkley

STUDIO OF BARBARA BARKLEY,
QUEMADO, NEW MEXICO

Michael Colombo

Circle of Night 2004
Handmade paper, 30" x 24".
All photos by Richard Faller.
My vision strives to be born
through the medium of
papermaking.

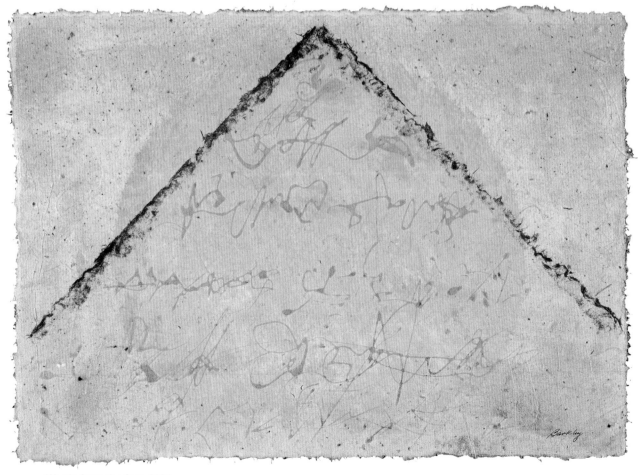

Words from the Sun 2004
Handmade paper, 24" x 30".
A favorite place to play is in the realm of abstraction.

26

I once read that geometry was invented to create altars and temples. Geometry gives me gravity, a point to leap from. I feel a kinship with ancient peoples who struggled to express in human terms their sense of the mystery of life, only to find that the ineffable cannot be captured within the limitation of words and dogma. My exploration in these realms is recorded in guiding the fluid chaos of papermaking.

Transforming paper from floating fibers that are swept up to capture the movement of water into stillness, likewise transforms me. As I watch the fibers swirl and mix in the vat, I am caught up in a timeless place. There I can focus on the eternal hints and questions, truths and mysteries. Ancient remnants, vague images, pictures delivered in dreams, phrases remembered upon waking — all inspire me.

Doorway to Open Sky 2004
Handmade paper, 36" x 18".
After the long process of preparation, I can hardly wait to begin layering the colored pulps and seeing the subtle patterns develop.

Woven Harmonics 2004
Handmade paper, 36" x 18".
As I do my papermaking, I feel antiquity in the textural richness of the paper. There is an alchemical feel to preparing the plant fibers and pigment, cotton rag, flax, and hemp for the many pulps that I use. Each lends its own character to the whole.

Jane Barthès

TADU DOWNTOWN, SANTA FE

I consider myself primarily a draughtswoman. My main commitment is to drawing. My work throughout the years has been a search for what is essential. Each massive canvas is a page from a sketchpad. Each drawing goes directly onto the surface without prior knowledge or preparation. Its immediacy is borne of my effort to practice a presence of mind in the moment. I am very intrigued with the essence of form, but feel the need to dig deeper. In my fascination by what lies behind form before it materializes, I feel a bit like a physicist who occupies an obscure corner of science with my "molecules" of drawing. Modern physics suggests that when stripped of its form, everything in material existence is merely matter and energy. My painting is essentially an experience of energy, being touched by something far greater than myself even if only momentarily. My art informs me and makes sense of the mundane.

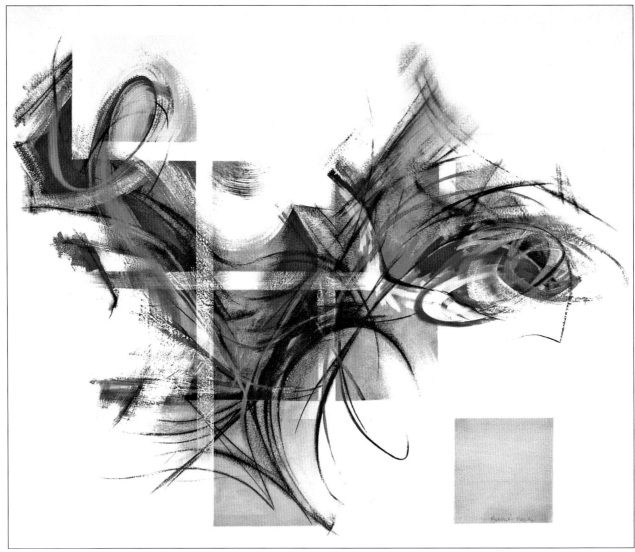

c4 Feb 04 2004
Charcoal and acrylic on canvas, 60" x 72".
All photos by the artist.
In many respects I see myself as a visual mathematician.

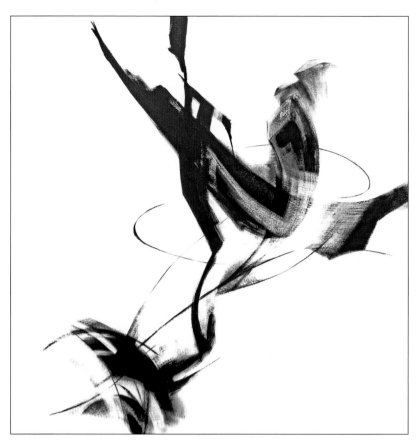

Oct-02-1 2001
Charcoal and acrylic on canvas, 60" x 60".
Giving presence to a moment of time is the
way I express everything I feel about being
human. The whole range of our energies and
complexities can be revealed in an all-
encompassing way and yet at the same time
also reach far beyond the smallness of my
'self'.

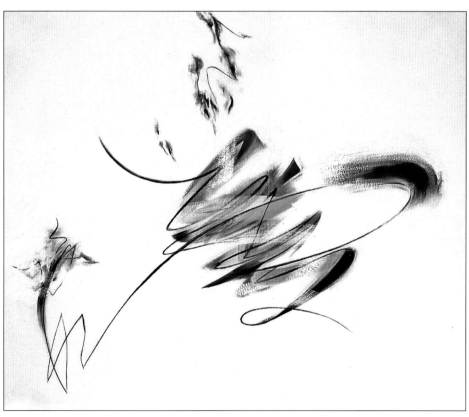

c13 Apr 04 2004
Charcoal, acrylic, and pencil on canvas, 60" x 72".
The artwork's soul begins the moment I make that
first mark on any canvas. The moment it leaves my
body, it no longer belongs to me.

Larry Bell
LARRY BELL STUDIO, TAOS

The artist with **Sumer #24 @ 20' h** 1999. Cast bronze, 20' high, located at The Art Foundry, Santa Fe. Photo by Neil Libbert.

I love beginnings. I have a passion for the new, for what is happening at the moment of conception. My emotions are wrapped into how it feels to make art, not thinking about old work. I like some of it but the rest confuses me, makes me nervous. I can't remember why I did it. Polishing an idea past its beginnings is the hard part.

Artwork is stored energy, yet dynamic, just waiting to be released. It is released in as many different ways as artists create, but common to them all is that the energy always guides the direction of the artist's sensibility. For viewers, the release happens when the viewer becomes a dreamer.

The energy happens in my studio all the time, yet unconsciously. When I absorb the energy created by being in my studio, change comes into the work, thus creating more energy. When the work leaves, the place where it goes becomes an extension of the studio.

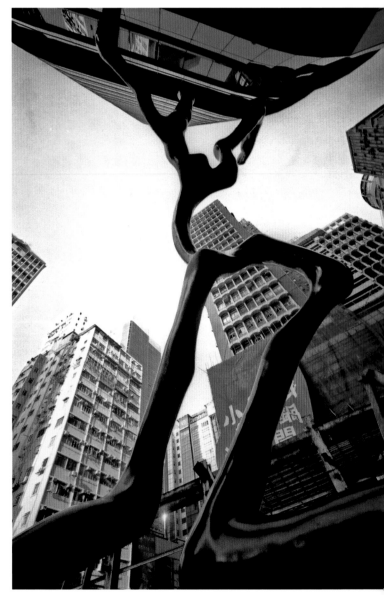

Sumer #26 @ 30' h "Happy Man" 2004
Cast bronze, 30' high. Photo by the artist. Collection of The Great Eagle Corp., Hong Kong; located at Langham Place in Mongkok. After observing what art school teaches — perspective drawing, figure drawing, painting, printing — I wasn't a student for very long. I began making my own things.

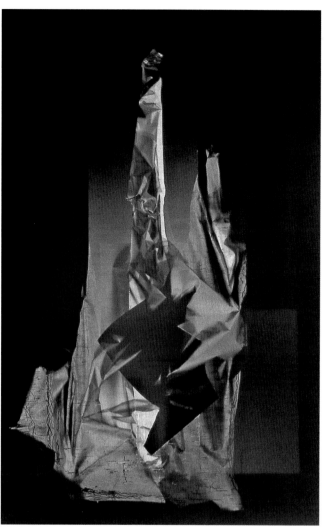

Erection 7 Black 2004
Mixed media on black paper, 59" x 47".
Photo by Paul O'Connor.
Artists cannot escape who they are or
what they do. If my work holds any
significance it will be in its variety.

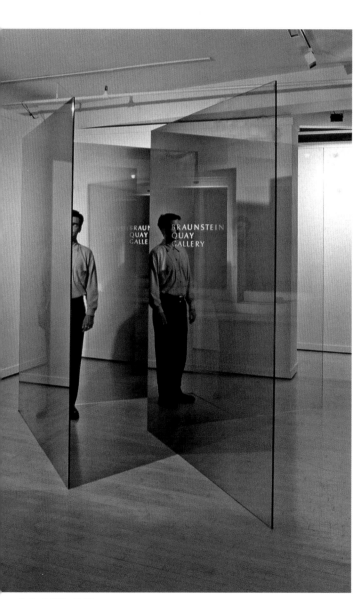

6x8x4-CD 1996
12mm glass coated with nickel and chrome, 6' x 8' x 4'.
Photo courtesy of Braunstein Quay Gallery, San Francisco.
After many years in the studio I found that the interface of
light and surface was my real medium.

Rebecca Bluestone

GERALD PETERS GALLERY, SANTA FE

Douglas Merriam

I am a contemporary abstract artist who uses traditional tapestry techniques. These include hand-dyed silks of varied textures and sheens. To these I add metallic threads woven on a cotton warp. Instead of applying paint to canvas, I dye the fibers first and then, in essence, weave a canvas. The effect is a very painterly work.

My desire to create art has always come from an intense need to communicate aspects of human experience that exist in the interstices, the spaces between our words. I am constantly exploring visual art's abstract language to reach into the depths of what it means to be human. I believe we can access these innermost places in quiet contemplation.

Untitled #41 *2000*
Silk, dyes, cotton warp; 70" x 24". Private collection. All photos by Herb Lotz. I pay homage to the magical marriage of mathematics and art by using subtle color and the Fibonacci progression of numbers to open up our many layers of knowing. The Fibonacci series is the number sequence 1,1,2,3,5,8,13,21. . . . Each number is the addition of the two before it. The ratio between any of these numbers is the shape of the Golden Mean. It figures in the Venetian Church of St. Mark and has become a standard proportion for width in relation to height as used in building facades, window shapes, and often in the dimensions of paintings.

Triptych #3 2002
Silk, dyes, metallic thread, cotton warp; 45" x 48".
Private collection.
The Fibonacci progression is amazingly ubiquitous. It occurs in spiral galaxies and the spiral that coils DNA. The proportions of the Golden Mean are said to be the most pleasing to the human eye. This is not an intellectual concept. We "know" it deep within our bodies.

Silk Journey #22-2 2001
Silk, dyes, cotton warp; 60" x 40".
Private collection.
In liturgies, prayer, chanting, dance, meditation, music, there is always a repetitive element that urges us into our innermost state of being. My work is a visual chant of repetitive geometric shapes, the fundamental shapes through which everything else is formed.

33

Erika Blumenfeld

CHARLOTTE JACKSON FINE ART, SANTA FE

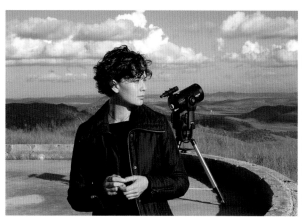

The artist with her telescope and the view from the McDonald Observatory, where she recorded *Moving Light: Lunation 1011.*

What is the nature of light? My inspiration begins with this question, which instills in me a perpetual sense of wonder at the universe. From this vantage point I pursue various events of light that we experience everyday: dawn, twilight, midnight, midday, the solstices and equinoxes, the full moon and lunar cycle. My intent is to document these actions of light, which occur over the cycles of day and night and throughout the astronomical year.

To record these fleeting moments of light, I expose photographic films and papers directly to the light source itself. Rather than using a traditional camera or lens, I use self-designed light-recording devices, which allow the light to directly travel across the surface of photosensitive materials. The resulting images record the subtle changes that light makes over time, and yield a visual account of light's trace. If I am attempting to do one thing with this work, it is to describe certain delicate, elusive, and transitory aspects of the phenomenon of light, which I experience as beautiful and poignant.

Light Graph: Twilight 2001
609 4x5 inch color Polaroids, 660 clear pushpins, 140.75" x 81.25".
Installation view from the artist's solo exhibition installed at the Portland Institute for Contemporary Art, Portland, OR.
All photographs by the artist.
This installation recorded the light as the sun set below the horizon; the Polaroids at the bottom documented the sunlight as it was diminishing and the black Polaroids above documented night after the sun had set.

**Light Recording: September
Full Moon (Harvest Moon)** 2003
LightJet C-Print, aluminum panel, laminate, 48" x 84".
The first in a series of moonlight recordings, this
piece documented the moonlight radiating toward
Earth during the full moon.

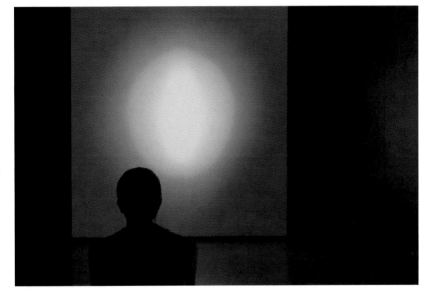

Moving Light: Lunation 1011 2004
Video installation, dimensions variable.
Installation view from the artist's solo exhibition at
DiverseWorks Art Space, Houston.
Recorded at McDonald Observatory in Ft. Davis, Texas,
this piece is a recording of moonlight over the course
of a 30-day lunar cycle, documented every night from
new moon to new moon. The piece was recorded
through the artist's modified telescope; the recordings
were then animated so that the entire lunar cycle is
experienced over a 4-minute video projection.

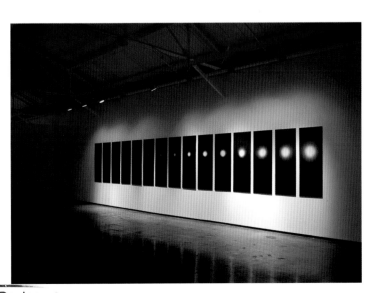

**Light Recording: Greatest Lunar
Apogee/Perigee of 2004**
LightJet C-Prints, aluminum panels, laminate; each
panel 55" x 20". Overall installation 55" x 342".
Installation view from the artist's solo exhibition at
DiverseWorks Art Space, Houston.
This installation documented what is known as
the Lunar Full Moon Perigee and New Moon
Apogee—the time during the moon's elliptical
rotation around the earth when the moon is at its
closest and its farthest away, respectively. This
piece recorded the moonlight over the 15-day
period of the year's most extreme perigee/
apogee.

Kevin Cannon
KEVIN CANNON STUDIO, TAOS

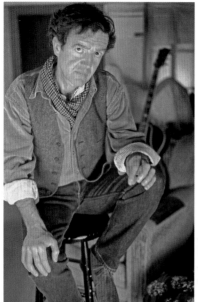

Judy Walgren

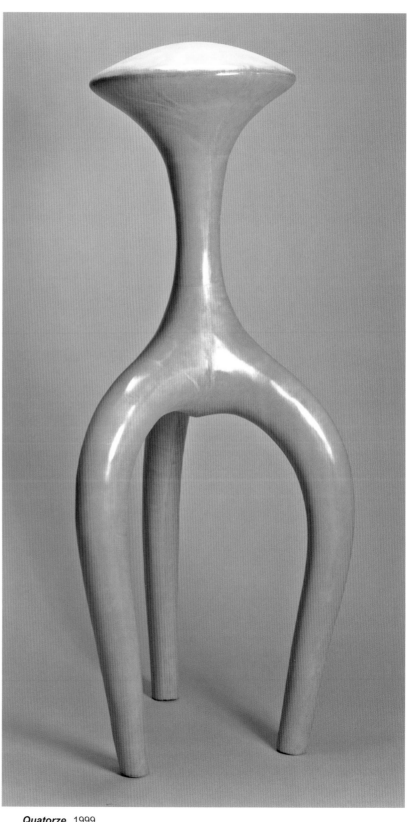

Quatorze 1999
Leather, 42" x 19" x 16.5". Collection of the artist. Photo by Paul O'Connor.

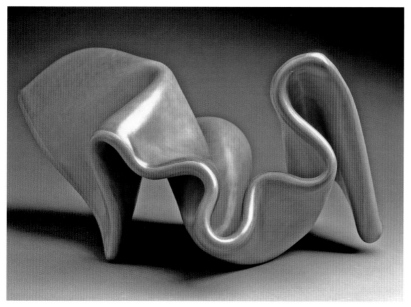

untitled 2002
10.25" x 21" x 4".
Collection of the artist.
Photo by Pat Pollard

Drawing of untitled wrinkle 1999
Graphite on paper, 22.5" x 30.25".
Collection of the artist.
Photo by Pat O'Connor.

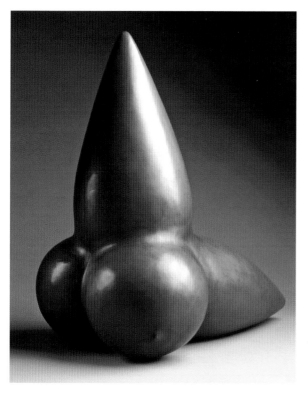

Kind Mist 2001
Leather, acrylic paint, 23" x 23.5" x 15.25".
Collection of the artist.
Photo by Pat Pollard.

Capitol Art Collection
STATE CAPITOL, SANTA FE, NEW MEXICO

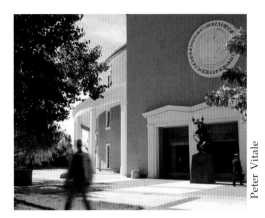

Peter Vitale

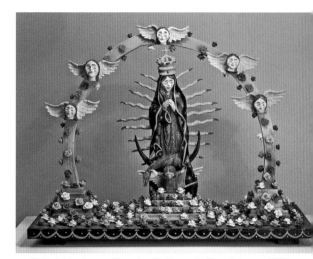

Gilbert Montoya, **Nuestra Señora de Guadalupe** 1994
Wood, gesso, paint, 36" x 43" x 16.5".

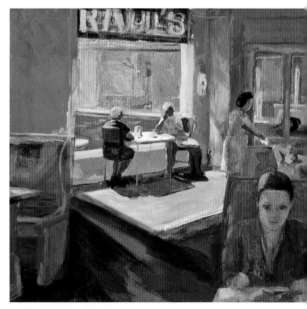

Ruth Meria, **Raul's** 1993
Oil on canvas, 52" x 55".

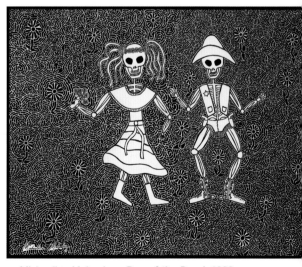

Michaeline Melandez, **Day of the Dead** 1993
Ink on board, 22" x 28".

Think of the State Capitol in Santa Fe and art is not necessarily what comes to mind. Santa Fe, with its abundance of art in museums, galleries, and shops can often be overwhelming for visitors. The Capitol Art Collection is an easily accessible, free, one-stop venue for contemporary art. It is among the most comprehensive collections of contemporary art in the region, featuring works by artists from Taos to Tucumcari and everywhere in between. The work is on permanent exhibition in the collection or on temporary exhibition in one of the Rotunda shows. Viewers can see something new on every visit to the Capitol as works are added on an ongoing basis.

The State Capitol building, often referred to as the "Roundhouse" because of its circular structure, houses this permanent, public collection of contemporary works by artists of New Mexico. It is a unique example of how art and politics can enhance each other. The Roundhouse's circular and spacious design offers optimal and abundant wall space and dramatic viewing angles. The collection is displayed throughout the Capitol Complex—the main building, the Annex walkway, the North Annex, and on the grounds.

The Capitol Art Collection's focus is contemporary art and currently consists of more than 400 masterworks that include painting, sculpture, photography, works on paper, mixed media, glass, ceramics, textiles, handcrafted furniture, and traditional works such as *retablos*, *santos*, *colcha*, embroidery, and weaving. The collection is diverse in imagery and rich in historic tradition—Modernist tendencies, Spanish Colonial techniques, Native American symbology, Catholic iconography, and multiple interpretations of the New Mexico landscape all abound. There are emerging as well as established artists, self taught as well as academically trained. Each artist adds to the colorful palette that makes up New Mexico's dynamic, expressive culture.

The Capitol Art Collection was created in 1991 when the New Mexico Legislature founded the Capitol Art Foundation, a non profit art organization whose sole purpose is to direct the Capitol Art Collection and oversee the selection, acquisition, and exhibition of the artwork. The Capitol Art Foundation is made up of twenty-five to thirty art professionals who represent the artistic and geographic diversity of the state. The result is a model for preserving, interpreting, and exhibiting contemporary regional and local art that serves as an example for Capitols everywhere.

Text and artworks generously provided by Cynthia Sanchez, Ph.D. Executive Director of the Capitol Art Foundation and Curator of the Capitol Art Collection.

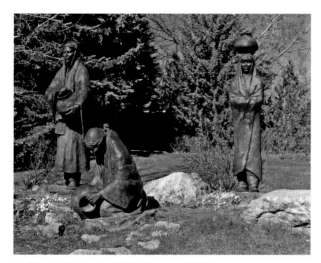

Glenna Goodacre, *Waterbearers* 1989
Bronze, 88" x 115" x 75".

Emmi Whitehorse, *Crystal Woman II* 1991
Oil on paper on canvas, 78" x 51".

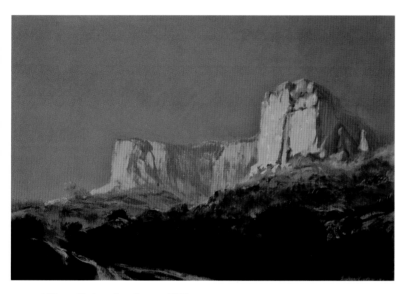

Wilson Hurley, *Sundown* 1972
Oil on canvas, 18" x 26".

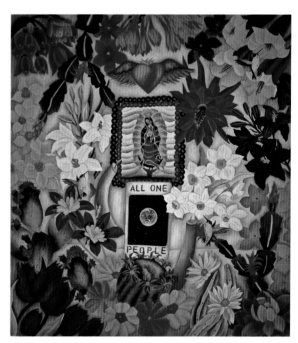

Pola Lopez, *All One People* 1991
Oil on canvas, 54.75" x 60.75".

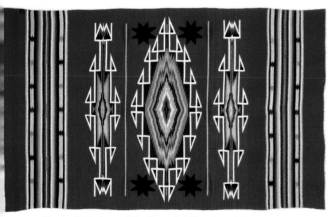

Eppie Archuleta, *Rio Grande Weaving* 1999
Wool, natural dyes, 50" x 86".

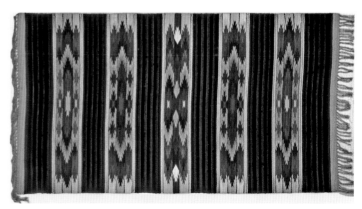

Norma Medina, *Rio Grande Weaving* 1995
Wool, natural dyes, 42" x 87".

Charles Carrillo
SANTOS OF NEW MEXICO, SANTA FE

I'm driven by a passion—my love for New Mexican history, my Hispanic culture, and most important, the devotions handed down to me by my ancestors. I celebrate these through my art. I consider myself a romantic about anything New Mexican. Everything I have learned in my life as a New Mexican is part of a tradition.

I never imagined that I would be make a living as an artist. When I was young it was the farthest from my mind. When I went to the University of New Mexico I dreamed of becoming an archaeologist, eventually acquiring a Ph.D. I did that for twenty years. Archeology helped me see the way the outside world looks at the material culture of my people.

I make objects of devotion but they are objects of art, too. People who have bought my pieces as objects of art have come back saying, "That image is growing on me; I'm developing a relation with the devotional aspect of the piece." It's amazing how many have turned around their sense of art to understand a *santo*, *retablo*, or *bulto* as more than art.

Altar de la Conquistadora 2005
Ponderosa pine, homemade gesso, homemade natural pigments, piñon sap varnish, 90" x 50" x 16" deep. Photo by the artist.

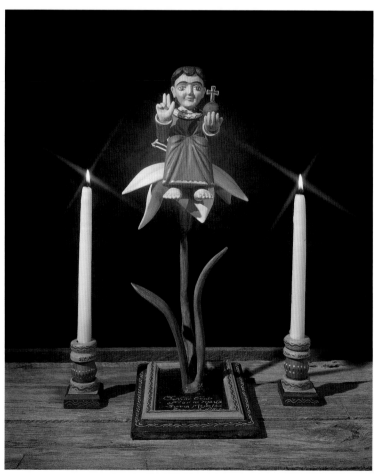

Santo Niño Flor de María 2004
Cottonwood root, natural pigments, piñon sap varnish, 15" x 4" x 6" deep. Private collection. Photo by Mark Nohl.

The last things I paint—even after my signature—are the eyes. I don't want the saint looking back at me till the entire statue is done. A piece takes on its own spiritual presence—call it thaumaturgic potency, if you will—that, when created, gives an essence that somehow recalls the living saint. If the pieces are used for devotionals they transmit that potency, that sacredness, that power, which renders them more than just a painting.

I've done social commentary pieces, but they always involved religious figures; I have never done a secular figure. The reason is tradition. It's not that I want people to consider me as simply a *santero*, but that I want them to understand the traditions behind devotional objects.

If we get to the point where we as *santero*s aren't affordable to our own people, we've undone the tradition. I go to Spanish Market with pieces that are affordable to everybody. If only museums can afford *santo*s, then we lose the tradition. The tradition must not escape us—especially for financial reasons.

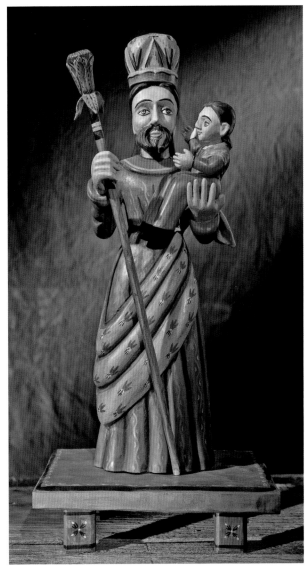

Señor San José 1995
Cottonwood root, natural pigments, piñon sap varnish, 32" x 10" x 8".
Collection of Dr. and Mrs. Rafael and Loretta Carrillo.
Photo by Mark Nohl.
I want to tell future generations that I was able to encourage my colleague santeros and santeras to follow the traditions, to know and actively celebrate the feast days, to light candles on the saints' feast days. That is how the traditions are perpetuated.

Sangre de Christo 1994
Carved cottonwood root, homemade natural pigments, piñon sap varnish, 21" x 13".
Collection of Paul Rhetts and Barbe Awalt.
Photo by Paul Rhetts.
I've sent my pieces to New York, Chicago, California, Ohio, Oregon, Utah, Mexico, and Japan. Spain's King Juan Carlos owned a piece, which I believe he gave to a church there.

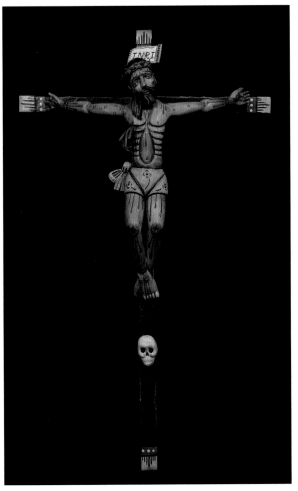

Carol Coates
TADU DOWNTOWN, SANTA FE

In my childhood in the country, where time was very still, I'd be found sitting in a bed of flowers, examining the intricate beauty of their centers. As I experienced life, I learned that I had sensitivities not considered "normal"—discouraged then, but assets today.

I enjoyed all of my senses, my emotions, and my mind. I had great empathy for those treated unjustly or misunderstood. Justice, compassion, integrity, and courage became major issues. In the artist's world, I found ways to escape, to understand, and to communicate thoughts, beliefs, and feelings.

Younger, I mostly adapted to others. As I learned about how my passivity was impacting my world and noted the importance of my choices, I became more proactive—the power of choice in a fast-moving river of choice, and chance has been my most central theme. My most recent work is based on a dance practice called "Contact Improv" and its constant references to choices in momentum.

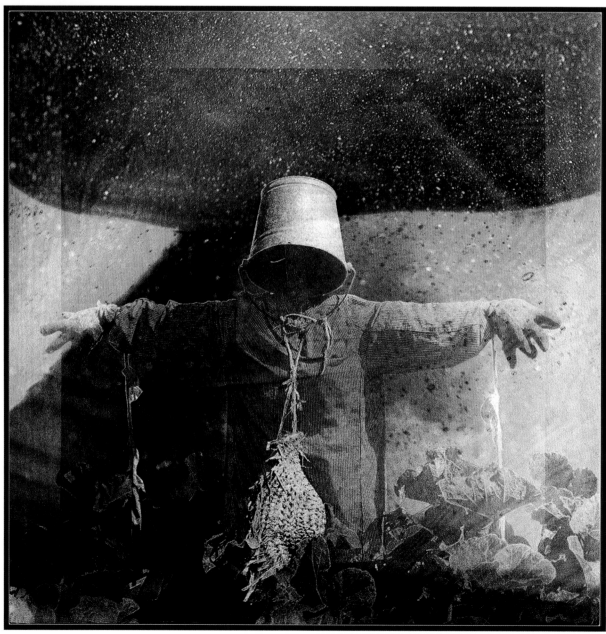

I've done work as large as forty-five feet in length, currently involving opaque image surfaces with translucent image overlays that create holographic effects. The surfaces of mesh, wax, or resins and the frequent sculptural presentations of the imagery honors my background as metal smith, sculptor, photographer, painter, and collagist.

If we have the opportunity, I would enjoy sitting with you and talking about their inspiration and my intent. If not, I hope that you find meaning in them for yourself. I hope that my work reveals something of value. It is my gift to you.

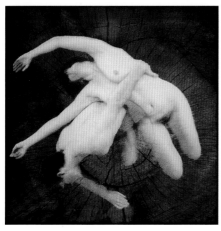

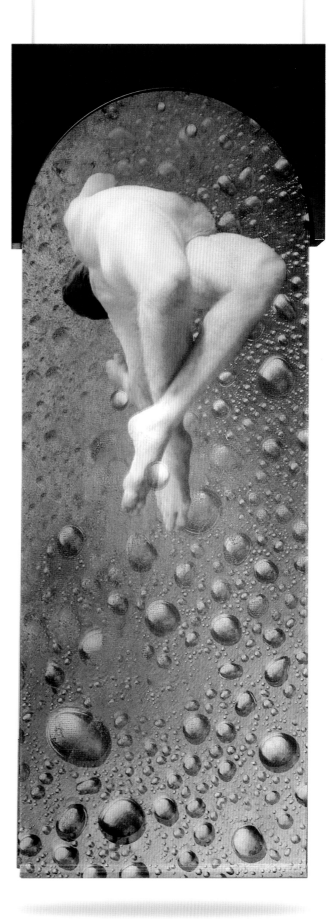

above
Contact III and IV 2005
Mixed pigments on mesh and canvas, 18" x 18" each.

right
Immerse 2005
Hanging banner (front image), mixed
pigments on mesh and canvas, 110" x 43".

left
Judgment 2002
Mixed pigments on mesh and canvas, 84" x 84".
Leonardo il Magnifico Medal, Florence Biennale, Italy, 2003.

Erin Currier
PARKS GALLERY, TAOS

Photo by Lenny Foster

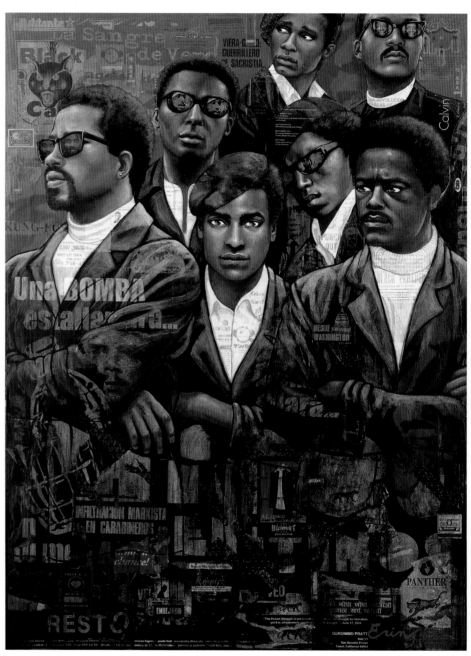

Black Panthers 2004
Mixed media, 48" x 36". All photos by Pat Pollard.
All of our African, Asian, European, and indigenous ancestors dreamed of the Americas in the context of freedom and liberation. Martin Luther King Jr. spoke of this dream forty years ago; European colonialists dreamed it when they came to the Americas, then promptly stole it from the people they encountered here, as well as from the people they brought here and enslaved. My "The Other America" series attempts to take stock of this dream, to examine to what extent this dream has been realized, and to measure the magnitude of the inevitable struggle to come.

The struggle of Native Americans, African Americans, and others in the United States is not unlike the struggle of the indigenous people of Mexico, Central America, Ecuador, Bolivia, and Peru against globalization, homogenization, the squandering of national resources, and racism; or the struggle of female school children in Chile against the chauvinistic, patriarchal, authoritative structure to which they are subjected; or the struggle of the economically deprived youth in Argentina, attempting desperately to eke out a living; or the struggle of Brazilians against corrupt police forces that provide *favelas* with weapons, and against bureaucrats who sell out everything and offer nothing.

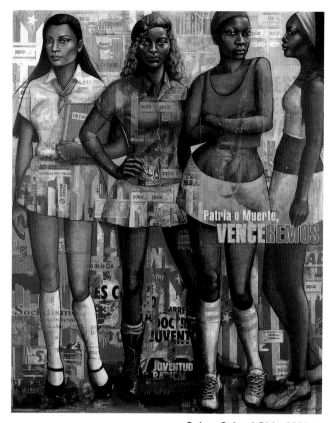

Cuban School Girls 2004
Mixed media, 60" x 48".

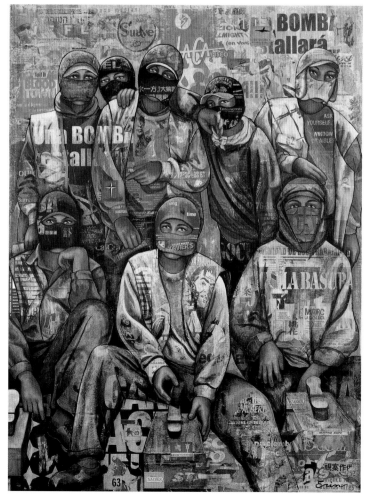

Lustrabotas De Los Altos 2004
Mixed media, 48" x 36".

Eddie Dominguez

ALLENE LAPIDES GALLERY, SANTA FE

Larry Gawel

All of my work is imbued with my love of the land, the home environment, nostalgia, and ideas of culture. I grew up in the small town of Tucumcari, New Mexico. In college I learned that there was a formal, academic way of thinking about art—there was a historical way to think about art, and there were museums all over the world that housed it. I didn't grow up like that. To me, art was my next-door neighbor making a quilt; it was my aunt crocheting, or my mother making a dress. Anything that involved somebody in any kind of creative expression was art. The most honest influences that I have had can be found in the little things of my home.

From my earliest memories, I always felt a strange responsibility to do community work, to bring art to places where art doesn't always live. I would hope that if I ever have done anything important, it would be that I brought art into the lives of many people.

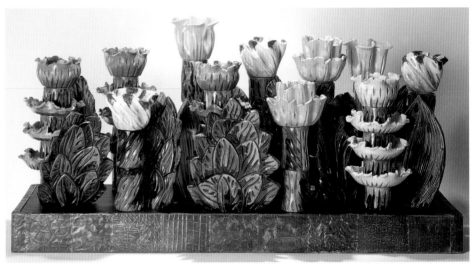

Anton's Flowers 1997
Ceramic dinnerware set,
50" x 14" x 21".
Renwick Collection of the Smithsonian Museum of Art, Washington, DC.
Photo by Herbert Lotz.
The inspiration for this flower garden dinnerware set came from a bouquet given to me at the birth of our son Anton.

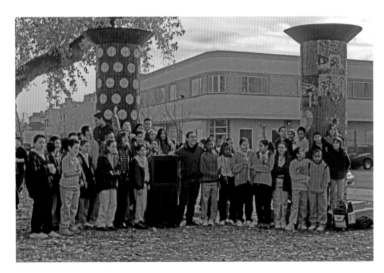

Pillars of the Community 2002
Two of three cast cement columns covered with tile mosaic, 12' high x 4' dia. each.
I have committed myself to bringing art into the lives of as many people as I can. Throughout my career I have contributed to public art projects at schools, universities, health organizations, senior centers, and the like. These projects are important to me because they foster a sense of community ownership in the artwork. *Pillars of the Community* was commissioned by The Albuquerque Community Foundation with a grant from The FUNd for a park that was adjacent to Washington Middle School in one of the oldest neighborhoods in Albuquerque. The columns represent information about the past, the present, and the future dreams of the neighborhood residents. At the dedication ceremony I was surrounded by some of the students who helped to make the artwork on the columns.

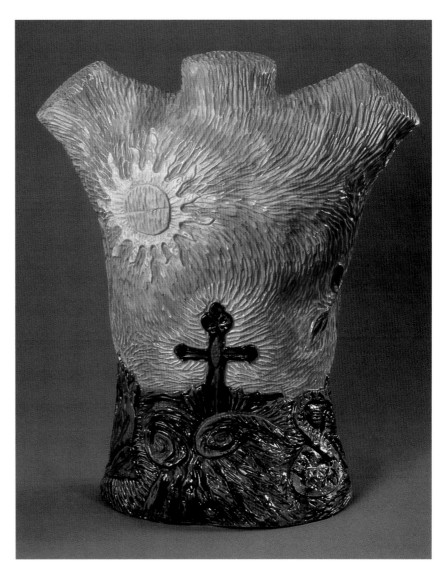

Body of Faith 2004
Ceramic, 25" x 22" x 10".
Collection of the artist.
Photo by Larry Gawell.
I often use the human torso as
a canvas on which to express
my ideas.

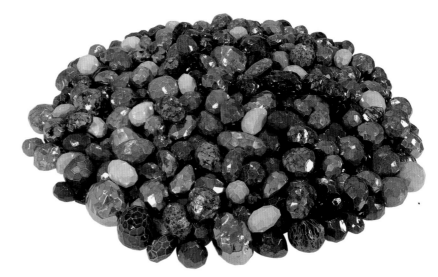

Diane's Gems 2002
Ceramic, 8' dia. x 12". Collection of
Museum of Nebraska Art, Kearney,
NB. Photo by Jose Rivera.
I'm a little obsessive by nature. It
shows up in pieces like this
fabrication of 350 ceramic
"gemstones"—a magnificent pile of
abundance and beauty for my wife.

Carol Eckert

THIRTEEN MOONS GALLERY, SANTA FE

W. Scott Mitchell

For a long time I called my pieces baskets, even though I realized that when most viewers thought of a basket, they imagined something different. Still, all of my pieces were vessels constructed with ancient basketry techniques. Now that I make staffs, books, and shrines, I no longer refer to my works as baskets, even though I still call myself a basketmaker.

I love art history, but not so much the scholarly side as the visual one. I am always lugging home big color-plate art books from the library. Influences from many periods, including Scythian, Gothic, Yoruba, and Egyptian, creep into my work.

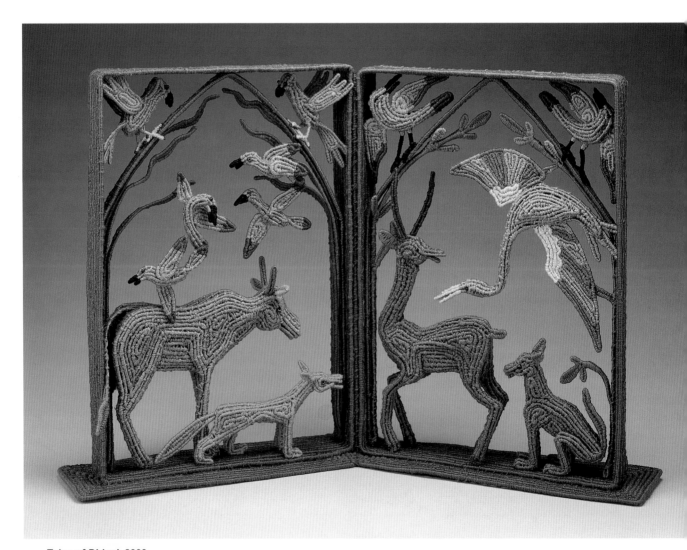

Tales of Bidpai 2003
Cotton and wire, 9.5" x 14.5" x 5". Private collection.
All photos by W. Scott Mitchell.

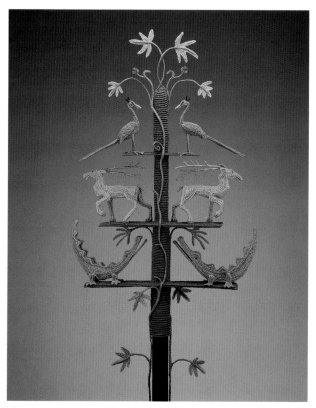

Arroyo Seco 2003
Cotton, wire, wood, 78" x 15.5" x 4".
Collection of the artist.

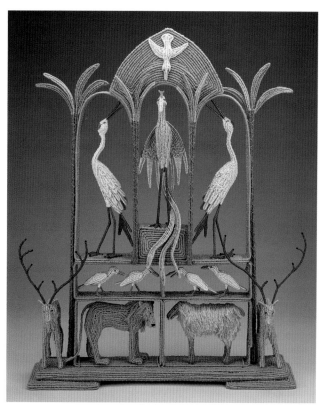

In Terra Pax 2004
Cotton and wire, 20" x 16" x 5".
Collection of the artist.

Each piece begins with symbols and stories—creation myths, legends of great floods, tales of journeys and quests, parables of good and evil. I am intrigued that cultures from so many different places and times share related traditions. The universal nature of animal symbolism appeals to me—snakes as symbols of evil (though they can also represent regrowth and renewal), storks and cranes as signs of good fortune.

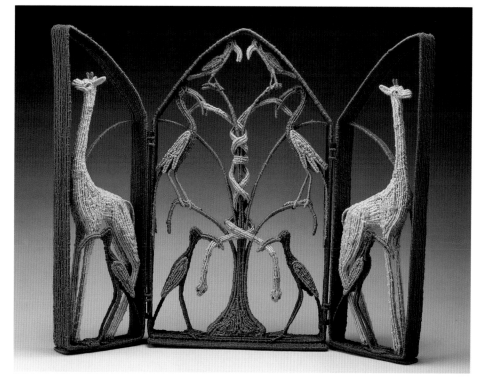

Giraffe Triptych 2001
Cotton and wire, 11.5" x 14" x 3".
Collection of Martin and Cathy Wice.

Tom Eckert

THIRTEEN MOONS GALLERY, SANTA FE

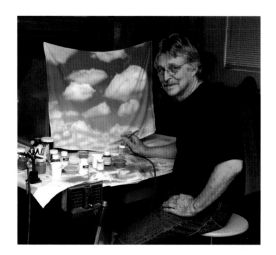

Sometimes it is hard to decide whether you choose art or it chooses you. Artists become great because their contribution is a result of their work. Neither greatness nor art can be contrived. Life is a lengthy artwork. Everything one learns, at some point, comes into that work. Much of my work is still about my early experiences in drawing, painting, and the many other things that I had to teach myself.

Viewers draw visual conclusions from the form and color of an object. I have always been fascinated by visual untruths, so I have spent years deceiving viewers by mimicking a certain material by using something different. You can do structural things with wood that are impossible with cloth, so I carve wood to look like cloth. Then I go a step further by making visually impossible forms that defy gravity or appear suspended by an invisible, magic force.

Numinous Levitation 1999
Polychrome wood, 15" x 19" x 15".
Private collection. All photos by
Vermillion Studios.
I am on a creative trail and sometimes cannot see the direction because of the landscape. I hope eventually to contribute something to the art world.

Aberrant Ascension 2001
Polychrome wood, 12" x 12" x 21". Private collection.
Ideas rather than the techniques inspire a work. Ideas
do not come easily. The bolt of inspiration hits only
after much thinking and sketching.

Stratagem 2000
Polychrome wood,
13.5" x 15.5" x 13".
Private collection.

Phantasm 2000
Polychrome wood,
12" x 12" x 10".
Private collection.
As long as you can think
of something more to do
to a piece, it is not finished.

Alexandra Eldridge
TURNER-CARROLL GALLERY, SANTA FE

Photo by Jennifer Esperanza

My paintings emerge from a place where contradictions are allowed, paradox reigns, and reason is abandoned. My search is for the inherent radiance in all things . . . the extraordinary in the ordinary.

As the process of painting parallels the movement of psyche, it helps me to understand the world as a deeper reality. The rich soul experiences of my life become tangible.

Each painting is a small acknowledgment of the inner life that can perhaps reveal its own share of soul, and that share of soul may connect to someone else's share of soul. Then perhaps beauty may be granted.

Stitched Together with Sugar Thread 2003 Mixed media on paper scroll, 64" x 36". All photos by Dan Morse.

Wait For Me Under the Lime Tree 2005
Mixed media, 72" x 36".

top
The Knowing That Unknows 2003
Mixed media, 60" x 48".

bottom
Come Sail Your Ships Around Me 2005
Mixed media, 24" x 18".

53

Richard Faller

ERNESTO MAYANS GALLERY, SANTA FE

Lorran Meares

Near Nageesi #1 1972
Gelatin silver print, 7" x 5.5".

City of Rocks 1970
Gelatin silver print, 9.5" x 13".

When going out with my camera, I try to set out with no preconceived notions or goals, but to remain open to my surroundings and to the call of the landscape. As for the rest, I consider photography to be a print making process, and making a print of a negative is a contemplative experience for me.

Point Lobos 1970
Gelatin silver print, 7" x 9".

Church, Ranchos de Taos #3 1969
Gelatin silver print, 6.5" x 5"

Church, Ranchos de Taos #1 1969
Gelatin silver print, 5" x 6.5".

Coprinus 1971
Gelatin silver print, 5" x 6.5"

John Fincher

GERALD PETERS GALLERY, SANTA FE

Herb Lotz

In this current series of paintings I am seeking a purified image, compared to my previous work, which was more traditionally pictorial. I have abandoned the use of photographs as resource material and now use only gouache drawings and the product of my imagination to arrive at these compositions.

Nature (specifically trees) inspires this body of work. I rely on a strong network of line to communicate my ideas regarding energy and order. Graphic muscularity is essential to the resolution of these pieces. Although the images are somewhat universally abstract in their completed state, I trust they speak to the viewer about the spirit of the West. This is the essence of the work.

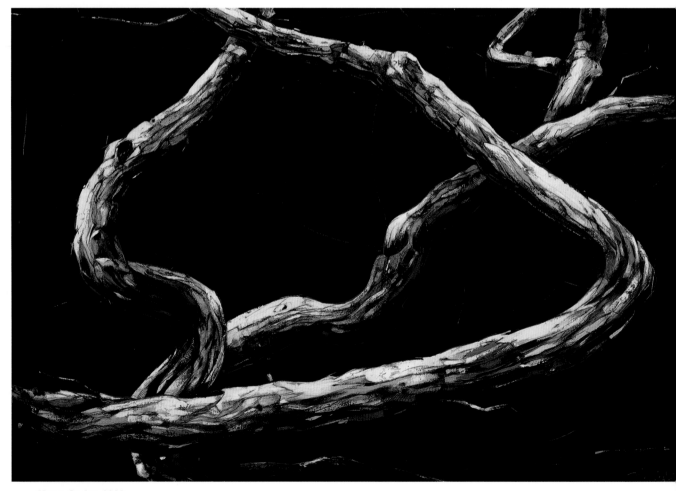

Moon Cedar 2003
Oil on linen, 48" x 72" x 2.375".
All photos courtesy of Gerald Peters Gallery.

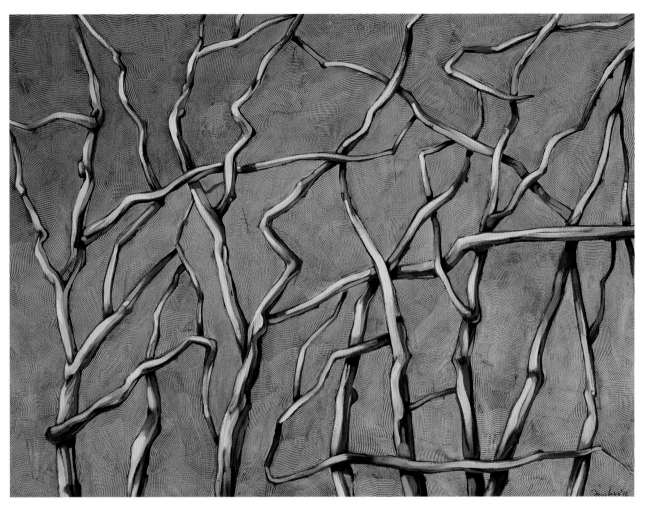

Barbados 2004
Oil on canvas, 36" x 48" x 0.5".

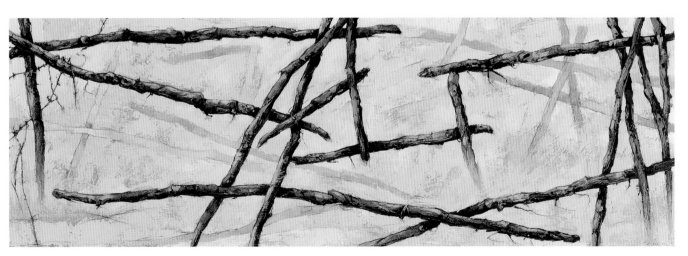

Quartz Mountain 2003
Oil on paper, 30" x 90" x 0.5".

Jody Forster

ANDREW SMITH GALLERY, SANTA FE

Since early childhood the natural world has dominated my mind and spirit with its wonders and grandeur. From the American West to the Antarctic to the Himalayas I have sought to uncover these wonders through the art of photography.

I do not believe in intellectual agendas as art, nor care to impose myself onto the world around me through imagery. My work is intuitive in origin. As an artist my purpose is to translate the wonder and mystery of the sublime in nature. Although the camera cannot see beyond the physical world, it is through artistic composition of light, shadow, space, and form that I attempt to reveal the spiritual essence of nature through a photograph.

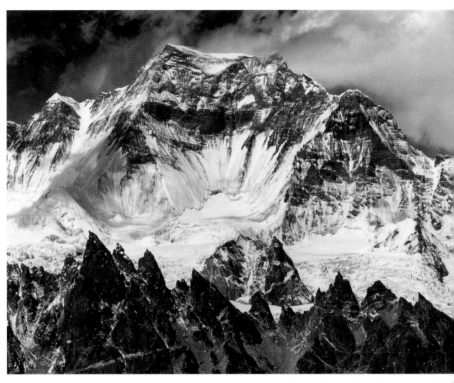

Gyachung Kang, Khumbu, Nepal 1985
Silver gelatin print, 23.5" x 18.5".

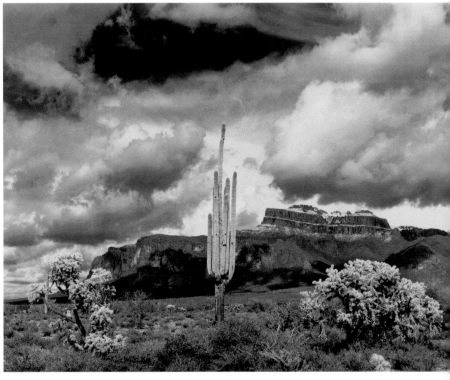

Winter Storm Clearing, Superstition Mountain, Arizona 1978
Silver gelatin print, 23.5" x 18.5".

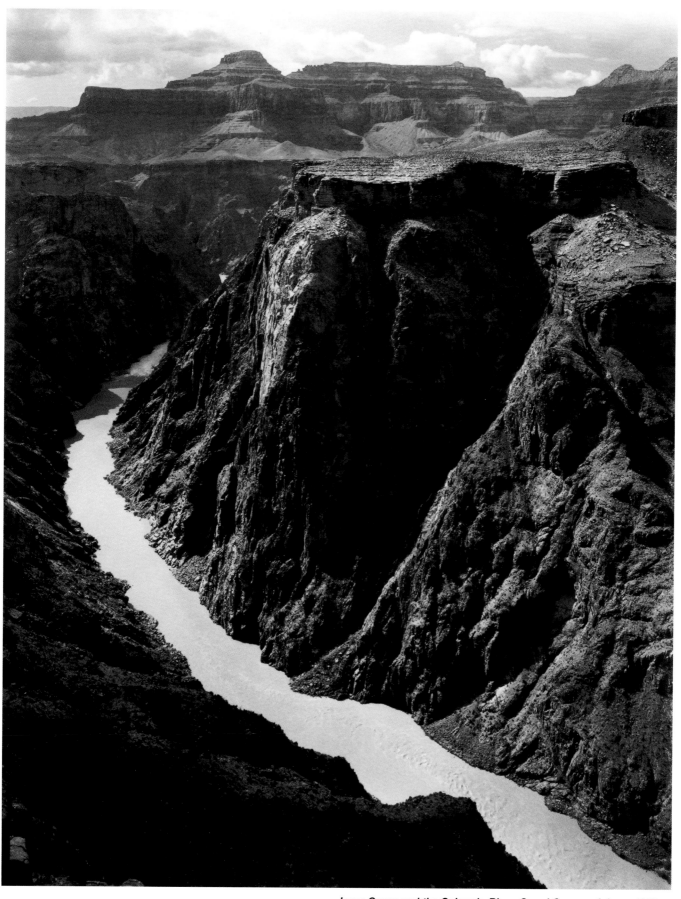

Inner Gorge and the Colorado River, Grand Canyon, Arizona 1980
Silver gelatin print, 18.5" x 23.5".

Miguel Gandert

ANDREW SMITH GALLERY, SANTA FE

I think of photography and my work as a window on our time. I try to create images that distill my reaction to culture and the time in which I live.

I prefer photographing acts of ritual, the things people do not because we have to—like a job—but something we need to do inherently as part of being who we are. Modernity has so homogenized today's cultures that we lose not merely our rituals but the very sense of ritual.

This interrupts the dance of our identity. I want to preserve that dance. I look at people's gestures, whether a tattoo or a kind of dress, and see ritual.

I often shoot with wide-angle lenses, not because of the angle of view, but because they allow me to get so close. You don't try to kiss somebody from across the room. When I'm photographing dance and ritual I use wide-angle lenses because they take me right into the dance. Intimacy is the key to human feeling. I owe something to the viewer and subject, and for me it's that sense of intimacy.

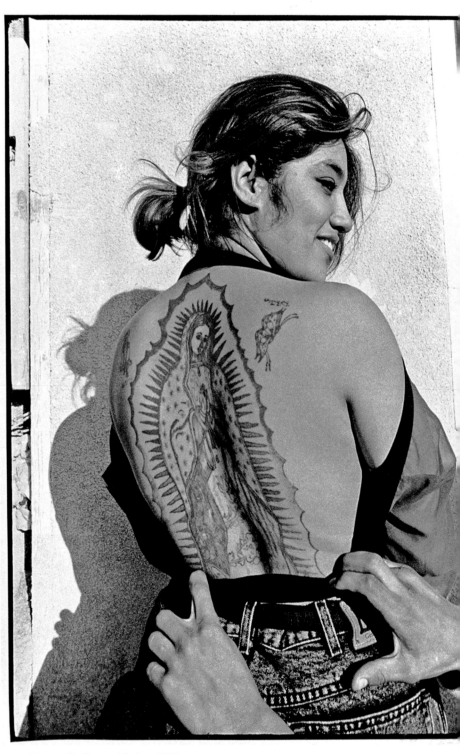

Teresa Gutierrez Mexico, 1992
Silver Gelatin Print, 20" x 16".
All photos by the artist courtesy of Andrew Smith Gallery.
I look for the magic of the moment. I saw this woman walking down the street, with the head of an "Our Lady of Guadalupe" tattoo peeking from behind her Lycra tube top. I followed her. At a certain point the light was starting to work well so I asked her if I could take her picture. Her boyfriend thought it was great. Suddenly his huge hands were pulling down her blouse, I made the picture and it came out *Wow!!*

Guadalupana Del Alma 1966
Silver Gelatin Print, 20" x 16".
Before asking someone to take his or her picture, you have to know why you want to make the picture. If you have a good answer, 95 percent of the time people will say yes. That's what I try to do. Connect, start a conversation, make a close friend. If you really want to make it as a photographer, you have to do what comes from your heart.

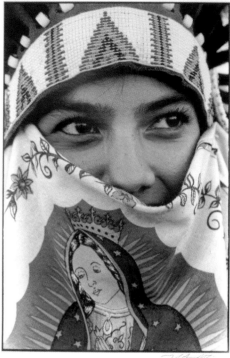

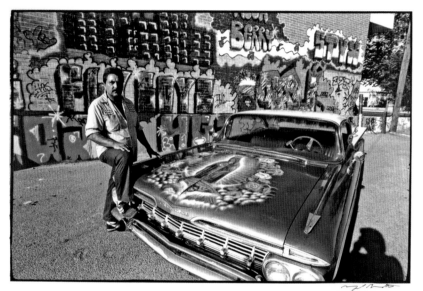

Frank Alderate with '59 Chevy, Albuquerque, NM 1986
Silver Gelatin Print, 16" x 20".
My pictures are not exotic. They are affirmations of life. Try to read and understand the stories in them. When people dress up and ritually perform, they are preserving their histories both ancient and yet to come.

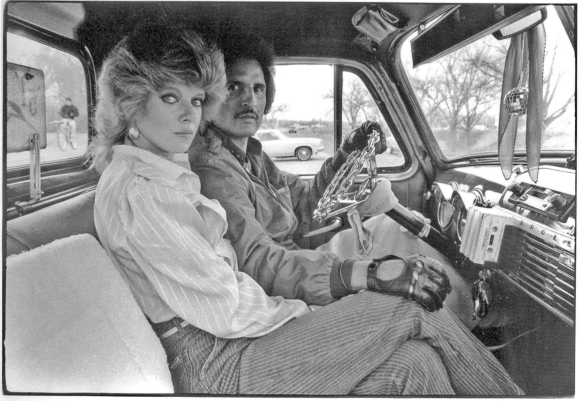

Couple In '51 Chevy, Albuquerque, NM 1986
Silver Gelatin Print, 16" x 20".

Joe Ramiro Garcia

LewAllen Contemporary, Santa Fe

Will Schmitt

The messiness of my paintings echoes inner material that I empathize with. I like the idea that many interpretations of something are possible—for example, that we probably possess more than five senses and they may not be understood. I'm convinced it is these extraperceptional senses that enable us to create and absorb art.

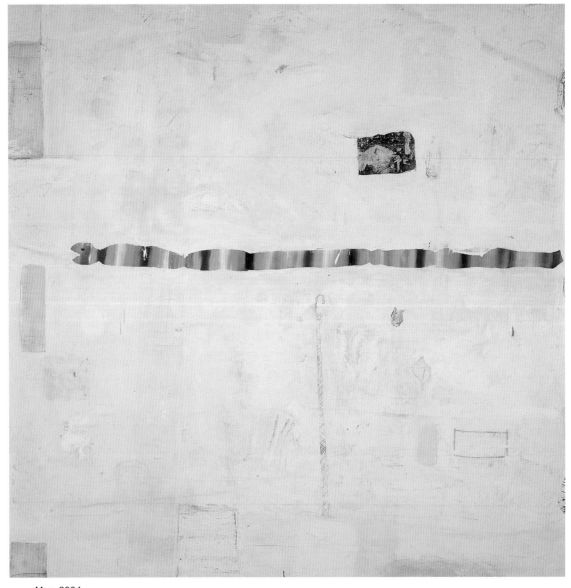

Voz 2004
Oil and alkyd on canvas, 72" x 72". All photos by Mark Nohl.
Some people believe that paintings have meanings. If there is a message in my painting, it is that I'm not sure of anything and that's okay with me.

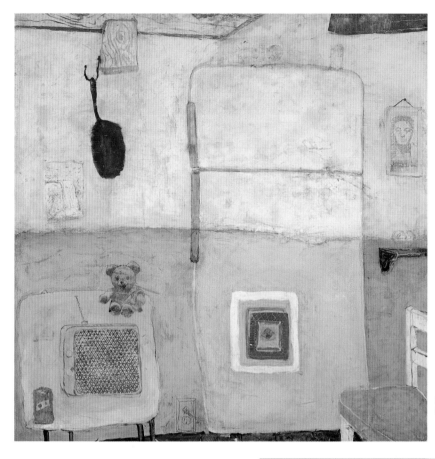

Dwell 2004
Oil and alkyd on canvas, 60" x 60".

We become transparent as we get older, often revealing parts of ourselves we would rather keep private. For me, painting is learning how to forgive myself. I put cartoons, animals, and objects into my work, but they are not narrative devices. Instead, I am sensitive to the charge or implication they lend to the painting's surface. They become like the layers of memories we all carry around.

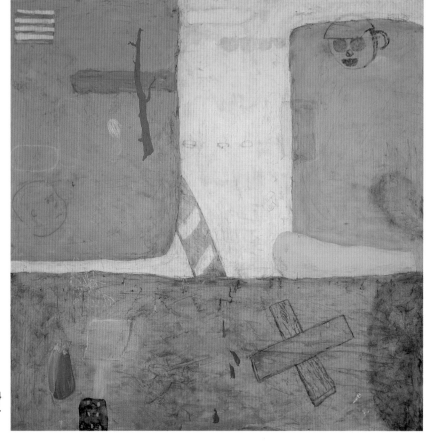

Swat 2004
Oil and alkyd on canvas, 60" x 60".

Tammy Garcia
BLUE RAIN GALLERY, TAOS AND SANTA FE

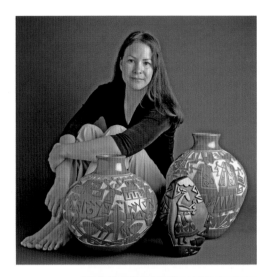

I enjoy creating pieces for which there are no names. I love the sense that there is no easy classification. There is a freedom there. I can let my imagination and creative sense free. Still, I look to the past for inspiration. I take ideas from historic pottery and incorporate that into what I'm doing and experiencing today. What I do is strongly rooted in the traditions of my culture; it is an honor to have this handed down. Yet I want my work to document what is happening today, to reflect what is occurring now. I need this challenge of trying new things, always knowing that what is contemporary today will be traditional tomorrow.

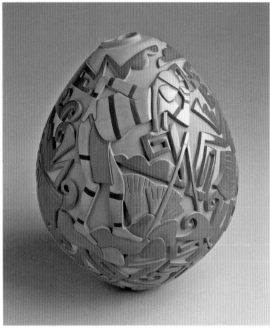

Koshari 2004
Natural clay, 10.25" x 7" dia.
All photos courtesy Blue Rain Gallery.
I'm still learning what is possible—what the clay has to offer.

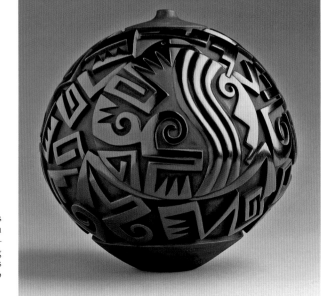

Seed Jar 2004
Natural clay, 8.25" x 8" dia.
I enjoy those pieces where I test the limits while having fun at the same time. Still, you have to have respect for the laws of nature—gravity. Sometimes, as I'm building, I'm holding my breath with every coil, wondering if it's going to collapse. It is so important to keep inventing, evolving, exploring new ideas.

Sentinel (viewed from 3 sides)
2004
Bronze, limited edition,
79" tall (83" with base) x 14" wide.
Each of us has an inherent God-given talent, a gift. If we urge our talent beyond our limitations, we succeed at what we put our minds to. If we don't utilize our talent, it—and we with it—are lost.

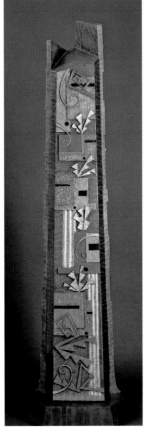 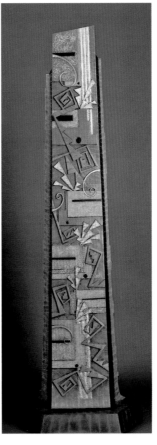 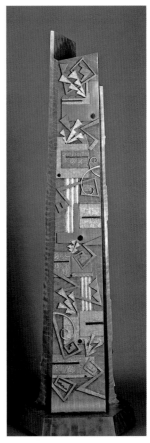

Harmony (viewed from 3 sides)
2004
Bronze, limited edition
63" tall (76" with base) x 11" wide.
I need the challenge of the new, not the shapes and designs I've done before. When a shape changes as I work on it, I give myself to the change.
The medium speaks,
and I listen.

 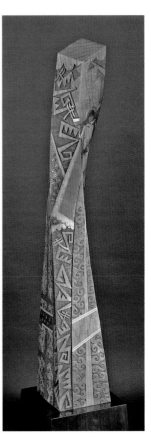

Sandy Goins

CANYON ROAD CONTEMPORARY ART, SANTA FE

Helga Ancona

I have always been inspired by the commonplace. A simple object sitting on a plate or napkin is full of wonderful details that are so often overlooked. I have an active outdoor life, so the time I spend in quiet reflection with my paints creates the balance between the outer landscapes and what I need to be within myself. For me, the small size of my works represents the power and hope of daily life around us. Perhaps my alignment with the basics helps others take more time to see, to touch, and to surrender to the magic that is every day.

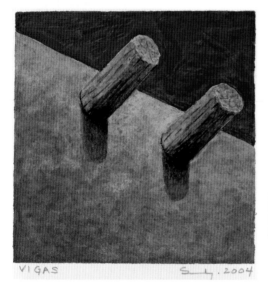

Vigas 2004
Gouache on paper, 3" x 3".
Private collection.
All photos by Joe D'Alessandro.

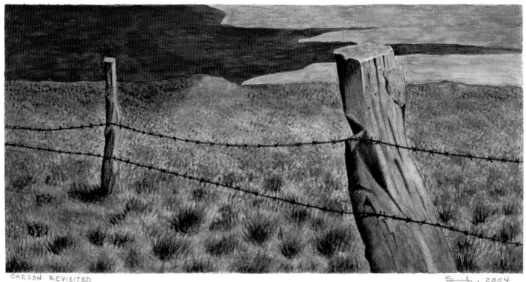

Carson Revisited 2004
Gouache on paper, 4" x 8".
Private collection.

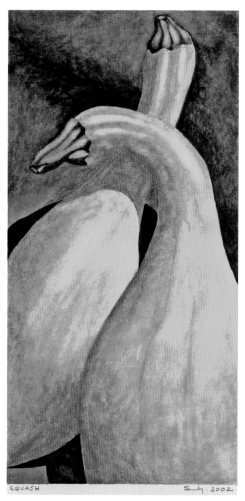

Squash 2002
Gouache on paper, 8" x 4".
Private collection.

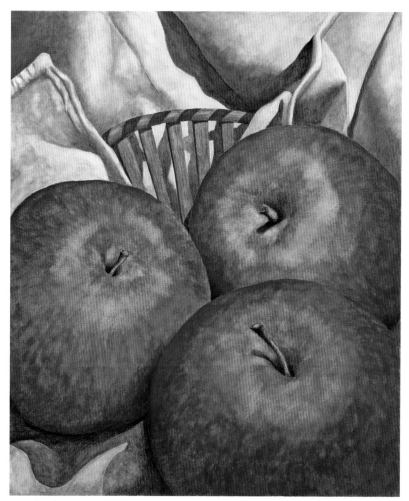

Apples 2001
Gouache on paper, 13" x 11".
Private collection.

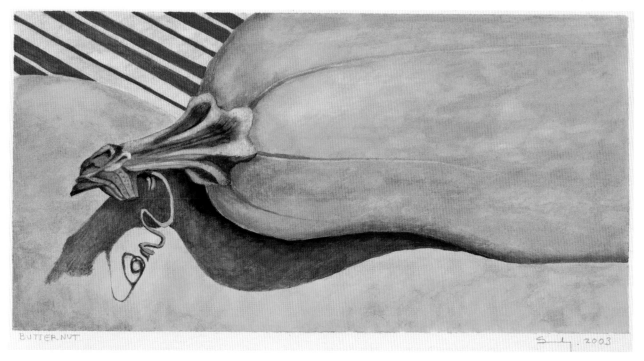

Butternut 2003
Gouache on paper, 4" x 8". Private collection.

Teri Greeves
THIRTEEN MOONS GALLERY, SANTA FE

Portrait by Hal Brainerd

I am Kiowa. My people currently live in what is now referred to as the state of Oklahoma. But we came from the North about 200 years earlier. We believe this because we have stories—stories that stretch into the infinite.

My mother ran a trading post on Wind River Reservation in Wyoming. In her store, I was exposed to Indian beadwork and a mixed traditional aesthetic that now informs my work. Along with the Shoshone ladies that first taught me, it is my grandmother, who raised a large family selling her beadwork, that I feel with me when I work.

I believe the objects I create come through me from those who came before me, for the children I have given birth to and for all future generations of Kiowa people.

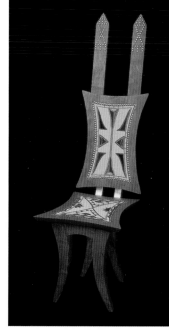

Ah-day: The Favorite One's Chair 2001
Size 13 cut beads, brain-tanned deer hide, figure cherry wood, brass tacks, 38" x 13" x 19".
Among Kiowas, the *Ah-day* child receive everything even if the rest of the family mus suffer. It is a position of great honor. This cha was created for all Kiowa *Ah-days*, past an present. It is my humble prayer of hope an love for all that is beautiful in Kiowa life.

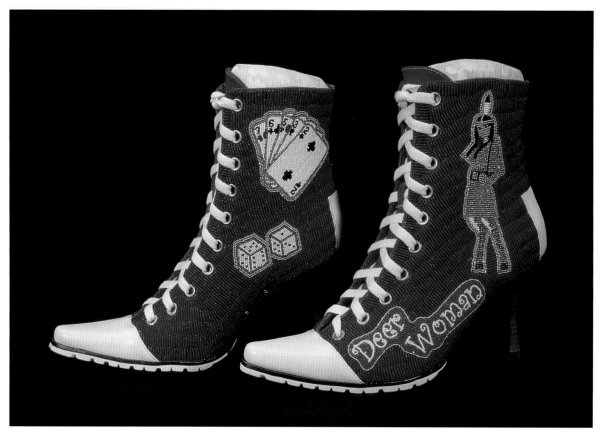

Deer Woman as Lady Luck 2004
Size 13 cut beads, seed beads, shoes, 12" x 12" x 4".
Collection of The British Museum, London. All photos by Dan Morse.
When I create any piece, I try to make it so my mother can understand it. Something about it makes her grunt in agreement or laugh in amusement. My audience is we Native people who have adapted and ultimately survived genocide.

68

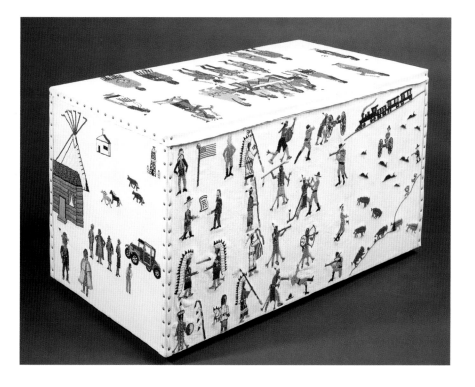

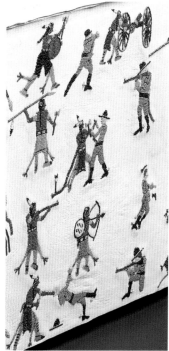

Detail from center section.

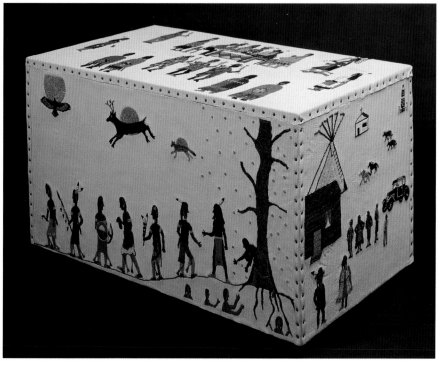

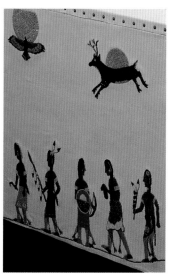

Detail from end section.

Gkoy-Goo: The Story of My People 2000
Brain-tanned deer hide, size 13 and 12 cut beads, brass and nickel studs, brass tacks, birch wood trunk, 17" x 16" x 32". Private collection.
This chest is a gift to my children, a pictorial history beginning in mythic times and culminating in the present. The story reads from right to left, the way we move through our sacred spaces. *Ah-ho* to all those who came before me. Look after my children and let them always remember who they are: *Gkoy-Goo.*

Woody Gwyn
GERALD PETERS GALLERY, SANTA FE

We are consciousness having a human experience. The outward facts of the experience do not add up to the whole, anymore than a realist work of art, with all tangible details carefully described, succeeds unless it somehow expresses what is invisible.

Each of us are living a life that has never been enacted before. The surface of each of our personal lives consists of our triumphs, our failures, our mothering, our fathering, our drive to do meaningful work, our comings, and our goings.

Beneath the personal is the abstract inner universe, what Theresa of Avila called the interior castle, the place shared by all consciousness, the source of our sense of mystery and core of all our yearnings.

For an artist the quest is always a vision of this inner universe.

Field/Pond I 2001
Egg tempera on canvas, 60" x 60".
All photos courtesy of Gerald Peters Gallery.

opposite page
Horse and Rider 1997
Acrylic and mixed media, 24" x 24".

Siegfried Halus

Dwight Hackett projects, Santa Fe

Photo by Jim Young

I have always been interested in exploring issues of human consciousness, love, gender, and myth as a way of examining and understanding my place in this world. I find myth and its contemporary reinterpretation a living stream far more significant to swim in than art fabricated solely by theory-driven motivations. This work has emerged out of a basic sense of mystery, wherein our humanness is examined and represented through the vocabulary of the body. The body—a profound language system—is a reality shared by everyone on this planet. We emerge and grow with this vessel, our body, whose gestural system is akin to dance. My work with the body represents a poetic, symbolic code that is distilled by the viewer, and its meaning is gleaned with an almost mythic realization.

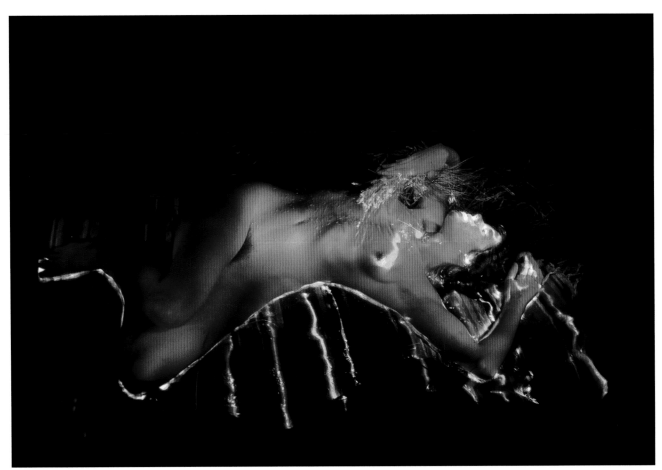

untitled 1982, Santa Fe
Cibachrome print, 20" x 24".

Much of my photographic work is about the mysterious visual territory of night. I work with extended time exposures—sometimes twenty minutes or more—in combination with natural and artificial light in the landscape or in the studio. I'm interested in the spiritual confluence of time, place, and people. The resulting photographs, with male or female nude models, appear as fragmentary tableaux from a ritual event, where gesture and meaning have preeminent reign.

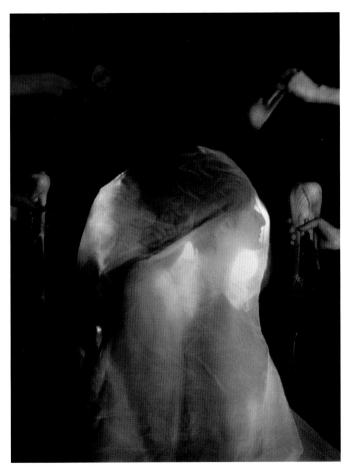

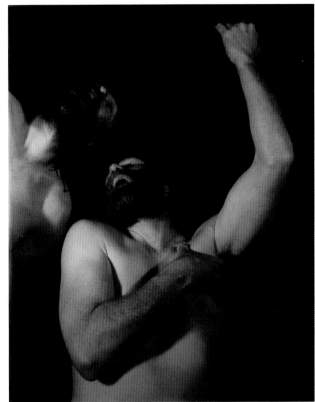

Bob Manley 1988, Boston
Unique Polaroid Polacolor print, 20" x 24".

The Zahir 1989, Boston
Unique Polaroid Polacolor print, 20" x 24".

Lamentations 2003, Santa Fe
Gelatin silver print, toned, 20" x 24".

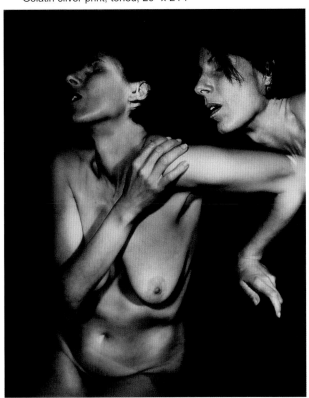

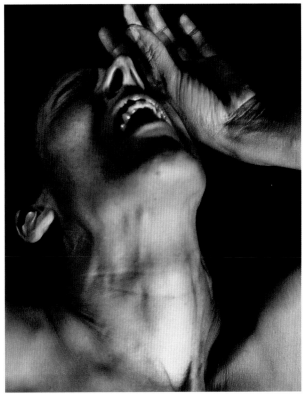

Lamentations 2003, Santa Fe
Gelatin silver print, toned, 20" x 24".

Frederick Hammersley

CHARLOTTE JACKSON FINE ART, SANTA FE

Charles Rushton

I learned nonobjective painting by painting shapes as I "saw" them through intuition and accident. I would apply paint to the canvas with no sketch or planning. I learned there is a logic of feeling in which I did not have to think, I only followed. I literally thought with my fingers using a piece of charcoal—draw, look, erase; doing this many times until an image materialized that I'd never seen before yet somehow "knew." When the last shape went in, the painting was done; there were no corrections. After a time I came to visualize the painting in my mind's eye. I was painting the center of me, painting my being alive.

I think of a painting as expressing an "image fact" upwelling from the subconscious filter of all my experiences. Intuition seems to feed on knowledge and experience, hence the image is not merely from myself but my culture as well. It records a tribal heritage that stimulates non-verbal understanding in the observer. I like to think a painting's life has something in common with people who look at it. They see something of themselves there. By themselves the image and the medium are secondary. My concern is the content and feeling carried by the image.

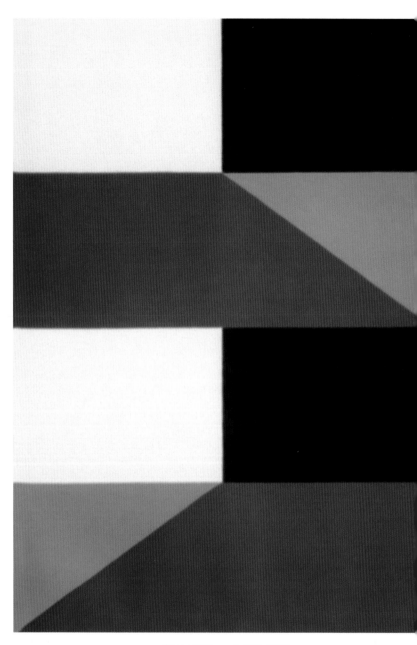

Same Changed, #14 1960
Oil on canvas, 30" x 21".
Collection of Ellen Berkman and David Bryant.
All photos courtesy Charlotte Jackson Fine Arts.
The evolution of my paintings has an order. As the number of shapes decreased the size of the canvas grew larger. The result was a closer connection between each of the parts, the geometry of the parts, and the shape of the canvas. Two shapes that work together combine in an indefinable way to become one. Add more parts and the result is a still larger whole.

Same Difference, #14 1959
Oil on linen, 24" x 22".
The dividend of a well conceived and well
made painting is pleasure. Pleasure is
experiencing esthetics as a form of visual feast.
It is a banquet of rightness and inevitability
made by the harmony of combinations.

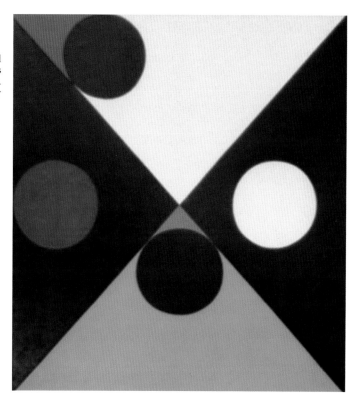

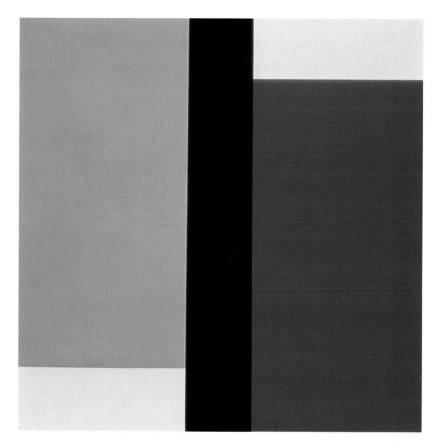

Adam & Eve, #2 1970
Oil on linen on masonite, 44" x 44".
In time I realized that I was really conjoining
opposites. It is not only the subject of my
paintings, it also is a fact of living. Our
existence is blend of opposites—day and
night, man and woman—continually
swinging back and forth much like breathing.

Harmony Hammond
DWIGHT HACKETT PROJECTS, SANTA FE

Gay Block

I approach painting from a post-minimal perspective of materials and process. The painting skin calls up the painting body. Boundaries and borders (always political be they body, land, or culture based), suggested territories, uneasy juxtapositions, and meetings that are constantly negotiated, worked over and around. With an edge of violence or eruption, it is one way to bring content into the world of abstraction.

Rupture 2002
Oil on canvas with metal gutter and latex rubber; 93" x 149.25".
Collection of the artist. Photo by Herbert Lotz.
The modernist painting field is "ruptured" by an old rusty gutter embedded into the thick charred black and translucent alizarin painting surface, suggesting circulatory systems of blood and water, and therefore body and land. But there are no life fluids. The gutter is dry, with stains of flesh and blood.

Sombra I 2005
Oil on canvas, 96.5" x 72.5".
Collection of the artist. Photo by Herbert Lotz.
The thickly crusted, near black painting with underlying blues, draws the viewer into its topography, giving form and substance to the transitory quality of shadows, which do not exist in the usual material sense. Contradicting conventional meaning and emphasizing a new materiality and an actual occupation of space, the painting conveys an embodied feeling of tragedy and tragic loss.

Rodney Hamon
Golden, NM

Art is like an extension cord pulled out of a wall plug and then plugged back in. When I plug in, I realize a state of being that is optimistic as I continually search for my personal masterpiece.

Peace and Loss of Innocence 2004
Lithography, 15" x 13". All photos by Herb Lotz.
This wooden toy needed a conscience. Instead of the normal "Angel/Devil" thing, I gave him thought bubbles. He is thinking violence or serenity.

The Developer 2002
Lithography, 13" x 15".
 A potato head and a Humpty Dumpty are
cast as the characters in the endless saga
of developing the land. Water is the issue.

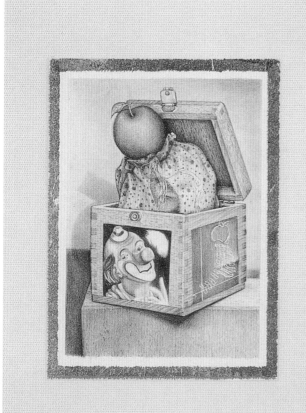

Toy Box 2002
Lithography, 13" x 15".
Now and again, I need to test my visual drawing skill.
The jack in the box was a gift to my daughter. It had the
potential to be drawn and slightly manipulated.

The Back 2002
Lithography, 15" x 13".
The Back is an emotional response to
sitting at a computer for too long or
when I push my body's endurance.

Bob Haozous
BOB HAOZOUS ARTS, SANTA FE

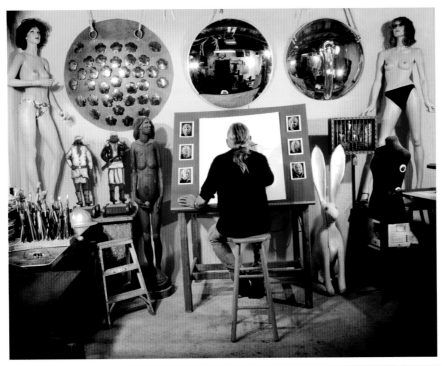

Self-portrait of the artist
with his works* (l. to r.)

Directly above ladder
Portable Apaches
#2 in an edition of 5, 1990,
painted steel with bullet holes

Above drawing table, left
Sky Shield 2003
stainless steel and bronze

Left of drawing table
New Image 1973
painted wood with balls

Above drawing table, right
Scudo Dell'umanita 2003
24 ct. gold-plated steel

Right of drawing table
White Rabbit, 1975
painted wood

Cage-like structure
Billy's World,
#1 in an edition of 7, 1999,
bronze edition

*Mannequins not included

We've lost our purpose, that's my statement.

Lodge 2004
Painted magnesium, barbed wire, chairs, and aluminum talking sticks, 5' 6" x 17'. Photo by the artist.
The effects of assimilation into western society forced the spirituality and philosophy of indigenous man underground. In time all that was available to new generations was a historic memory supplanted by superficial symbols and dialogue. The wisdom of Indigenous man is still available but we contemporary Indian people lack the knowledge to penetrate and understand the profound meanings within the lodge.

Survival instinct forces us to seek alternatives, some desired, many not. Contemporary Native American artists have accepted the aesthetics, art production methods, and market demands of the Euro-American world. This has created a market-driven art that deprives the Native American of a genuine contemporary internally directed art statement. Simply stated, an honest reflection of today's life experience is unmarketable. Contemporary art collectors label true representations of the Native American human condition as outrageous and rebellious and few are willing to display the traumas and truths of cultural disintegration in their living rooms or on their walls. There are few commercial rewards for Native artists who express an artistic statement that derives from an honest percept of their culture. The result is the near elimination of a true internal Native American dialogue.

Our traditional concepts of balance and beauty were based on the positives and negatives of life. Today this once all-important foundation of self knowledge has been edged aside by a preoccupation with the glory of individual success and economic reward. This can be reduced to a single purpose—"What is romantic, historic, and safe is saleable." The result: many native artists bypass the production of forms of expression that serve their community in exchange for artwork that guarantees prestige and external economic merit badges for their successes.

An immediate and vital change in focus and purpose of Indigenous art requires an honest internal candor about every facet of our identity. This is tantamount to reversing the entire course of an assimilation that has been externally imposed on Native Americans. Change can only come from within. This cultural re-direction must be based on the demand for an artistic statement that goes beyond design/craft expertise and places historic self glorification in its proper place.

Earth Dialogue 2002
Four 3/8" painted steel disks, 24' dia. each. Commissioned for the Seattle Seahawks Stadium in Seattle, Washington.
Photo by Ken Wagner Photo.

This sculpture on the scoreboard tower of the Seattle Seahawks Stadium is meant to be viewed looking up from below. Each disc represents the cyclic nature of Indigenous man; the four colors are the sacred and directional colors of the Chiricahua Apache people. The bottom disc refers to man's claimed place in the universe with his sweeping technological advances surrounding the nature that makes him. The green represents the tribal society symbolized by order and place. Within the disc the organization becomes disrupted and individualized. The third yellow disc is intended to convey an answer to our environmental problems by using the Apache symbols of yellow and the four directional cross as a guide to the meaning of the tower, the answer being Indigenous man's nature-based identity. The fourth disc, the white disc, portrays the sky as man envisions it. Though beautiful and complex when combined with the tower structure, and symbolic of mankind's achievements and self glorification, the end result is dwarfed by the true nature of the sky that surrounds the stadium.

Zonnie and Jaymes Henio
RAMAH WEAVERS ASSOCIATION, RAMAH, NM

I learned to weave from my grandmother Zonnie starting at six. Our family raised sheep so we migrated with them through the seasons. I learned on the traditional loom. Since we moved so often, we could disassemble it in minutes. Everything we were and had came from land and the sheep. They kept the family together and gave us strength.

For me weaving was a time of much learning. Zonnie was my Great Teacher. As we wove she talked about having respect for the Creator and the elements of nature all around. Her designs came from what she saw around us. She didn't put absolutely everything she held dear into a weaving; she always inserted a little mistake because she believed we shouldn't take everything out of nature, we should always leave a little still there. All the places we knew were sacred—every rock, tree, living thing—we must respect. This also meant things like the universe, the morning before sunrise, the afternoon. Zonnie would tell me about each part of the sunrise—first light, when the birds start to sing, the orange bright before the sun, the break of the sun itself over the hills. And after that, all the colors of the day as the day went by.

Money meant little. Zonnie bartered her weavings because she wanted someone to accept a weaving instead of buying it; she felt they would appreciate it more.

When I was young I didn't pay much attention to this. Then one day in my teens she came to me at a sheep shearing and said, "Do you remember the things I told you when you were young?" She gave some hints. I went back over them in my memory and that's when I learned

for the first time that she was talking about weaving and living as almost the same thing.

When I took up weaving I never thought I would be someone sought after for my work. It makes me proud. Once I grasped what Zonnie was talking about, she told me to always go off on my own and experiment. I saw the same things, but differently. She saw more in terms of symbols while I see things realistically. When I weave a bird I make it exact (but not totally, I always leave that little mistake in).

Much of my work comes from what I see out herding sheep or talking a walk. When I see all this beauty around I want to share it. Inspiration starts with a color that attracts my eye. Even dark brown can do it. The design doesn't come into my head, it unfolds as I work. I work from the bottom up, discovering what the weaving will be as I go. It used to take about two weeks to do a piece. Now that I'm working a job it's more like six months, mostly on weekends.

The first stitch is a blessing for me; the last stitch is a sign of release, letting go. When I'm done the piece is a part of the Great Spirit. I hope whoever takes it has the same appreciation. I always feel the Great Spirit is beside me, working through me. I'm a little sad when a piece goes away and I won't see it any more. But it really wasn't for me to keep anyway, but for someone else. I learned that from Zonnie. And to have a good life while making my living. That keeps you healthy and happy. And ongoing.

My family is very supportive of me as a weaver because no one else in the family is carrying on my grandma's work, her knowledge, her songs, prayers, and offerings that have been passed on from my great-great-grandmother. All that has come down to me intact. There's nobody else in my family that could carry that on, so you could say I was basically volunteered by my grandmother to continue our weaving tradition.

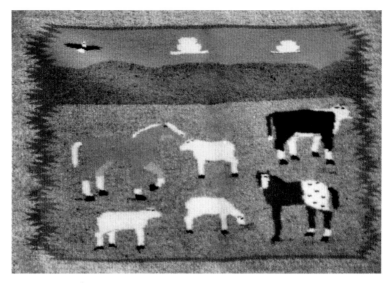

The community really likes what I'm doing, just from knowing my grandmother and the status she had in our community. They are very proud of me and approach me with great respect, because that's the way I approach them through my weaving.

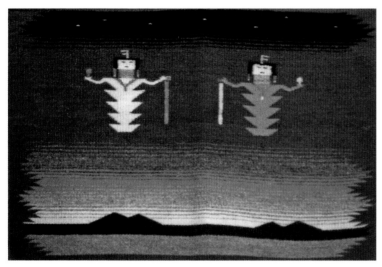

I belong to the Ramah Navajo Weavers Association, as did Zonnie, and also Nancy Beaver, who is still active today. The Ramah tradition goes back a long way, and we are dedicated to keeping it vital by living it. To us the process of Navajo weaving should be passed on to the many generations to come in the future.

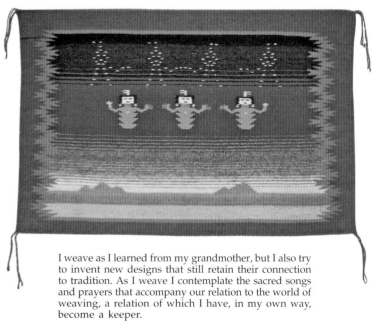

I weave as I learned from my grandmother, but I also try to invent new designs that still retain their connection to tradition. As I weave I contemplate the sacred songs and prayers that accompany our relation to the world of weaving, a relation of which I have, in my own way, become a keeper.

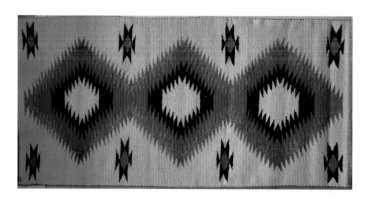

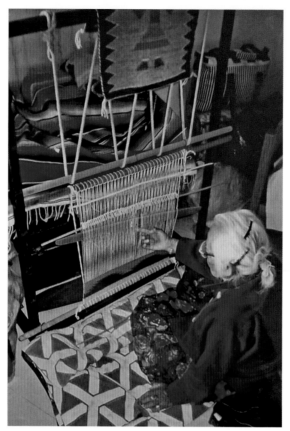

Zonni Henio, 1891-2005

Zonnie's last weaving 2004. She was 114 years old.

Condensation of the article Sararesa Begay
published in The *Navajo Times* July 18, 2002

Young Navajo master weaver Gilbert Begay loves to pass the time by quietly spinning yarn.

"If I have the night off from work, I spin," said Begay, who has woven Navajo rugs since he was in the fourth grade. "If I have spare time, I spin."

Begay learned to weave from both his grandmothers. "I started out with commercial yarn, then hand spun. I began with weaving throws like my grandmothers. Later I tried family patterns, new weaving styles, and vests."

One of his rug creations is on display at the Alaska Native Medical Center. "Being a male weaver is a special role that I enjoy because I am encouraged and supported by my family and community."

Jaymes being interviewed by Saraesa Begay for an article about the Ramah weavers published in the *Navajo Times.*

Male weavers featured

Begay along with three other male weavers, Roy Kady, Jaymes Henio, and Ron Garnanez, are the featured male weavers at the *Dine' be'iina,* "The Sheep is Life Celebration," event at Diné College in Tsaile, Arizona.

The three weavers got to know each other during a 1999 Navajo exhibit titled "Weaving in the Margins" produced by the Museum of Indian Arts and Culture/Laboratory of Anthropology, a unit of the Museum of New Mexico in Santa Fe.

Kady, a full-time agropasturalist, said the "Sheep is Life" male weavers exhibit is a continuation of the 1999 exhibit in which male weavers share their art and their personal stories of how each became a weaver. "I feel more open about weaving because of the positive influences of my community. My mother's weaving tools were handed to me seventeen years ago. Since then I've been doing this full time."

Use of Navajo spirituality

Kady, who is from Goat Springs, Ariz. near Teec Nos Pos, uses Navajo mythology in his "Kady myth rugs." His weaving reflects aspects of the Navajo creation story or the spiritual life of the Navajo people. "Each rug has its own personal account from the weaver. Each weaver has his or her own style.

Kady, who has sold his rug creations to collectors and museums, said he doesn't weave for the money or notoriety. "For a lot of us it is hard to sell our rugs. Weaving is so intimate. We weave because we love it."

To commemorate today's Navajo experience, Kady is working on a rug that reflects "the unbalanced time of the Navajos."

"I'm dedicating a rug to today's Navajos to give them hope to be as one again for a good life. We need to get back to our spirituality, stop polluting the earth, stop polluting the water and stop polluting the air. Navajos need to return to respecting Mother Earth and not be so concerned with making money."

Jaymes and weaver Gilbert Begay (spinning yarn on a Navajo Lap Spindle) during interview with *Navajo Times* writer Saraesa Begay.

Vegetable dye processing

Jaymes Henio also believes today's Navajos need to learn how to balance the traditional and modern way of living. "You need to be connected with yourself, your surroundings and Mother Earth. Through weaving I am able to center myself." His paternal grandmother Zonnie, who is over 110 years old, taught him the art of weaving when he was six growing up in the El Morro area near Ramah, New Mexico.

"I started out carding and spinning. I spin everything, and try not to use commercial wool."

Henio, who by weaving standards is well seasoned and culturally sophisticated, has the rare knowledge and skill of Navajo vegetable dye processing.

"I try to get the natural pastel colors. The pastel colors are very rare and are totally hand-processed. Few weavers today know how to make them."

Jaymes specializes in the "Two Grey Hills" rug design and has rugs exhibited in New York City, Los Angeles, San Francisco, and Europe, and one at the Smithsonian Institute as well.

He said he shares his weaving stories and experiences with others to let them know that Navajo people can be more self-sufficient and make a living off the land. "Find a connection with you and the earth, that's why we Navajos are here. I'm an example of living off the land. I didn't set out to sell my rugs to collectors. I still just consider myself a weaver doing traditional blankets."

Through weaving, Henio and Kady have become closer to the earth and the traditional Navajo way of life.

Richard Hogan
LINDA DURHAM CONTEMPORARY ART, SANTA FE

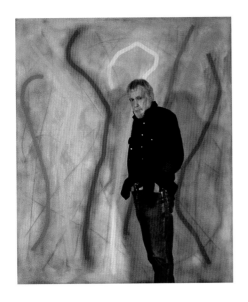

My paintings are not "about" something; they are a state of "being" something. I find the images rather than make them. The first marks on a canvas are an entry point, a kind of cutting or digging into the space. I make lines, remove them with erasers and paint thinner; make more lines, remove them; until in that density of marking in charcoal and paint I find a line or lines that look "right." I might change a line as many as twenty or thirty times, sometimes significantly, sometimes subtly. At some point I can feel the painting click into place.

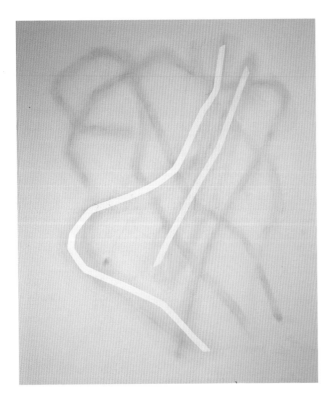

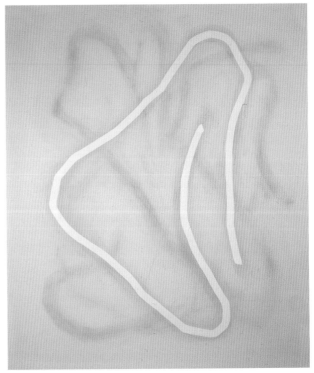

above left
Iona 2002
Oil on canvas, 84" x 72".
Collection of Linda Durham Gallery. All photos by the artist.
I want the paintings to retain a sense of their coming to be, the traces, the remnants of possibility, the intensity and density of time and attention.

above right
Mull 2002
Oil on canvas, 78" x 66".
Courtesy of Lemmons Contemporary, New York.
My paintings don't have titles. They have names.

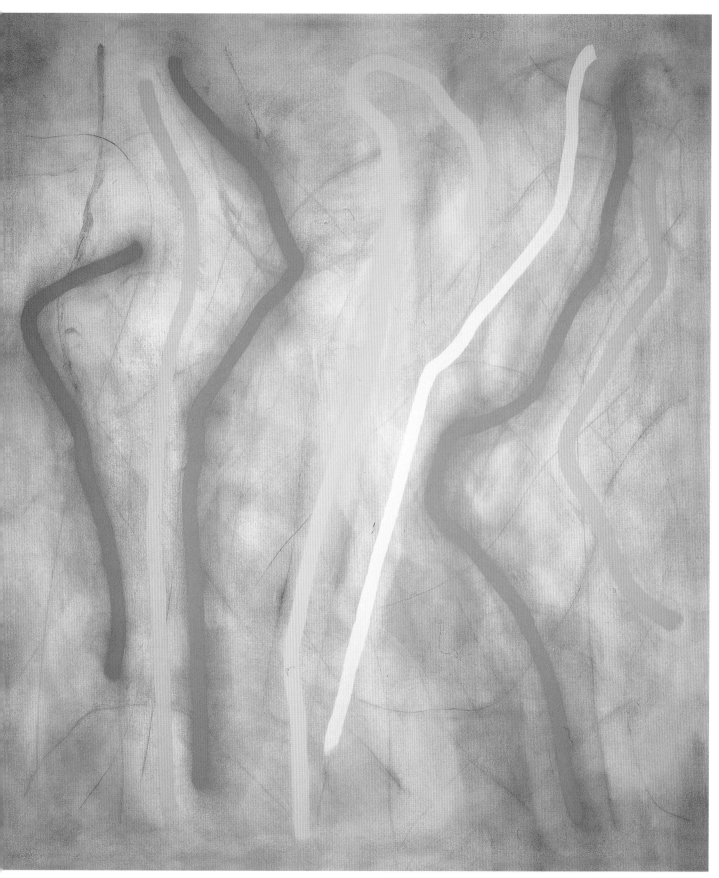

Seven Sisters 2000
Oil on canvas, 84" x 72". Private collection.
I want my paintings to have a luminous presence, to be there as fully
and forcefully as everything else in my world.

Colette Hosmer

ADDISON GALLERY, SANTA FE
PARKS GALLERY, TAOS

The artist in Yanqing, China at the site of her installation *Global Current*, 2002. Stainless steel, 10' dia.

I was romanced by art from an early age (against tough competition from science). "Natural selection" finally ran its course and I found myself making art. Science never vanished, though, as I often use organic materials and colored earths which I collect and process.

My work refutes the notion of our separateness from the natural world. Sometimes we humans live as though humanity is somehow isolated from the rest of life. The sense that everything exists in overlapping environments has been lost. Instead of being part of the landscape, we stand apart and "view" the world around us.

I strive to dig beneath the layers civilization has put on art, down to a layer we all can identify with no matter our language, culture, region, or era we live in. There is some basic place that connects all of us. Truthful art comes from that place.

Neon Globe with Minnows 2001
Minnows, steel, neon; 39" x 10.5" dia.
Photo by Herb Lotz.

top left
Liquidation 2004
Pennies, nickels, dimes, metal faucet; 22" x 13" x 14".
Photo by Addison Doty.
Art is a mirror. It draws us into the unknown of the future
and reflects it back onto humanity.

top right
A Physical Map of the Earth (Ball Jars) 2003
Dirt, loam, sand, volcanic material, mudstone; each 7" x 3.5" x 3.5".
Photo by Steve Yadzinski.
The first thing an artist who isn't working for the market learns is the soft parts
of the self that art shines into—vulnerability and insecurities, but also
extraordinarily positive moments, euphoria, enlightenment. You can't have
one without the other, failure without discovery, discovery without failure.

bottom left
Still Life with Duck 1998
Cast Hydrostone duck, organic feet & bill, mixed media; 35" x 24" x 20".
Photo by Herb Lotz.
I've tried to make pieces that will sell, become popular, and it never works.
The work is flat, I have no energy for it, I'm bored. I just can't work that way.

bottom right
Bathtub Installation 1995
Dried minnows, bathtub; life size.
Installation at La Posada, Santa Fe. Photo by John Conlon.

Frank Buffalo Hyde

CLINE FINE ART, SANTA FE AND SCOTTSDALE
JOHN CACCIOLA GALLERY, NEW YORK

Painting—the action, the act, a series of connections you can make or disguise.

Lochness 2004
Mixed media, 40" x 40".
All photos by James Hart.

Totem 2003
Mixed media, 20" x 20".

Hero 2001
Mixed media, 51" x 67".

Luis Jiménez
BETTY MOODY GALLERY, HOUSTON

The most unrecognized element in art today is the human one. Art should in some way make a person more aware, give one insight into where he or she is at, and in some way reflect what it is like to be living in these times and in this place.

I wrote that in the introduction to a catalog of my work published in 1969, and I still believe that.

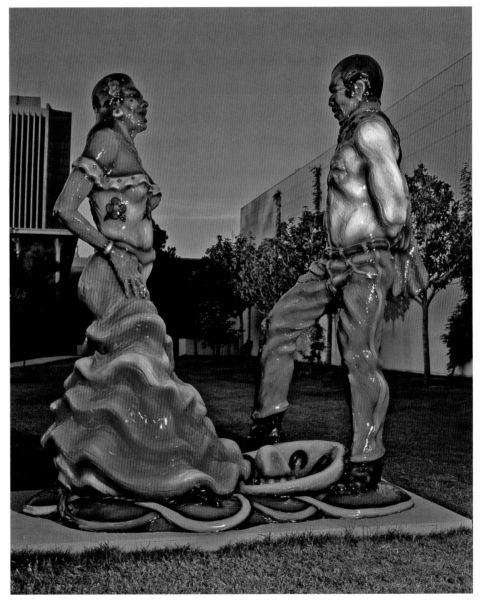

Fiesta Dancers 1985
Fiberglass with acrylic urethane coating,
114" x 96" x 59".
All photos by Ann Sherman.

Maestro 1995
Fiberglass with acrylic urethane coating,
120" x 126" x 72".
Installation at the University of Oklahoma.

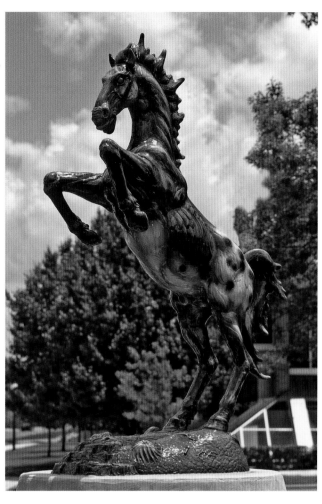

Southwest Pieta 1984
Fiberglass with urethane coating,
120" x 126" x 72".

Tom Joyce
EVO GALLERY, SANTA FE

The study of fire, the history of iron, and the influence of the printed word build on histories shaped by the creative and destructive consequences brought about by the way we use these forces and technologies. They each exert a decisive effect on cultures worldwide and in a multitude of ways provide me with inexhaustible avenues for thought.

The discarded books I use in these sculptures were salvaged from many sources, including municipal landfills. They offer symbols of storage systems for information— whether recorded in accessible oral, printed, digital or other audio/visual media, or stored in my mind and body through the experiences I've had and the training I've received—that are at best temporary, fragile depositories. My observations and questions about these subjects are addressed through this body of work called *Pyrophyte*, a term collaboratively coined with my librarian sister-in-law, Karen Pangallo, to describe certain seeds that in nature require being scarified by fire before they can germinate.

Platen
Iron and books, 75.5" x 10" x 2".
All photos by Nick Merrick © Hedrich Blessing.

Here I sandwiched seven found books between long iron plates heated to 2000 degrees Fahrenheit, and then squeezed them in a 100-ton hydraulic press until the flames generated from the heated plates consumed the books. Like printers' platens, I had etched scribe lines onto the plates' surface as if laying out the position of a printed page for a book. All that remained inside this scribed space was a ghostly residue of the books' outline.

Pith
Iron and books, 18" x 18" x 18".

Books, like seeds, hold tremendous potential awaiting germination. Some seeds, like the serotinous pine, generate new life only after fire has charred its cones. In Pith, a volume of air, like an inhaled breath, is trapped in the center of this construction by books placed into the iron openings.

Quoin
Iron, books, and wood, 14" x 28" x 28".

Quoin (pronounced coin) is a printer's term for the wedging system that applies side pressure to securely hold type set in a chase. This sculpture is pulled together with the force of opposing wedges and is made to roll like a gyro.

Chase
Iron and books, 56.5" x 11" x 8".

A chase is a rectangular cast iron frame a printer uses to set type in before it's locked into the press platen where ink is applied and paper is imprinted. The books used here are alternately charred and suspended between structural channel-iron from a dismantled paper pulp mill.

Bridge
Iron, books, and wood, 60" x 57" x 16".

The set of encyclopedias at the center of this hanging sculpture is suspended between the pinching forces of the two wooden beams. Only the fulcrum of pressure applied from each side keeps the construction in place.

Mark Klett

LISA SETTE GALLERY, SCOTTSDALE

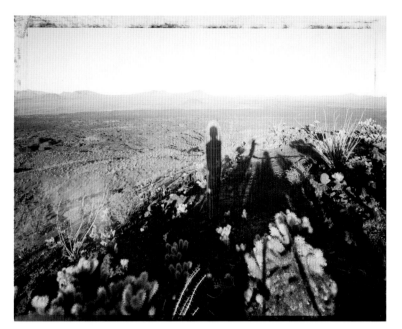

Self portrait with Saguaro About My Same Age, Pinacate, Sonora
10/29/99
Gelatin silver photograph, 16" x 20".

I see photography as a doorway for contemplating time and space. In a picture the natural world turns into a kind of nature/culture/time coordinate system for tracking an era. Landscape photographs become maps in four dimensions. The camera is my tool of choice for exploring the land, discovering how people connect with their environment and shape their surroundings. This process keeps me motivated.

Under the Dark Cloth, Monument Valley
5/27/89
Gelatin silver photograph, 16" x 20".

I'm interested in the photography of ideas. Photographs pose questions, but the answers are only as interesting as the search to find them combined with what one learns along the way. I started with one question—what is the relationship between time and change? Lately I've returned to my interest in visualizing change, and my work has led me to search for ways that photographs can fold and unfold time.

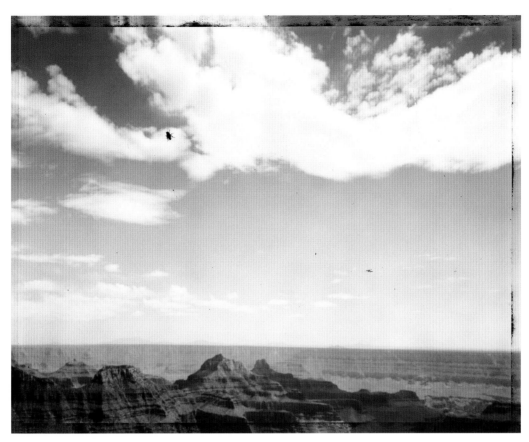

Fly, North Rim, Grand Canyon 7/4/04
Gelatin silver photograph, 16" x 20".

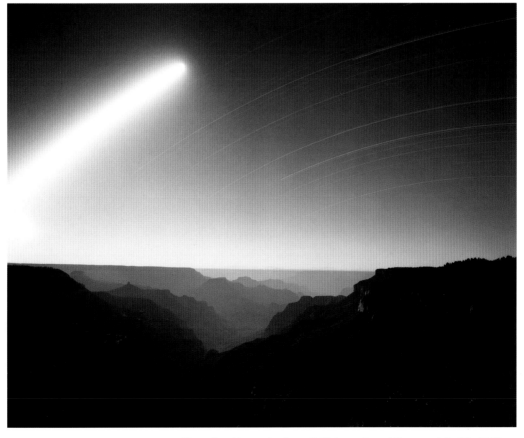

Moonrise Above the Powell Plateau, Grand Canyon July 5th, 2005
Gelatin silver photograph, 16" x 20".

Nancy Kozikowski

DARTMOUTH STREET GALLERY, ALBUQUERQUE

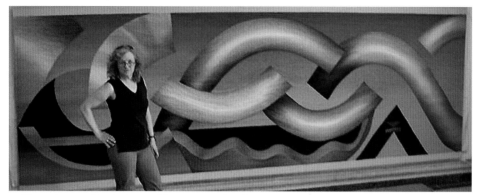

The artist standing in front of her 2004 work *Silver*. Tapestry, 5' x 16'. Collection of UCLA.

One time as a young woman I was spinning yarn from wool at a crafts fair when an elderly woman told me that I reminded her of her grandmother. When a group of friends visited my family garden, they reminisced about their childhood. Today I create experiences that open windows to the future, the past; experiences that evoke a taste for design and creativity, a passion for tradition. My work *Silver* pictured above was an attempt to weave wool into a tapestry that looked like precious metal.

When I was sixteen, I learned to spin from a Navajo Weaver named Zonnie Henio (see page 82) at the Indian Cultural Center in Santa Fe. *Black Cross* demonstrates the so called "lazy lines" that are clues to the techniques of the Navajo weavers. When I wanted a Navajo loom I found one on display at the Fred Harvey Western Museum at the Alvarado Train Station in Albuquerque. I made a detailed drawing of every knot and stick, then built my own by hand. Zonnie was my spinning teacher. She died recently at the age of 114, yet the last time I visited her a year before, she was still tending sheep with her daughter Florence and her grandson Jaymes as they returned from their seasonal grazing sites.

Black Cross 1989
Hand woven, hand dyed tapestry, 47" x 46". All photos courtesy of Dartmouth Street Gallery. Art has a broad definition. It is a license to explore and I have spent a lifetime doing just that. Creativity is the most nutritious food for the future. These have blessed me with a wonderful life.

98

When the Spanish Moors brought their sheep to New Mexico they traveled up the Camino Real from Mexico to Santa Fe. That famous trail is now 4ᵗʰ Street in Albuquerque, just a few blocks from my home. The Moors influenced the Navajos and the Hispanic weavers of New Mexico, which, in turn, influenced my work.

Reverse Target Red 1993
Hand woven, hand dyed tapestry, 56" x 56".
Living in this crossroads the Camino Real and Route 66 are the warp and weft of my life.

The large tapestries I've made for public or corporate places—Albuquerque Airport, Mount Sinai Medical Center in New York, the Bernalillo County Court House near Albuquerque, the Delaware Corporation in Philadelphia—all celebrate culture, traditions, and history.

Twisted Belt #5, Variation 2 1996
Hand woven, hand dyed tapestry, 48" x 48".

Carolyn Lamuniere

STUDIO OF CAROLYN LAMUNIERE, SANTA FE
ELAINE BECKWITH GALLERY, JAMAICA, VT
HAND ARTES GALLERY, TRUCHAS, NM

Richard Faller

Surrealism is the style most people use to describe my painting. I think they are responding to a certain other-worldly quality. I guess that's pretty close to how I would define myself. I have a foot in both worlds and that's how I am most comfortable.

I believe there is an essential core of aloneness in each of us. I feel it, and actually love it. Music is an important conduit for me. It is crucial for my centering and well being. Music pulls me into the beyond and comes back into my art.

I majored in art history at Skidmore College in Saratoga Springs, New York. Although my heart is in France, I am most influenced by Nordic art. I love to paint. Even as a child I preferred to be alone painting than to play with other children. My first validation was being accepted into a show called *The Best New England Artists Under 30* at the De Cordova Museum.

I came of age in a time of high ideals and antimaterialism. I still believe those qualities are important, with simplicity being the key. I try to do what I can in a quiet, simple way.

top left
Chateau de Drée 2005
Oil on canvas, 16" x 20". Photo by James Ferreira. Courtesy of Elaine Beckwith Gallery, Jamaica, VT.

bottom left
Mission San Miguel, Santa Fe 2005
Oil on canvas, 16" x 20". Courtesy of San Miguel Preservation Project. Photo by Chris Alba.

Early Autumn Light 2004
Oil on canvas, 40" x 34".
Courtesy of Elaine Beckwith Gallery, Jamaica, VT. Photo by Richard Faller.
I have lived in many old, historic towns. There is a certain sense of mystery in spaces that have absorbed the feelings and lives of generations. Every space becomes a symbolic representation of what is without.

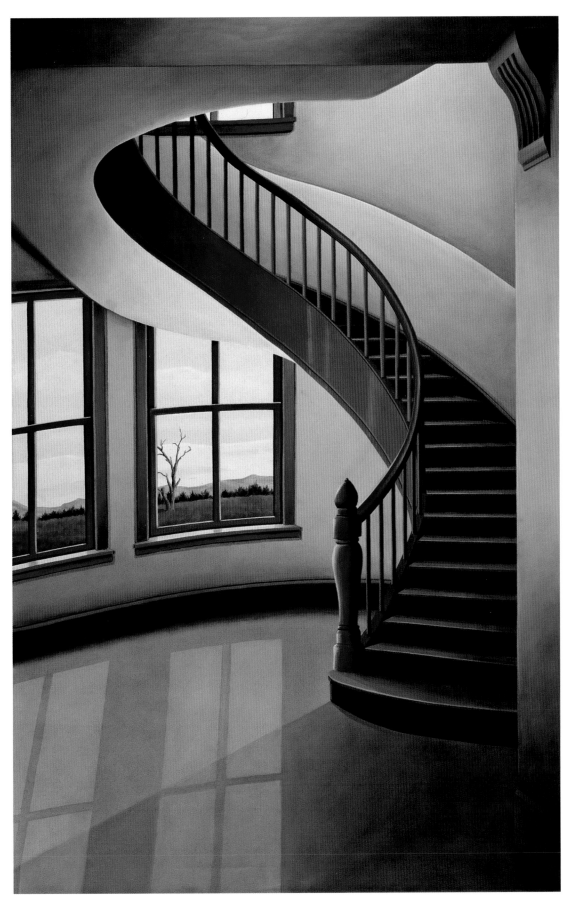

Spiral Staircase 2002
Acrylic on canvas, 44" x 34". Courtesy of Hand Artes Gallery. Photo by Richard Faller.

Carm Little Turtle
BOSQUE FARMS MILL & ATELIER, BOSQUE FARMS, NM

Patty Hanna

In my work composition, balance in the painted surface and aesthetics are more important than the articulation of meaning. If an image succeeds in making a statement, it's exciting. In order to keep a narrative piece open-ended, I commonly shoot images so that the models' faces are not seen. Viewers are allowed to make their own interpretation. I try not to capitalize on the spiritualism of my heritage by giving the impression that I have, through images, a monopoly on the spirit world. My work is down to earth and dirty. It deals with sex, food, and money, the politics between men and women, the human spirit, the need to communicate, and the importance of humor in that quest.

She traded her Storm Pattern for a Bull 1994
Black and white photograph sepia toned with oils,
9" x 13.35". All photos by the artist.
To me, aesthetics are more important than meaning.

In Front of Bars, In Front of Cars 1981
Black and white photograph sepia toned with oils,
8.75" x 13".
The motivation behind my work as an artist is the same universal impulse that has always driven artists—the need to communicate based on knowledge and truth.

I pose my models against unobtrusive backgrounds, or the rugged terrain of Northern Arizona, or the exquisite mountains and clouds of New Mexico because, beauteous as these are by themselves, they also act as metaphors of the politics that backdrop the relations between men and women. I stage some scenes with the models' faces facing away to suggest the dreamy poems of inner reflection or solitary journeys. Women mend the frothy veil of sex, food, and money that men continually rend. I selectively hand-paint certain areas to heighten that sense of schism.

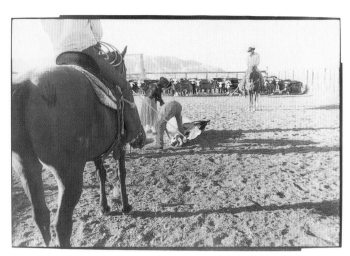

Not Handy with Words, They Appropriated Thunder in Their Eyes 2003
Black and white photograph sepia toned with oils, 9" x 13.35".
I want timelessness in my work, and I find it in the timeliness of feelings that evoke the past, present, and future as a simultaneity.

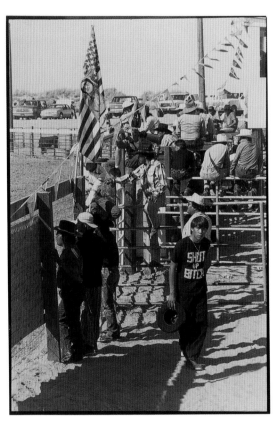

Shut Up Bitch 1995
Black and white photograph sepia toned mixed media, 15" x 8.75".
My mother always painted and proved to be a major influence on my work. My earliest memories are of paints and the painted surface. My own attempts to blur the boundaries between photography and painting are a result of that influence.

The props and costumes in my work are icons in my private symbolism. I'm not interested in the prettified mythology that Euroamerican culture glues to indigenous people. Fake images of native nobility might salve a troubled collective conscience, but it's a salve that doesn't heal, it only sooths. Trying to anesthetize a pattern of genocide, appropriation, and racism might be comforting, but it doesn't erase. Isn't the dominant culture still dominating today?

Earth Man Getting Breathless 2003
Black and white photograph sepia/mixed media, 9.75" x 13.35".
If metaphor is a quest to communicate, it can be one with a sense of humor.

Arthur López
PARKS GALLERY, TAOS

Incarcerated Love 2004
Mixed media, 22" x 8" x 7". Private collection. Photo by Pat Pollard.

I was inspired to do this piece by a TV program about domestic violence in New Mexico. I know people who have been the victims of spousal abuse. When victims are asked why they stay with the abuser, they respond that they love the person and think the abuser will eventually change. When abusers are asked why, they say it's because they love the victim so much. Both feel trapped by their love, but the reality is that domestic violence is about control, not love. Control is represented by the puppet strings in the piece. Most abused women cannot cut the strings from their abusers until the abuse gets so bad that the abuser is incarcerated, or the victim is killed. I felt compelled to artistically identify abuse's complexities—and at least one possible solution: cutting the strings during incarceration when the abuser can't reach the abused.

As long as I can remember I have loved art in all forms and mediums. As a child I created pictures of wonderful fantasy worlds where anything was possible and dreams came true.

I have been working as a *santero* (saintmaker) for about four years. Although I continue to carve and paint Roman Catholic saints in the centuries-old tradition of Northern New Mexico Hispanic artists, more recently I have begun to mix traditional with contemporary styles. I wanted more flexibility and creativity. Religion is the basis for everything that I create. As with religion, I want to create enduring emotions.

When I create a piece it has to end in a spiritual feeling. At first the wood is empty and dead. As I chip away each layer it begins to come alive. It speaks to me more and more as the image emerges. I use traditional New Mexican methods and materials for the final surface painting—natural gesso as the base for the colors, natural and water color pigments, pine sap varnish as a sealer, bee's wax as a final coat.

Forgive Me Son For I Have Sinned 2003
Mixed media, 16.5" x 17.25" x 9.5". Collection of Sheila and Kirk Ellis. Photo by Wendy McEahern.
A priest recounts his sins to an altar boy, who cries as he hears the confession. Placing an altar boy as confessor gives them back the power which had been taken from them by their priests. The abused altar boys remained faithful to God and the Church, which to me demonstrated that they understood the stronger, higher power of Faith that underlies the Church.

Nuestra Señora del Carmen 2002
Jelutong, pine, gesso, natural and water based pigments, 21.5" x 15.5" x 13.75" dia.
Promised gift of Diane and Sandy Besser to the Museum of International Folk Art, Santa Fe. Photo by Paul Smutko.

Nuestra Señora de Guadalupe: Paz en El Mundo 2003
Mixed media, 17" x 10" x 7" dia. Private collection.
Photo by Wendy McEahern.

Félix López

FÉLIX LÓPEZ, SANTERO, ESPAÑOLA, NM

My embrace of this tradition also was due in part to the rising consciousness of the Chicano movement accompanying the Vietnam War. My first *bulto*s were quite crude, but with much effort and persistence—plus working with other carvers—a style of my own emerged. Its most readily identifiable hallmark is a sense of peace and spirituality conveyed via calm and graceful images, often placed in an architectural setting. Other stylistic elements are elongated bodies and limbs, and a subtle, subdued color palette. Once I have carved a *santo*'s components I apply homemade gesso, then paint it using colors I make myself from local minerals and vegetable pigments—a practice I started early on, in 1979, when I began to study how natural pigments were made back in colonial times.

A *santo* is meant to be a focus for devotion. Hence *santo* making is a spiritual exercise that requires prayer and contemplation. I feel it is a gift from God to be able to work at what I love, earn a living at it, and receive recognition. My children Joseph and Krissa Maria have continued in my footsteps and have become well known artists in their own right.

My roots are in the villages of the Sangre de Cristo Mountains in northern New Mexico. The mountains, the sky, the awesome natural landscape of the land, the historic churches, and Indian Pueblos still take my breath away.

Religion played an important role in my family's life. My parents, particularly my mother, instilled in us love of God and love of neighbor. This was reinforced by the Catholic education we received from kindergarten through junior high school and by the 18th and 19th century images that grace the great church of Santa Cruz de la Cañada, built in 1733 and located just a few yards from our home. These childhood influences and beliefs eventually turned into creativity, triggered in part by the death of my carpenter father in 1975. With no art background and no one to teach me, I began to make *santo*s (images of Jesus, Mary, and the saints) as a way to fill the void in my life left by his passing.

The heritage of *santo* making is particular to New Mexico and dates back to when Colonial New Mexico was a remote inland frontier of the Old Spanish Empire. Then as now, religion was an integral part of daily life. Because not enough *santo*s came from Mexico to satisfy the spiritual needs of the growing colony, New Mexicans began to make their own. They excelled at *retablo*s (paintings on wood panels) and *bulto*s (three dimensional images) carved out of pine, dried cottonwood root, or aspen

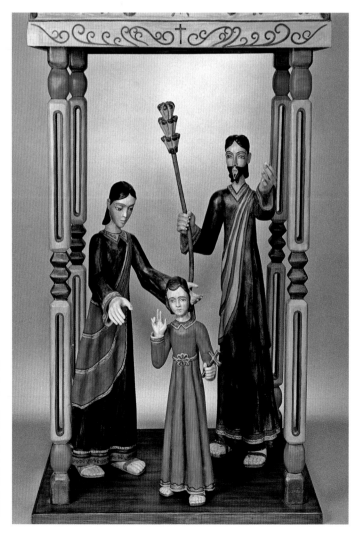

La Sagrada Familia 1997
Aspen, cottonwood, pine, homemade gesso, natural pigments, pine sap varnish, beeswax; 58" x 32" 26.5". Courtesy of Hijos de La Sagrada Familia Seminary, Barcelona, Spain. Photo by Anton Studio, Santa Fe. Saint Joseph, Mary, and the Christ Child in a niche (symbolic of a house built by St. Joseph, the carpenter) convey a sense of deep love, commitment, and sacrifice necessary to keep a family together. The elongated figures are centered in the niche. Mary's attention is on Jesus, who holds a cross and is giving a blessing, while Joseph holds a hollyhock staff and extends a welcoming gesture into their house. The niche and images are unified by a similarly rich color scheme of intense greens, blues, reds, and yellows.

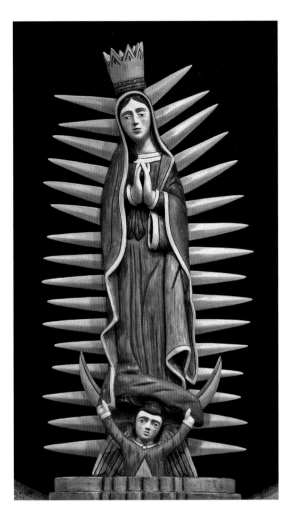

Nuestra Señora de Guadalupe 2003
Aspen, pine, homemade gesso, natural pigments, pine sap varnish, beeswax; 58" x 24" x 20." Photo and permission courtesy of St. Norbert's Abbey, De Pere, WI.

Fr. Steve Rossey from St. Norbert's Abbey commissioned this traditional image of Our Lady of Guadalupe, Mexico's and the Southwest's patroness of justice and peace. She also is revered as *Madre del pueblo, de la raza* (Mother of our people, of our race). In the last several years there has been a significant increase in the number of people of Mexican descent to the Green Bay area. The Abbey's image of Nuestra Señora de Guadalupe is a way to reach out to the Mexican community.

Over the years I have carved hundreds of *bulto*s for individuals, churches, and museums. I try very hard to adhere to the true spirit of the *santero* (saint maker) while also incorporating new ideas into traditional practice. I also do conservation work on historic *santo*s. This is something I learned to do partly on my own, but also through working with conservators. The latest project was being part of a team of Museum of New Mexico conservators and other *santero*s working to save the artwork at the Santuario de Chimayo, New Mexico. This church a few dozen miles north of Santa Fe is often called "The Lourdes of America" and is the destination of a renowned religious pilgrimage every Good Friday.

San Miguel Arcángel 2002
Aspen, pine, homemade gesso, natural pigments, pine sap varnish, beeswax; 70" x 24" x 20". Courtesy of Dexter Cirilo. Photo by Sundancer Photography Studio, Española, NM.

San Miguel Arcangel stands firmly atop a carved columned pedestal ready to battle against the forces of evil with his sword in his right hand and the scales of judgment in his left. Rich green, red, and yellow complement the power and drama of the *santo*.

107

Estella Loretto
GENTLE SPIRIT STUDIO, SANTA FE

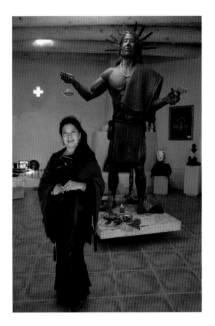

There is a person way down deep inside of me that speaks using the words of my art. No other words can say what and who that person is. That person is also the Creator, the Great Being, the Higher Power. I am just a channel for that spirit. I have been given a talent to do art that has some kind of healing effect on people. The Great Being takes over my body and puts its message into the world through my eyes, my hands, my body. My calling is to carry the Creator's messages of peace and serenity and harmony.

In my art I try to tell my daughter Fawn—and her children one day—to live in the moment, to follow their dreams, to not limit themselves. I tell them to live their dream as fully as they can, to nurture themselves. Be happy with what they are doing. Take time to care for themselves.

I want people to know me through my artworks. We have only so many breaths when we are born into this world. With whom do we want to share them? What do we really want to share? I hope the things I make will guide people spiritually, for my breath will be with them in the artwork I make.

Art puts a spell on you. To need art is a form of prayer. And yet it is also spiritual play. Art is creative energy that needs to be moved and expressed. Art is not merely an assembly of colors that resonate, not a combination of shapes, not something that merely gives pleasure. I need to take what I have deep within me, change it, move it from where it is to the place where it moves others, so that in the end what I have made expresses my soul.

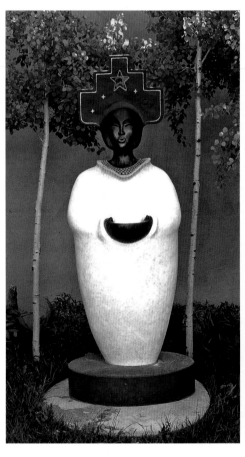

Everything has eyes, a spirit, a thing within that moves us. Where someone might see an apple, I see a mask, and it's talking to me. When I work, I don't work through my mind. I listen to the words behind the mask. I listen through my spirit and my heart, then share in my art the mystical thing behind the mask that gives off its beautiful inner energy.

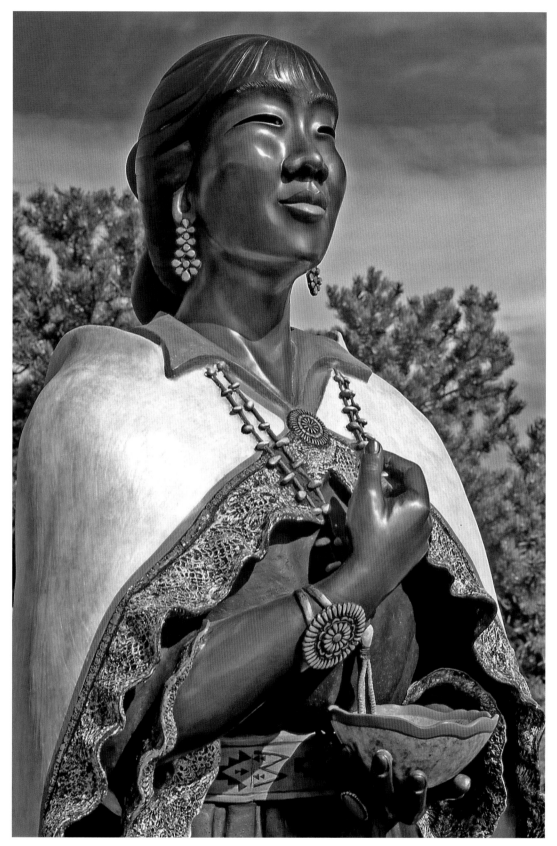

Blessed Kateri Tekakwitha 2003
Commissioned by Archbishop Michael J. Sheehan of Santa Fe, Estella's bronze outdoor sculpture stands in the parvis of the Cathedral Church of Santa Fe.

Kateri Tekakwitha was born in 1656 in the Mohawk community of Ossemenon, New York (named Auriesville today). Her Turtle Clan name meant "putting things in order." Orphaned at the age of four when her parents died of smallpox, she suffered a disfigured face but did not die. At twenty she was baptised into the Roman Catholic Church. Four years later she died. Her smallpox scars miraculously vanished and her face became beautiful and young again. In time she came to be called "The Lily of the Mohawks." She was beatified by Pope John Paul II in 1980.

Jennifer Lynch

FENIX GALLERY, TAOS
LYNCH PIN PRESS, INC., TAOS

Laura Shields

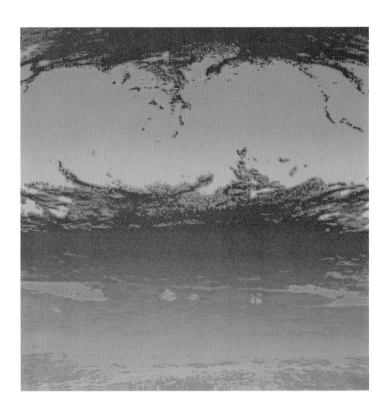

The themes of my work derive from natural phenomena and are specific to particular settings. The Fractal series came to me through my observation of nature. At that time I knew nothing of the concept of Fractal Geometry. My work with natural forms and patterns, along with observations made by others, brought the science of Fractal Geometry to my attention. I read more about it and began to understand its significance and its relationship to my work. My pieces do not claim to represent the complicated mathematics developed by Benoit Mandelbrot in the 1970s but only the essence of it. My interest is exploring the patterns and compositions that can be developed, looking at nature in a different way, and having the viewer exercise a perception of things. Fractal Geometry is in all natural systems; for example, the branching sequence of trees and river systems is not dissimilar to that of the human nervous system. Throughout ancient history, patterning and ornamentation of various textiles and ceramics have depicted common themes in cultures that have not intermingled. Possibly there is a relationship between these repeated structures, natural patterns, and the mind's eye.

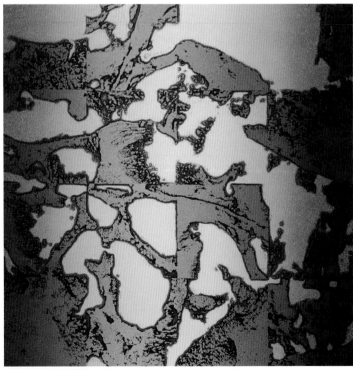

top
Fractal Series #38 2003
Solarplate viscosity etching, 10" x 10"
mounted on 18" x 18" steel.
All photos by Pat Pollard.

bottom
Fractal Series #29 2003
Solarplate viscosity etching, 10" x 10"
mounted on 18" x 18" steel.

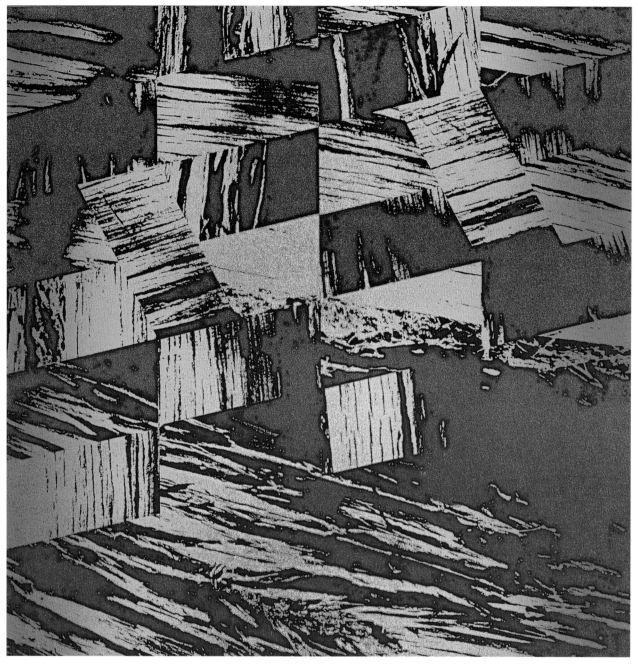

Fractal Series #21 2003
Solarplate viscosity etching, 18" x 18" mounted on 24" x 24" steel.

My process begins with the camera; it is my sketchbook. I seek separate elements in the environment that share similar properties. After a picture is made I blow it up out of proportion, change its scale, cut it apart at varying intervals or shapes, and put these elements back together like a puzzle. I know it is finished when the pieces fit. The work at that point is an intuitive process. Color and pattern operate as metaphors for natural rhythms that provide a point of departure for the contemplation of our relationship to nature and creation.

Chadwick Dean Manley

tadu downtown Gallery, Santa Fe
Boyd & Dreith, Denver

I have spent the better part of my life observing the different aspects of my work and trying to parse what of it is art, what is design, and what is simply industry. This impossible topology of aesthetic and function confounds the shared similarity of ingenuity and creation. While the question and observation of this distinction between art, design, and industry still seems somehow worthy, the lines between and values of these different parts of my work fade away the closer I examine them.

As a young artist I used to try and create a refined "experience of art" for other people, but over time I have found my inspiration in a subtle feeling that pervades all the work I do, whether it be art or not. My job is to make sure I find that feeling or its promise when I open the doors of my studio in the morning and to have it course through my veins as I close my doors at night.

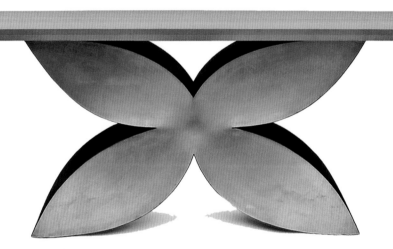

flora
Steel, silver, bamboo,
90" x 18" x 30".
All photos by the artist.

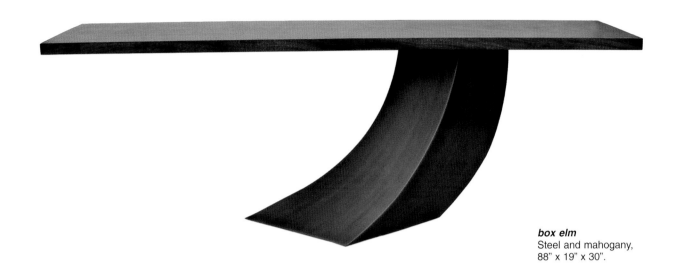

box elm
Steel and mahogany,
88" x 19" x 30".

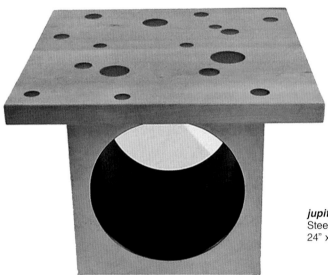

jupiter
Steel, silver, maple, and resin,
24" x 24" x 18".

op
Copper and wood,
60" x 18" x 16".

Diane Marsh

ADDISON/PARKS GALLERY, SANTA FE

The subject matter that permeated most of my work throughout the 1980s and 1990s was the transformation of human suffering into compassion through the acceptance of suffering—and more, recognizing that suffering is a necessary part of life. In my paintings, the figure is an expression of a concrete reality. The paintings often include words scratched onto the paint surface, floating there with intimate icons of symbols, children, and animals. These icons and words represent ideas of pain, hope, suffering, and renewal. All are bathed in, and glow from, an ethereal inner light. Light is very important to me as "content," but even more important is how light can be used to convey a sense of a mystical realm.

My paintings are a visualization of the process of inner awakening and transformation. I want to communicate the message of compassion for all life forms, including our earth. I hope that I have not backed away from telling the truth, while creating an object of beauty along the way.

Do Not Go Gentle 1993
Oil on linen, 36" x 72". Collection of Jon Jenkins and Robert Scott, Houston, TX.
Nature offers a place for human connection to spirit, a place to heal. We are intimately bound to the natural world. If we harm it, we harm ourselves.

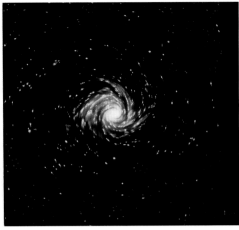

Rage Rage Against the Dying of the Light 1991
Oil on linen, 24" x 48". The Hess Collection Museum, Napa, CA.
People often find my images difficult or painful. In *Rage, Rage Against The Dying of the Light* and *Do Not Go Gentle* I portray a journey into the inner or "dark" reaches of our soul—symbolized by the endless universe or a vast primeval forest—in a search for truth, transcendence, and self-growth. Through suffering the doorway to compassion may open in each of us.

The Lost Girl 1991
Oil on linen, 56" x 80".
The Hess Collection Museum, Napa, CA.
In this painting the left panel contains a picture of a small child with the words "I will come back to me" scratched into the surface of the paint. Through it I convey a sense of going back in time to heal our wounds, to search for our authentic self, in order to become whole.

The Ending of Sorrow 1994
Oil on linen, 52" x 78". Collection of the artist.
I believe that to find peace within we must face our sorrow, not run from it. We need to experience our pain and grow through it in order to become more fully realized human beings. The right panel in this painting has a quote from Krishnamurti, the world teacher born in India in 1895, whose wisdom is not associated with any group or religion:

> Sorrow is sustained only when there is an escape from sorrow, a desire to run away from it, to resolve it, or to worship it. But when there is nothing of all that because the mind is directly in contact with sorrow, and is therefore completely silent with regard to it, then you will discover for yourself that the mind is not in sorrow at all. The moment one's mind is completely in contact with the fact of sorrow, that fact itself resolves all the sorrow-producing qualities of time and thought. Therefore there is the ending of sorrow.

The small images floating around his words are icons for suffering, hope, healing, spiritual discovery, and renewal.

Sylvia Martinez Johnson
STUDIO OF SYLVIA MARTINEZ JOHNSON, REGINA, NM

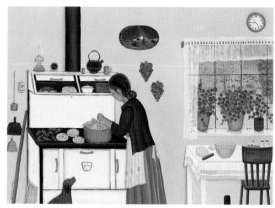

Grandma's Kitchen 2002
Oil on linen, 24" x 36".

I was born and raised in northern New Mexico. I grew up around the many wonderful Hispanic and Indian traditions of the Southwest. I am a self-taught artist but credit my beginning to my childhood neighbor Ann Spies Mills. She inspired me with her fantastic artistic talent, which oozed from every fiber of her being. I remember helping her create a doll house made from boxes, fabric, jar lids, and beads. My early art work consisted entirely of fabric and beads. It wasn't until my early forties that I began experimenting with paint. I soon realized painting was my true love.

Matanza (my grandparents' house and all my family) 2000
Oil on linen, 24" x 36". All photos by Lynn Lown.
Painting is a marriage of my artwork and my spiritual world.

116

The Final Victory 2000
Oil on wood with tinwork frame, 60" x 48".
I want to create images that stir the spirit and the innermost soul.

The Incarnation of Christ 1998
Oil on wood with gold leaf and precious stones, 84" x 48".
In studying the Renaissance masters I became enamored with their broad use of jewels and gold leaf. I began using these techniques in my own work. I feel it contributes greatly to my religious work and my own pleasure.

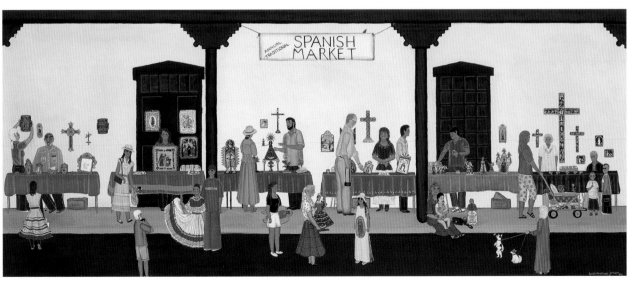

Spanish Market 2002
Oil on linen, 22" x 42".

Ada Medina

KLAUDIA MARR GALLERY, SANTA FE

Jenn Moller

My elemental sculpture uses mixed media such as wood, paper, paint, stain, leather, earth, wool, and wax. Each form is mounted on the wall, asserting lines and masses. Whether geometric or organic, severe or quirky, the work is a natural progression of its own laws. The works are simultaneously allusive and unfamiliar.

These forms are made in the thick of direct experience beyond the initial glimmer of ideation. I build them with care and attention, knowing at the same time that the aim is not a discrete object. Their vitality is found in that hidden moment, where the seemingly irreconcilable material/insolidity, abstract/referential, formalism/animism, rawness/nuance support each other as a totality with no separation. I am interested in work whose physical and non-physical dimensions contain each other, yielding an unsettled, unsettling form that is reversibly object and non-object, resisting single or rigid interpretation. This, after all, is the reality we inhabit daily.

Untitled (palos) 2003
Wood, stain, satin polycrylic varnish; 55.5" x 2.25" x 2.375".
Collection of the artist. All photos of art by Margot Geist.

Untitled (with wool) 2004
Wood, stain, leather, waxed nylon
thread, wool; 3.5" x 45.75" x 3".
Collection of the artist.

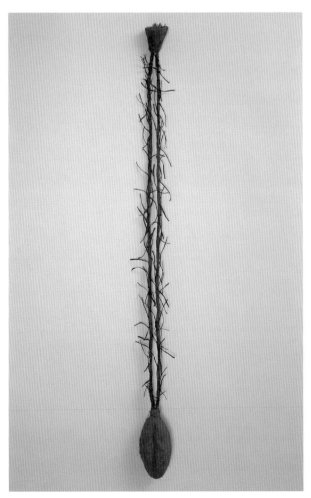

Via 2003
Paper, jute, ink, sinew, twigs, wax, earth; 44" x 3.25" x 3".
Collection of the artist.

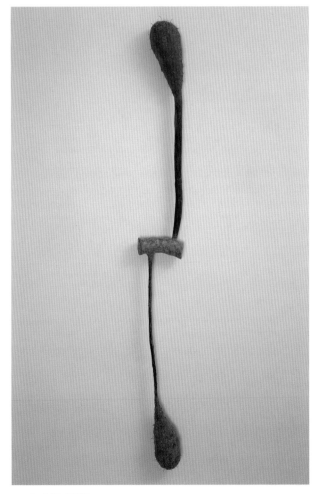

Ambhi 2003
Branches, paper, acrylic, ink, wax, straw, earth;
47.25" x 5.125" x 2.5".
Collection of Libby Atkins.

Mary Neumuth Mito

GERALD PETERS GALLERY, SANTA FE

Painting is part of the rhythm of my day.

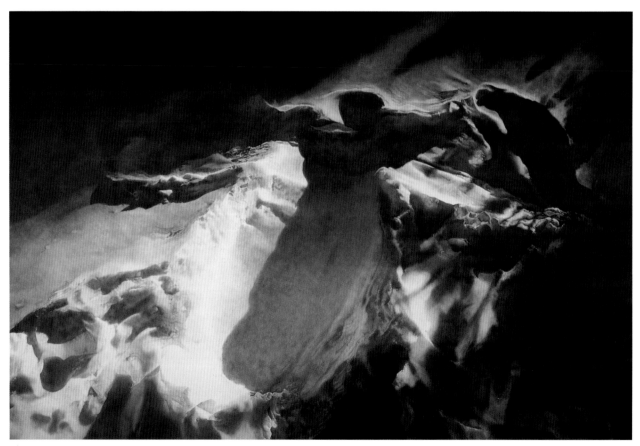

Avenging Angel 2003
Oil on canvas, 78" x 117".
Courtesy of Gerald Peters Gallery.
All photos by Gerald Peters Gallery.

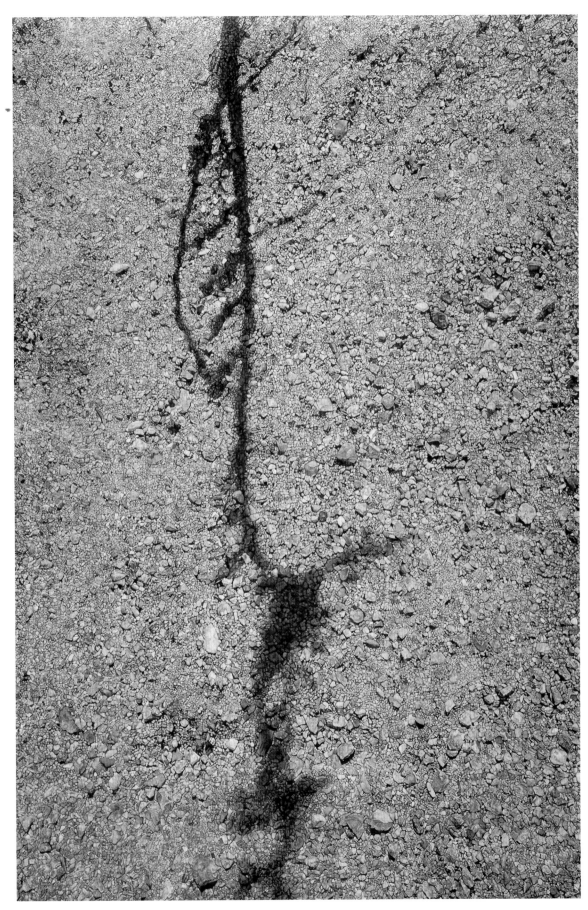

Daughter Running
Oil on canvas, 97.25" x 65". Courtesy of Gerald Peters Gallery.

Delilah Montoya

ANDREW SMITH GALLERY, SANTA FE

Luis Jiménez

I view art as a serious and responsible vehicle for exploring Chicana ideology. I question my identity as a Chicana in occupied America, and articulate the experience of a minority woman. I work to understand the depth of my spiritual, political, emotional, and cultural icons. I explore the topography of my conceptual homeland, Aztlan, and use documentary methods to state the configurations of my vision.

La Llorona in Lillith's Garden 2004
Digital image with light jet and ink jet output, 10" x 8". Collection of the artist. All photos by the artist.

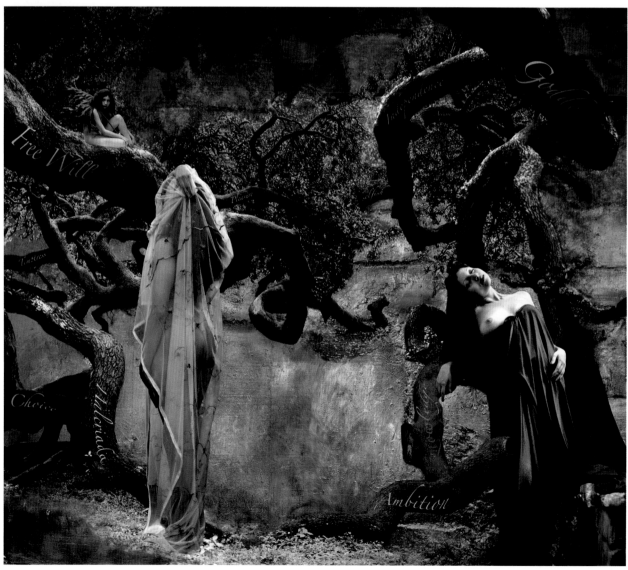

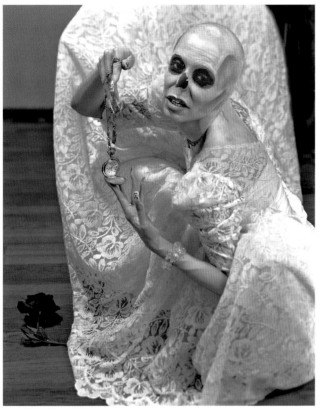

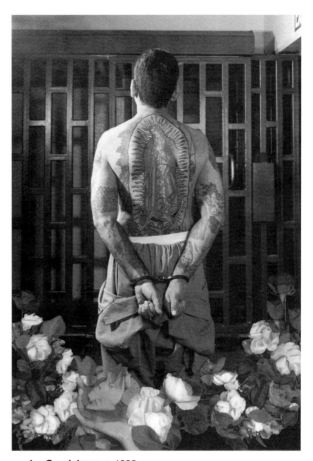

La Guadalupana 1998
Digital image, 20" x 24".
Collection of the artist.
I was invited to create an installation at the Musée Puech Denys in Rodez, France. I installed a seminal work there, *La Guadalupana*. It is a 15.5-foot photomural that explores the Guadalupe as a cultural icon from New Mexico's colonial past.

Ahora 2002
Digital image with light jet and ink jet output, 20" x 30".
Collection of National Hispanic Cultural Center.
San Sebastiana: Angel del La Muerte (usually called *La Muerte*) is an allegorical icon for death. I created a video and digital installation of this folk icon that reinvents her into a Diva. Traditionally perceived by the Northern New Mexican *Penitiente* Brotherhood as a grimacing skeleton in a death cart, I gave her a new persona to reclaim her as a woman empowered.

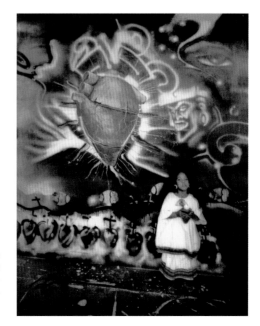

Teyolia 1993
Collotype, 10" x 8". Collection of the artist.
El Corazon Sagrado/The Sacred Heart is a collection of collotypes that explore the way this icon is embedded into the religious fabric of my culture. My images of Albuquerque's Chicanas and Chicanos express the concerns of their hearts, explore the Sacred Heart as a cultural icon, and pay tribute to that community.

Jesús Moroles

LewAllen Contemporary, Santa Fe

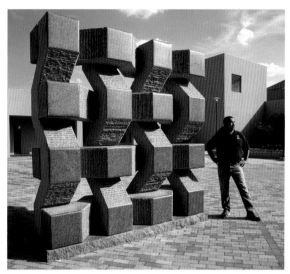

No one really knows what I do. I've done over 2,500 pieces, and I can't imagine anyone ever seeing more than the tip of the iceberg that's the stone before their eyes.

I don't make drawings or models. I sketch the design directly on the stone. When I give the piece a name, it's only so I can remember it, not because the name has any grand meaning.

I don't read reviews or criticisms about other artists or my own art. We're influenced by the multitude of things around us, why be influenced by someone's opinions?

I just keep on going with my own ideas.

The artist with *Granite Weaving* 2001
Dakota mahogany granite, 9.75' x 9.75' x 32".
Photo by Frank Ribelin.

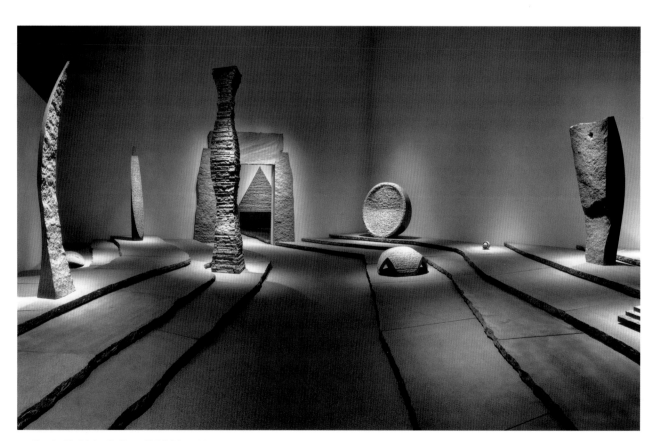

Davis McClain Gallery Exhibition, Houston, 1990.
left to right
Granite Landscape 1990 Fredericksburg granite. ***Spirit*** 1990 Texas rose granite. ***Shell*** 1990 Texas granite. ***Eclipse*** 1990 Dakota granite. ***Portal*** 1990 Fredericksburg granite. ***Granite Pyramid*** 1990 Texas granite. ***Granite Column*** 1990 Texas granite. ***Moonscape*** 1990 Texas granite. ***Dome*** 1990 Texas pink granite. ***Round Rocks*** 1991 Italian black granite. ***Wedge*** 1990 Texas rose granite. Photo by Gary Faye.

Mountain Fountain 1983
Dakota granite, 108" x 54" x 54".
Commissioned for the Museum of Fine Arts,
Santa Fe.
Gift of Duncan & Elizabeth Boeckman in Honor
of their daughter Katherin Boeckman Howd.
Photo by Susan Moldenhauer.

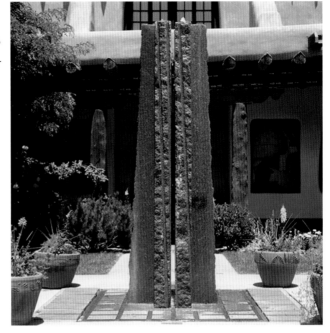

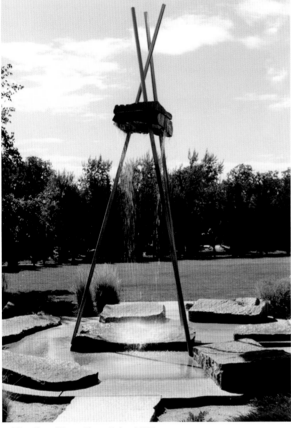

Floating Mesa Fountain 1996
Stainless steel and Texas granite, 264" x 96" x
84". Collection of Albuquerque Museum,
Albuquerque, NM. Photo by Ann Sherman.

Mountain Steles 1989
Fredericksburg granite with stainless steel,
360" x 276" x 204".
Commissioned by Desert Mountain Corp.,
Carefree, AZ. Photo by Susan Moldenhauer.

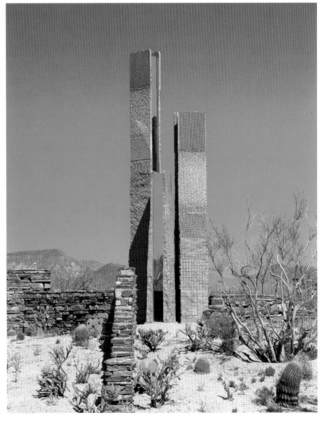

Forrest Moses
LewAllen Contemporary, Santa Fe

Robert Reck

My subject is the abstraction of landscape in paintings. My paintings are not pictures of nature. Nature is nature and paintings are paintings.

A painting is progression, not conclusion. I make a first mark, which changes the space on the canvas. Eventually the surface will contain a lot of marks that add and subtract to move toward a conclusion. Sometimes there is complexity; other times an expanse of space achieves an overall vibration of color. A painting may have an image contained in its marks, but it also may be seen simply as marks.

I study a painting over a period of time to adjust to the living spirit of it. My studio has paintings developing at different stages, with the work on one painting suggesting answers to problems in others. My task, then, is to see and discover the direction in a landscape, to give life to the rhythms and pulses behind its appearances.

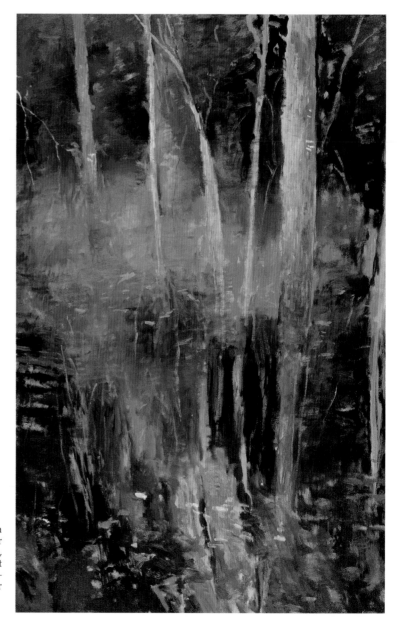

Woodpond Reflections 2003.
Oil on canvas, 78" x 50".
Collection of Mrs. Q. Cook.
All photos by Richard Faller.
I use a camera to arrest a moment in a place. I seek its essence. In a waterway or rocks, fields, or a pond, I see overall color, patterns, textures, the atmosphere of that place and its layer upon layer of patterns—limb, leaf, rock, and earth—to simplify later in paint.

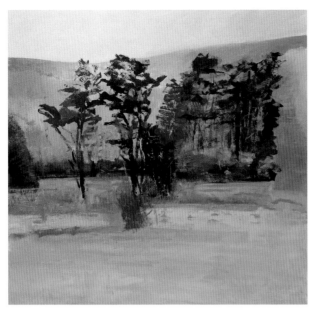

Yellow Field, Dark Trees 2002
Oil on canvas, 48" x 50".
Collection of Molly Hauser.
My subject is the abstraction of landscape in paintings. My paintings are not pictures of nature. Nature is nature and paintings are paintings.

Bosque Grasslands 2003
Oil on canvas, 40" x 96".
Collection of Ruann Ernst.
A painting's marks, scratches, and smudges come rapidly. Their energy keeps the strokes alive. I work until I see it develop a life of its own. Then I move ahead more slowly and carefully. I don't want to disturb the direction it has taken.

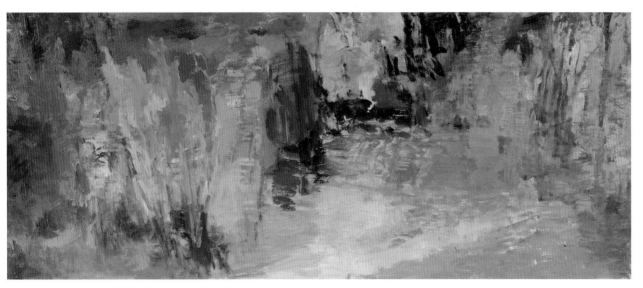

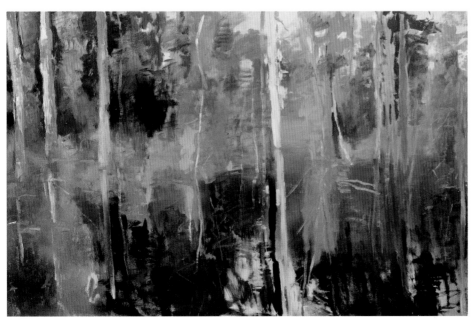

Deep Wood Pond 2003
Oil on canvas, 50" x 78".
Collection of Linda and Ken Elliot.
I draw inspiration from the waning year's months of transition, fall to winter. More color, line, and detail is visible after the green of summer has gone.

Carol Mothner
GERALD PETERS GALLERY, SANTA FE

I believe artists have a responsibility to address issues that we face during our lives. I say this with no little irony because I have run away from many issues about which I felt strongly. Yet I have also addressed others with great vigor—aging, being a woman, the violence of our time, and others of like kind.

Most of my life I have done small, intimate pictures. It fascinates me to watch people approach my art. They start from far away, seemingly compelled to get closer and closer because of the painting's smallish size. Then they notice all the detail. By the time they are face to face with the piece, it seems as though a mystery is revealed to them. Perhaps my work has indeed answered some question in their lives, even though I do not always put a specific mystery into a painting. I certainly hope so.

Transformations: The Missing, 9/11 2002
Egg tempera on panel, 14" x 14".
Private collection. Photo courtesy of Gerald Peters Gallery.

Elizabeth, Age 16 2005
Watercolor, acrylic, and graphite
on gessoed board, 18" x 17".
Courtesy of Gerald Peters Gallery,
Santa Fe. Photo by Wendy
McEahern.

Mary, Age 80 1989
Graphite on museum board,
30" x 23". Courtesy of Greenville
County Museum of Art.

Patrick Nagatani

ANDREW SMITH GALLERY, SANTA FE

I was going to be an engineer, but dropped out of all my freshman classes in August, 1963. I went to Hermosa Beach, California, and read Henry David Thoreau. One passage has stuck in my mind ever since: "If a man does not keep pace with his companions, perhaps it is because he hears a different drummer. Let him step to the music which he hears, however measured or far away."

It took a few more years and a lot of life experience for me to evolve to a mature artist, but that day there was only the ocean, a thought, and a desire to never look back and commit my life to art.

BMW, Chetro Letl Kiva, Chaco Canyon, New Mexico, USA
1997/1998
(Nagatani/Ryoichi Excavation Project)
Ilfochrome, 17.75" x 22.875".
All photos by the artist.

Koshare/Tewa Ritual Clowns, Missile Park, White Sands Missile Range, New Mexico 1989–1993
(Nuclear Enhancement project)
Ilfocolor, 27.5" x 36.5".

130

Chromatherapy. *Mr. Yoshitomi and Toki.* **Plate 8** 1978/2004
Ilfoflex 2000, 10" x 18".

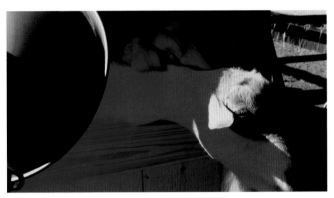

Chromatherapy. *Transmogrification.* **Plate 33** 2004
Ilfoflex 2000, 10" x 18".

Chromatherapy. *Tonation in Color Charged H$_2$O.* **Plate 27** 2004
Ilfoflex 2000, 10" x 18".

When I see something that fascinates me
I research the hell out of it.
Maybe it becomes art.

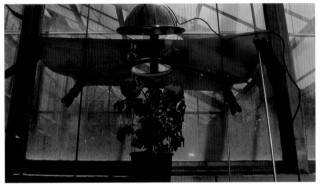

Chromatherapy. *Growth Pulsation.* **Plate 29** 2004
Ilfoflex 2000, 10" x 18".

Chromatherapy. *Extensive Aura Balance.* **Plate 23**
1980/2004
Ilfoflex 2000, 10" x 18".

Chromatherapy. *Anechoic Multi-Tonations.* **Plate 31** 2004
Ilfoflex 2000, 10" x 18".

Arlo Namingha

NIMAN FINE ART, SANTA FE

I have one foot in the foundation of where I started and the other in expanding, wanting to grow, breaking the barriers that classify me as a "Native" artist.

Guardian 2004
Bronze edition of 9, 34.25" x 8.75" x 75".

In Memory and Honor of Lori Piestewa
Lori Piestewa lost her life in combat when the 507th maintenance company was ambushed in southern Iraq. She has left behind two children. Lori was the first woman and Native American to die in combat in the Iraq war. She served her country and her tribe with honor and pride.

Partial proceeds of each bronze casting will go to the educational scholarship trust fund set up for Lori Piestewa's children.

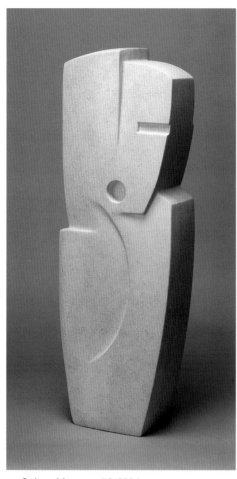

Passing Clouds #2 2004
Paduk wood, 48" x 41" x 2".
Collection of Peter and Eleanor Frank.

Cultural Images #4 2004
Indiana Limestone, 26.25" x 9" x 4.75".
Collection of Phillip and Jeri Hertzman.

Cultural Images #1 2004
Bronze edition of 12, 24.5" x 7.5" x 3.6".

Dance 2004
Bronze edition of 6, 52.5" x 15.5" x 13".

Dan Namingha

NIMAN FINE ART, SANTA FE

The inspiration for my work may derive from my culture, but the language is universal.

Vertical Passage 1998
Bronze edition of 15,
25.25" x 9.5" x 5.5".
All photos courtesy of Niman Fine Art.

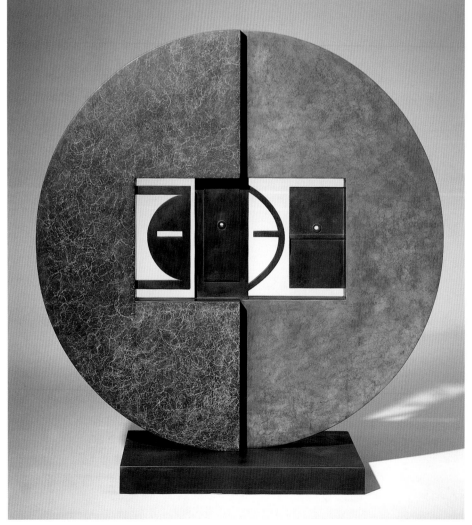

Dualities 1997
Bronze edition of 6, 51.5" x 48" x 17.75".

134

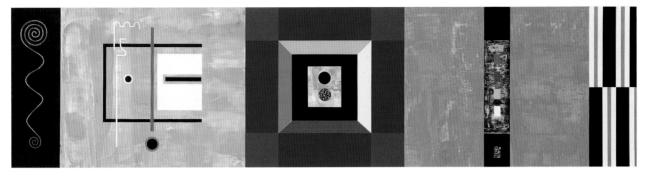

Montage Series #3 2004
Acrylic on canvas, 24" x 96".

Cardinal Directions #3 2004
Acrylic on canvas, 64" x 60".

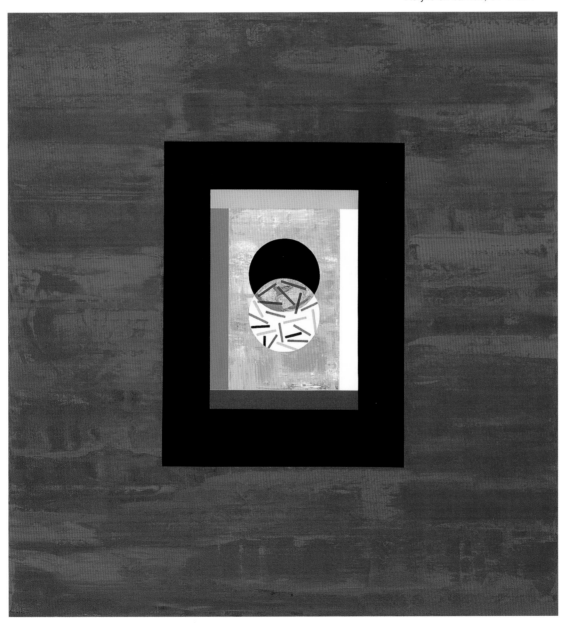

Les Namingha
BLUE RAIN GALLERY, TAOS AND SANTA FE

Why?

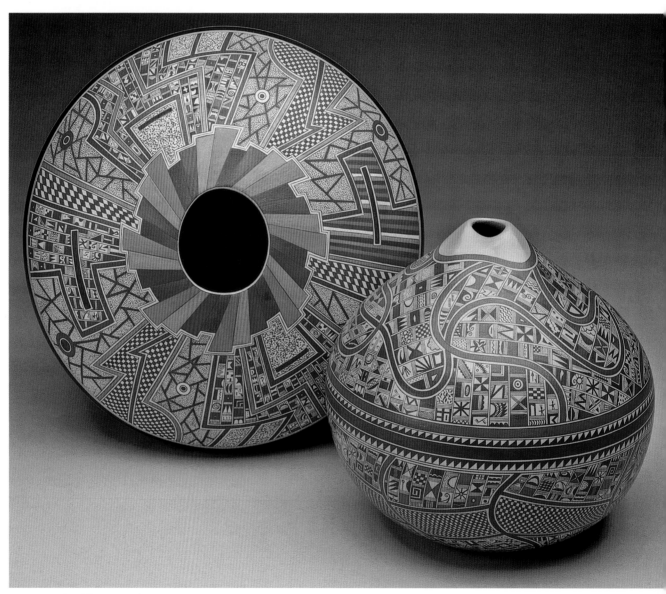

untitled (both works) 2004
Mixed media on clay; *left*: 6.5" x 10" dia.; *right*: 7.5" x 7.5" dia.
All photos courtesy Blue Rain Gallery.

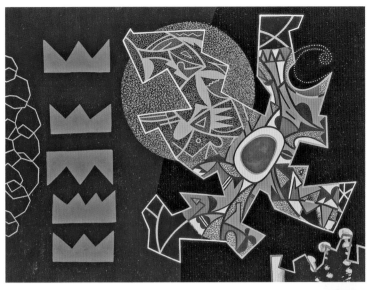

Rotation 2003
Acrylic on paper, 12" x 16".

When I was about nine years old, I spent many summer days herding sheep for my grandfather. I remember on one of those days, I picked up a small, hard-packed dirt clod and proceeded to carve a mask of a kachina with my finger nails. When I finished, I stared for quite some time at the miniature offering. My young soul beamed with surprise and satisfaction as the face of a spiritual being stared back. I finally laid it down on the ground where it blended in with the reddish-brown soil, and I went on my way to tend to the sheep.

Art is a self-answering question.

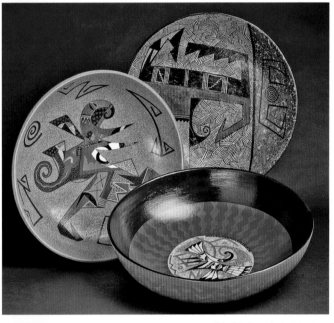

untitled (all works) 2004
Acrylic on clay, 4" x 14" dia. (all works).

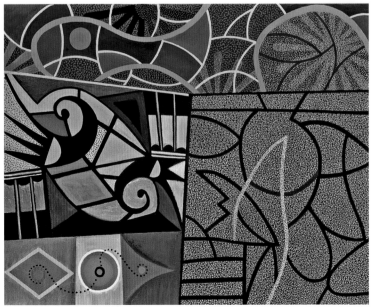

Blossoms and Birds 2003
Acrylic on canvas, 16" x 20".

137

Margaret Nes

HAHN ROSS GALLERY, SANTA FE

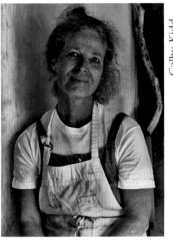

Colby Kidd

Art has always been a journey of mystery and wonder for me. It can be both exhilarating and terrifying, joyous or hard. It can flow as easily as a river or be as sticky as quicksand. It has taught me a certain faith, a sense of caring enough to keep on. Who knows what may lie around the next corner, beyond what can be imagined? Making art is my way to be in this world. It is a way for me to explore the physical world and my own internal world, to find where these meet in the universality of existence. It is part of my whole life. I can't imagine not doing it.

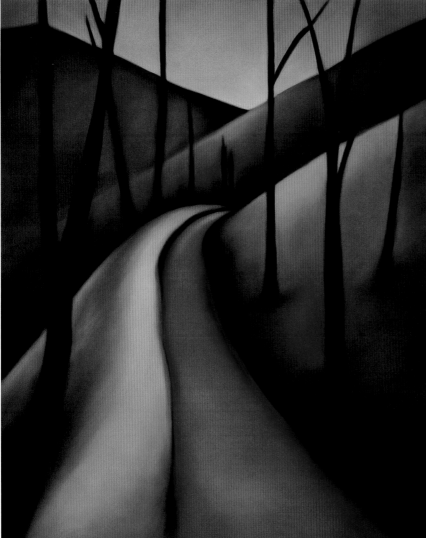

this page top
Small Fruit with Large Leaves 2000
Pastel, 18" x 24.5".

this page bottom
Blood of Our Acequia Madre 2001
Pastel, 26.5" x 21.25"
Coming up with something unique, be
it utilitarian, aesthetic, or both, seems a
mysterious and almost magical act. We
do it together and we do it alone.

opposite page top
The Wizard 1989
Pastel, 13" x 20".
Making art and experiencing the
music, art, poetry of others, acts as an
antidote to all that dulls my humanity
and spirit. The creative process is not
bound by particular social or cultural
views of reality. It can blow open new
areas of awareness, understanding, and
experience.

opposite page bottom
Passageway 1990
Pastel, 23.25" x 19".
The heart of art is in the process itself.
It is an open field where curiosity and
wonder can roam freely, where we
can recognize the unknowns at the
heart of being and where doors can
open beyond language and
preconceptions. It is part of our very
being, not something relegated to or
defined by those we call "artists."

P. A. Nisbet
THE MUNSON GALLERY, SANTA FE

I am profoundly moved by the astonishing beauty of this world. I have spent three decades exploring nature and creating paintings from these experiences. I have always sought moments in the landscape where light and form reveal a deeper working, an intelligence that is, to me, profound and beyond the reach of words. In the studio I draw inspiration from painters who predate the twentieth century, particularly Turner, Friedrich, Moran, and the Luminists. Their works are inspired and spiritual.

I am attempting to perpetuate this tradtion in my own work.

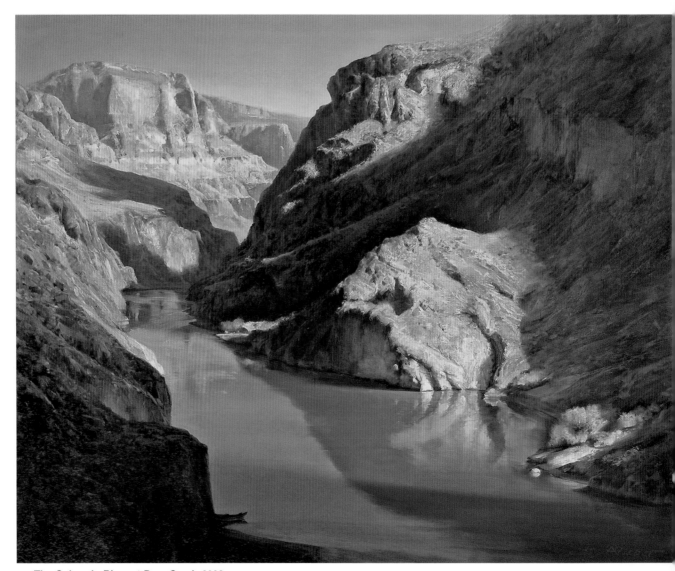

The Colorado River at Deer Creek 2002
Oil on canvas, 32" x 40".

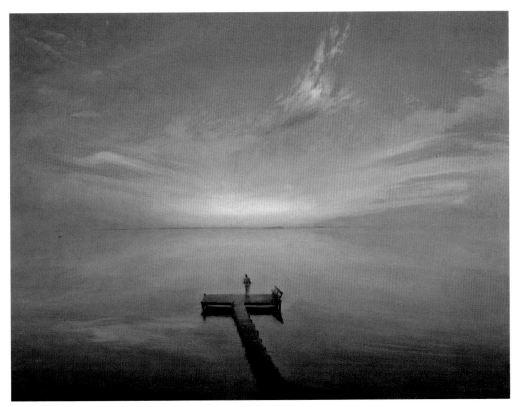

The Sermon 2001
Oil on canvas, 24" x 32".

Lava Falls 2003
Oil on canvas, 24" x 36".

Dino Paravano

GERALD PETERS GALLERY, SANTA FE

I was born into art. My first memories are my father's paintings hanging in our house. From that time I knew that I wanted to be an artist. In pre-school I occupied myself with coloring books; in grade school I would draw my classmates. Encouraged by my father, I continued to pursue my ambition all through my adolescent years.

Now I have been painting for over five decades. There is always so much more to do, so many ideas swirl in my mind. I never sit idly waiting for inspiration; I have many projects going at any given time. The day doesn't have enough hours, and I work long into the night.

I have traveled the world pursuing subject matter. Since I see a potential painting in the most unlikely places, I hope to visit many more interesting places.

One lifetime isn't enough.

Near Canyon Lake 2001
Pastel, 21" x 29". Collection of Laura Noble. All photos by the artist.
Art is a passion, a desire, a way of life. It represents fulfillment of expression through admiration of the world around me.

Pride's Proud Family 1995
Pastel, 22" x 42". Collection of Annette Bishop.
I am a realist, a painter of nature. I don't paint political statements, nightmares, or
misery, but what pleases my eye. I don't just paint what I see, but how I would
like it to be. I change, rearrange, add, remove, and visually bring out the best of
the subject.

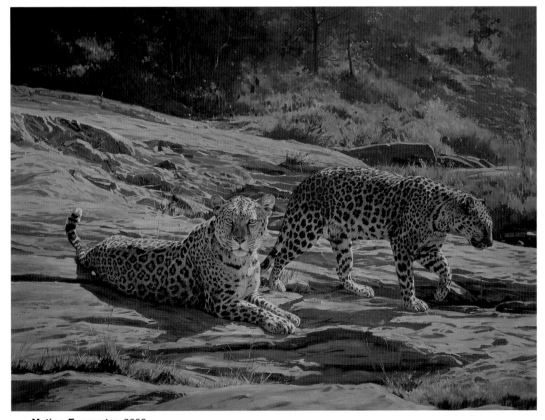

Mating Encounter 2003
Oil on canvas, 36" x 48". Collection of Fausto Yturria, Jr.
I want to depict whatever catches my eye, although I have painted mostly wildlife for
many years, it is something I always enjoy.

Florence Pierce

CHARLOTTE JACKSON FINE ART, SANTA FE

I arrived in Taos, New Mexico, the summer of 1936, on my eighteenth birthday, with the intention of studying art during summer vacation. As it turned out, that was the beginning of a three-year stay.

My mentors were Emil Bisttram and Raymond Jonson, who were then proclaiming abstraction as the art of the future. I became the youngest member—and one of only two women—in their Transcendental Painting Group. This was the beginning of my personal commitment to the life of an artist.

I eventually settled in Albuquerque, where I have done most of my art. For the last twenty-five years I've worked exclusively in polyester resin.

Untitled 1995
Resin relief, 16" x 16". All photos courtesy of Charlotte Jackson Fine Art.
My art is my reality. It is about stilling and freeing the mind.

Untitled 1995
Resin relief, 16" x 16".
My work is concerned with turning inward
and toward the mysterious and uninformed,
far away from the concrete world and its
marvelous distractions. It is non-objective,
with no association to the politics,
religions, or social concerns of our times.

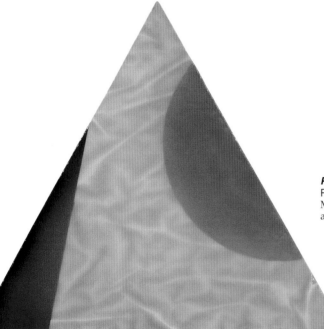

Peak #8 1983
Resin relief, 41" x 47".
My intent is to make art pristine, pure,
and timeless.

Untitled 1995
Resin relief, 16" x 16".
Simplicity, power, and presence
have been my objectives; the frank
pursuit of beauty.

Ron Pokrasso

DELONEY NEWKIRK FINE ART, SANTA FE
LYNNE FINE ART, SCOTTSDALE

Veronica Lucas

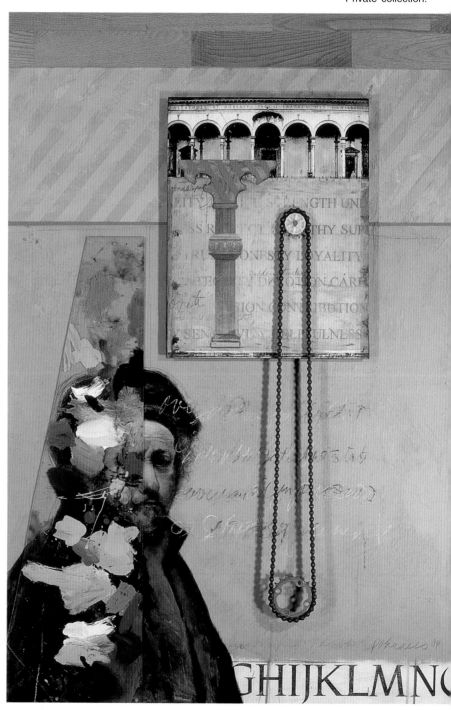

But Does It Work? 2004
Acrylic/intaglio/collage/drawing/assemblage on wood,
54" x 36" x 4".
Private collection.

My artistic development spirals around a need to express, making new discoveries, and continually returning to themes long familiar in my work.

I have always relied upon things that are close to me, things that speak about the passions in my life. Yet it is not enough for a work to convey a literal visual meaning. It is more important to allow content to come through me in the working out of a successful composition.

My relationship with my art falls somewhere between full control and letting anything happen. The result is an exploration of the balance between frenzied paint scribbling and the simple lines of notebook paper; between the regularity of black and white on a piece of sheet music and a multicolored paint palette; and between the organic charcoal sketch of a tree and the linearities of piano strings. I juxtapose seemingly unrelated or competing elements to create visual and technical contrast.

I work by diving in. The passion of creating is vital. Usually there's a vague general direction, but rarely do I have a clear idea of what will happen. If I knew where I was going, I'd be lost.

I have a conversation with the piece as it unfolds. As the piece acquires its own personality, it lets me know where it wants to go and I decide how to get it there. The work is complete when it stops asking for more.

All American Russian Boy 1998
Monotype/lithograph/collage/drawing/assemblage on paper mounted on
board, 23" x 35" x 2". Collection of the artist.

Tune For the Total View 2001
Acrylic/drawing/collage/assemblage on wood, 72" x 48" x 4".
Private collection.

Lesson Plan: Teach the 'P' Word 2001
Acrylic/collage/drawing on board, 54" x 36".
Private collection.

Ken Price

Fenix Gallery, Taos
James Kelly Contemporary, Santa Fe

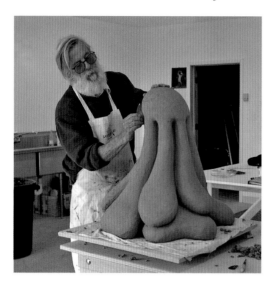

Mo 2000
Fired and painted clay, 13" x 24" x 28.5".
All photos courtesy of the artist.

Lulu 2001
Fired and painted clay, 11.5" x 13.25" x 10.5".

Sour Puss 2002
Fired and painted clay, 21" x 21" x 14".

Long Tall Dexter 2003
Fired and painted clay, 23" x 23" x 24".

Baby J 2003
Fired and painted clay, 13.5" x 10.5" x 9.5".

Al Qöyawayma
BLUE RAIN GALLERY, TAOS AND SANTA FE

As I work I breathe life into a lump of clay. It comes alive when I put it in my hand. It tells me, "Make me beautiful, make me what I am supposed to be." I talk to it at every step. It is born without form, flexible as a child. Like a child it is pliable and not yet completely formed. I breathe more life-giving clay into it and it grows.

My creation becomes yet another thread in an ancient woven pattern. I am content to be part of that pattern.

There is broken pottery everywhere in this land called the Southwest. As I climb the mesas and walk the deserts, I find ancient pieces made by our ancestors and left behind to remind us how long we have been in this land. The clay I choose may contain the dust of my ancestors. I must be respectful, for someday I too might become part of a vessel and become useful again, reflect the Creator's beauty and love just as I do today.

I am privileged to be present as the unseen hands, the gift of the Creator's energy, flows into my work. I am one with the clay, one with my Creator, one with every living thing. I am at home.

Carved Sikyatki Polychrome, "Ancient Ways" *(top)* 2004, Hopi Clay, 5.5" x 12.5" dia.
and **"Sunrise"** *(bottom)*, 2004, Hopi Clay, 5" x 12.5" dia. Photo courtesy of Blue Rain Gallery.
I am a descendent of the Coyote clan. We were the sole occupants of an ancient village called Sikyatki. Sikyatki pottery was famed for its low shoulders and intricate designs. Our clan's origins, language, traditions, and religions were originally different.

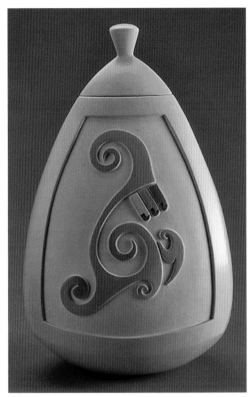

Let the Sun Dance 2003
Hopi Clay, 10.25" x 6" wide (3-sided).
Photo courtesy of Blue Rain Gallery.
My style was inspired by my aunt, Polingaysi Qöyawayma. One day as I was playing with a clay sculpture, she watched and said, "You have it." Those three words have never left me. I build a piece using Hopi clay and coiling methods to keep the walls thin and lightweight, but the motifs I use are inspired by ancient architecture, dancing figures, and corn, animal, and feather motifs.

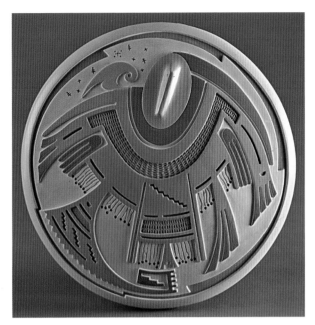

Let's Dance 2003
Hopi clay, 4.75" x 12.25" dia.
My grandmother Sevenka passed on to me our clan's spiritual tradition, "We do not walk alone. Great Spirit walks besides us. Always know this and be grateful." Call it God or Creator, its hand is in all parts of my life. Do I pray when forming pots? Certainly!

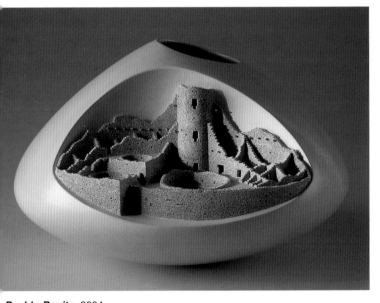

Pueblo Bonito 2004
Hopi clay, 11.5" x 17.25" dia.
Photo courtesy of the artist.
This is a recent work in my twenty-plus-years "Mesa Verde Series", in which I continue to work alongside my newer Sikyatki blended polychrome "new style."

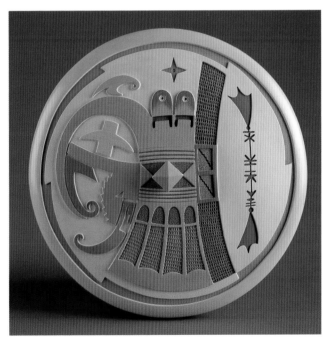

Hokuléa, Star of Gladness 2003
Hopi Clay, 5.5" x 12" dia.
Photo courtesy of the artist.

Editor's Note: Mr. Qöyawayma's website *www.alqpottery.com* has a number of superb poems he has written to describe his work and values. Readers are encouraged to visit it.

Kim Rawdin

PATINA GALLERY, SANTA FE
CERVINI-HAAS GALLERY, SCOTTSDALE

Susan Rawdin

Practicing a craft like silversmithing or goldsmithing in the simple, traditional manner such as I do has very ancient roots. I am connected to the primal international world-mind. I feel equilibrium, a sense of place, a centering that opens something up in my mind. I have always asserted that my bracelets represent a kind of microcosm of landscape. I have also developed the inner space, the free Haiku I compose and stamp on the inside of the bracelets. There is a polarity between this microcosm of landscape and the emotional inner space of the free Haiku. This polarity is the essence of the piece. It creates a place, a singularity in time. So my bracelets are "places."

My style comes from an urgent need to simplify and purify everything. It is the modern touching the traditional, East meeting West. A piece doesn't feel right to me until I have reduced it to its essential form and concentrated my concept of time into it.

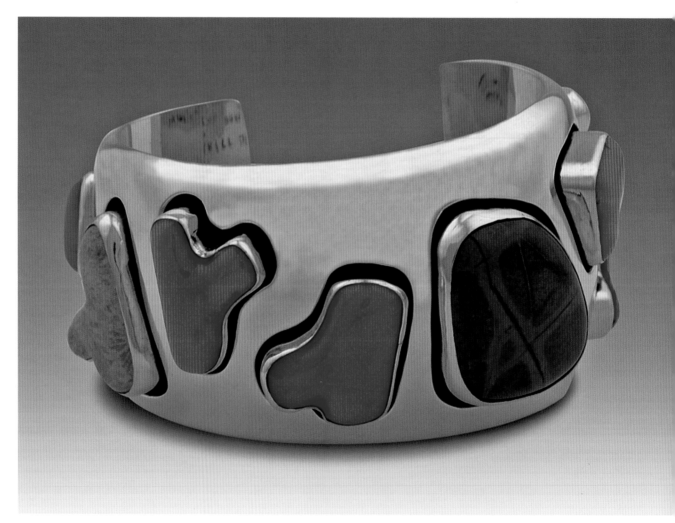

In lieu of names for his pieces, the artist's own Haiku are stamped on the inside bands:

ships take to the skies
like sumi brushes
in all this blue

2000–2005 Gold, red coral, petrified coral, sugalite, gem silica;
1.75" x 2.125" dia. All photos by ENVISIONSPACE.

152

was always an artist but the discovery that my voice was in jewelry took me by surprise. I came west as a young man from New York. I as involved in the contemporary New York art scene while I was a ine Arts student. In my teens, I loved art and haunted all the great useums in New York. Then the Southwest called to me. The energy nd spirit of the land that I felt as a child while reading *Arizona ighways* magazines in my school library deeply influenced me. I me to Arizona in the early 1970s and finished school with an Art ducation degree.

In 1976 a job teaching silversmithing opened at a high school on e Navajo reservation near the mouth of the Canyon De Chelly. I ught in a modern hogan specially designed for silver-smithing. I ared it with the master Navajo silversmith Gene Jackson, the artist residence at the time. There was also a Navajo Medicine Man mployed to teach culture. Because I experienced the craft of lversmithing from the heart of a traditional culture, I was able to ter a special world on its terms, not mine. That spiritual initiation as kept me going.

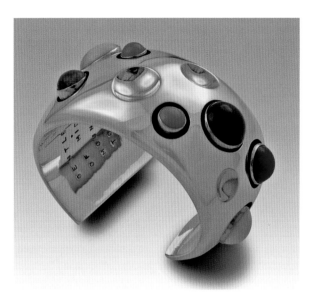

gentle light of mid september
mountain walking
to the top of myself

2004 Sterling, 18k and 22k gold, lapis, coral, chariote, chrysoprase, black onyx, ivory, jasper, turquoise; 1.5" wide to 2" wide.

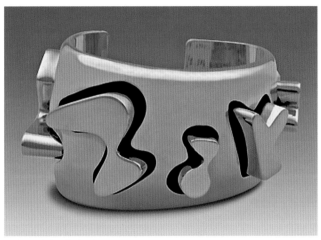

dawn island clouds
and the astounding sun
the everyday world is enough

1996 18k gold, 1.75" wide to 2.25" wide.

spring cross winds
call back the past
those days still so real
almost return

2003 18k and 22k gold, jade, Boulder opal, blue chalcedony, coral; 1" wide to 1.5" wide.

cloud worlds
of no time
islands of pure light
have you been to far places

2005 18k and 22k gold, lapis, pink chalcedony; 1.375" wide to 1.875" wide.

153

Bette Ridgeway

TADU DOWNTOWN, SANTA FE

To fully appreciate my work requires a willingness not only to see with your eyes, but also to listen with your heart. For, amid the colors and forms, the dynamic movement of light and shadow, you might discover something unexpected, held captive in this purely visual medium.

Like a composer who creates with melodies and harmonies, I compose with color. To capture that moment—when Mimi pours out her heart to Rodolfo in *La Boheme*, finding that perfect high C, as the audience waits, breathless, and a collective shiver runs through the opera house—would, for me, be heaven. The transcendence, the sudden clarity as beauty becomes truth—that is the *music* I attempt to create in each of my paintings, recorded with juicy, fluid pigments on hard, unyielding steel.

Journey in Red I 2005
Acrylic and resin on steel, 16" x 16".
Private collection. All photos by the artist.

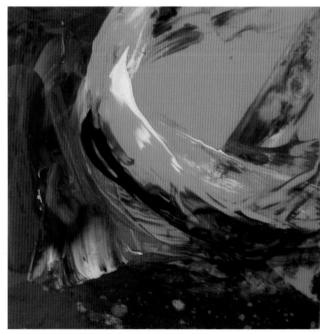

Spectral Dance I 2005
Acrylic and resin on steel, 12" x 12".
Courtesy of tadu downtown, Santa Fe.

I am led by my intuition and spend time meditating before each painting session. An empty space is created within me into which the raw elements—color, form, and light—flow. Once there, they are tended, nurtured, allowed to gestate, before being carefully expressed.

There is an intimacy to pushing the paint around with my fingers, manipulating it into submission. The challenge is to stop the movement at the perfect moment, freezing the image and sealing it with many layers of thick acrylic resin, glass-like and impervious, protected for the ages.

I call this process layering light.

Journey in Red II 2005
Acrylic and resin on steel, 16" x 16".
Private collection.

Birth of a Star 2005
Acrylic and resin on aluminum, 16" x 16".
Private collection.

Johnnie Winona Ross

JAMES KELLY CONTEMPORARY, SANTA FE
RICHARD LEVY GALLERY, ALBUQUERQUE
PARKS GALLERY, TAOS

I don't think of the act of painting in verbal terms. It is a visual language that can express a range of sensations beyond the verbal.

When I hear a beautiful piece of music—say "Blue in Green" from Miles Davis's *Kind of Blue*—I get an odd sensation in my lower back. I feels almost like vertigo. The same happens when I see a great performance, or the style of the petroglyph panels in Barrier Canyon. I feel it when I view a special landscape or extraordinary painting by another artist.

I think that this "vertigo" feeling is a form of transcendence in which we experience a mystery beyond what we can understand. We are moved without conscious thought. We subtly change, view the world and react to it a bit differently than before.

My paintings are about creating a vehicle that allows one to experience that same moment of mystery, transcendence enlightenment—the magic that I feel.

Salt Creek Seeps #12 2003
Oil on linen, 60" x 57". Private collection.
All photos by Pat Pollard.

Salt Creek Seeps #11 2003
Oil on linen, 48" x 46.5". Private collection.

Roswell Artists-in-Residence (RAIR)
ROSWELL, NM

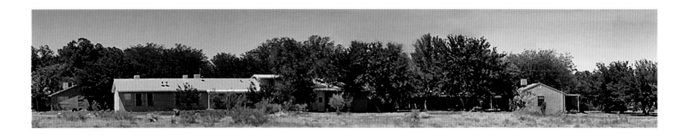

In September 1967 the celebrated painter and print-maker, WPA and war correspondent artist Howard Cook arrived in Roswell, New Mexico to begin a one-year painting residency sponsored by the Roswell Museum and Art Center. In the absence of permanent facilities Cook was required to undertake his residency in a rented house. Thus began the Roswell Artists-in-Residence Program, the brainchild of Roswell businessman and artist Donald Anderson to "have someone to talk to about art."

Howard Cook was the first of nearly two hundred artists who have benefited from this unique program over the past thirty-seven years. Over time those informal beginnings expanded to a complex of six houses and nine studios located on twelve acres of land. Each artist is provided with a house that can accommodate either a single person or a family.

Termed the "Gift of Time," the RAIR program offers grants of six to twelve months plus a stipend to the artist and family. The Program asks only that the artist make the most of the opportunity. RAIR has become one of the most desirable residencies available to visual artists. Participants are chosen through a highly competitive selection process based almost exclusively upon the quality of their work. The program's benefit to artists of all ages, stature, education, and experience has garnered such respect that it has become a model for new and existing programs the world over.

Text graciously provided by William Ebie of Taos, NM

The Anderson Museum of Contemporary Art in Roswell showcases works of art produced by alumni of the Roswell Artist-in-Residence Program. More than 300 diverse works of art enliven its seven galleries and 17,000 square feet of exhibition space.

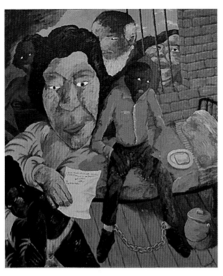

Robert Colescott, *A Letter From Willie*, 1987

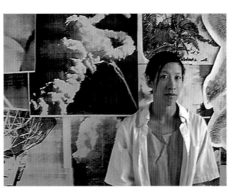

Guest artist Edie Tsong at her
photography exhibition, 2001.

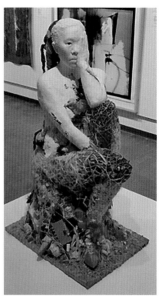

Yoshiko Kana, *Home
Sweet Home*, 1996

Robbie Barber, *Mobile Aire*, 2001

Kasper Kovitz, *Come on Boys Here's Good Water*, 2005

Jerry Williams, *Tell-A-Vision*, 1993

Diane Marsh, *Anton's Flowers*, 2002

Luis Jiménez, *Honky Tonk*, 1981

Meridel Rubenstein

LewAllen Contemporary, Santa Fe

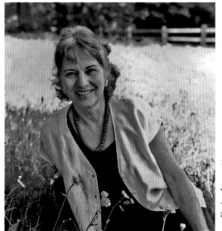

Evie Lovett

I've been trying to bridge the continental divide since I was born. Mother/Father, Detroit/Vermont, Vermont/New Mexico, US/ Vietnam, East/West. Place and the land on which it rests have meant everything to me. For over twenty years, I have mixed mediums and metaphors to make art about our tenuous connection to place. I combine still and moving imagery to suggest the possibility of change. Although trained as a creative photographer, my methods have expanded to include the use of potently charged materials and mediums to reinforce my content.

Gulf of Tonkin Coral Sutra
Robe, three Iris prints, 67" x 50".
All photos by the artist.

Prior to inventing photography, Louis Jacques-Mandé Daguerre experimented with the hyperreal diorama and a painted image that would circle the viewer. But I want the viewer to move, to circumambulate the image to get a sense of the whole. In my installations the whole space becomes the image. My technical strategies mirror the intention of the work; they help construct meaning and activate viewers. Without the three-dimensional space—a space for reflection and restoration—the images would just be photographs. Highly crafted, light-filled works can help create the necessary frequency to pierce hearts and open minds.

From the artist's essay about her work in the monograph *Belonging: Los Alamos to Vietnam*.

top
Bohr's Doubt 1991
12 palladium prints in steel frame, 80" x 66".

bottom
Oppenheimer's Chair 1995
Photo/video/glass installation, 9" x 7" x 10".

161

Ramona Sakiestewa

LewAllen Contemporary, Santa Fe

Making art allows me to work through philosophical ideas, scientific concepts, and emotional issues. It is ultimately my spirit made into tangible form.

Urban Galaxy 3 2004
Wool Tapestry, 46" x 45".
Collection of LewAllen Contemporary.

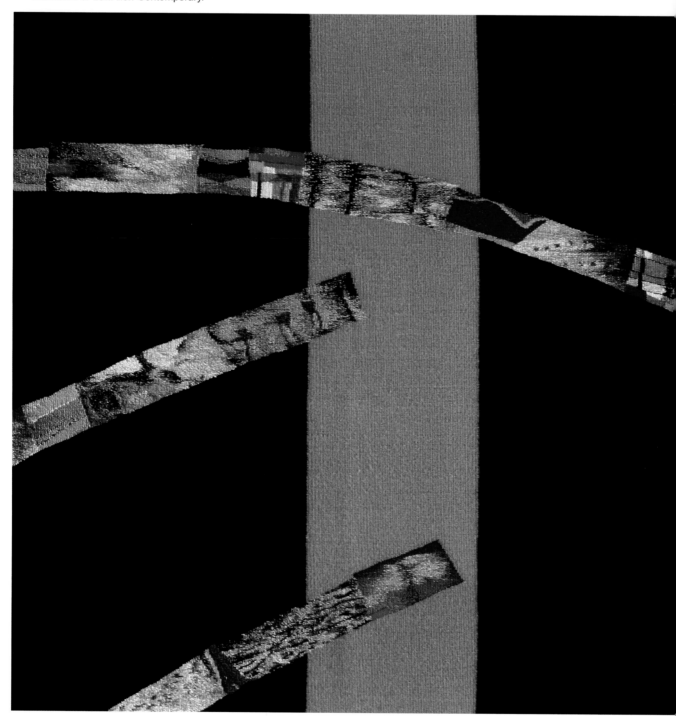

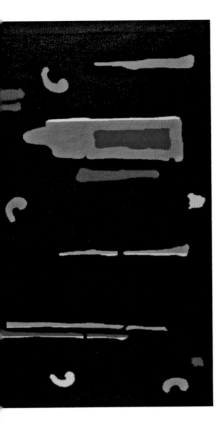

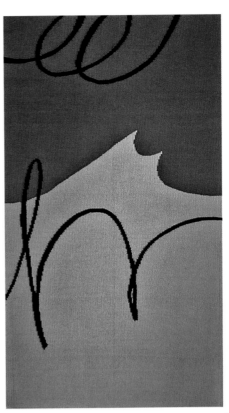

Shrine Series 1 1999
Wool Tapestry, 40" x 65".
Private collection.

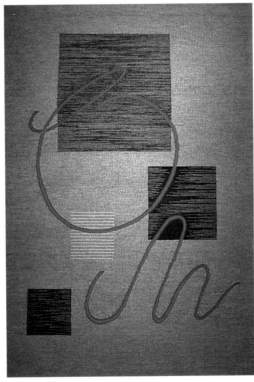

Migration 28 2002
Wool Tapestry, 43" x 25.5".
Collection of LewAllen Contemporary.

Migration 15 2000
Wool Tapestry, 65" x 45".
Collection of LewAllen Contemporary.

Untitled 3 2003
Wool Tapestry, 25" x 25".
Private collection.

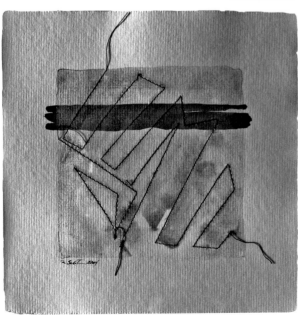

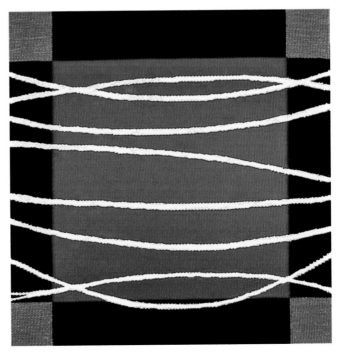

Shard 5 2004
Watercolor and thread on losin paper, 9.5" x 9.5".
Collection of LewAllen Contemporary.

163

Santa Fe Art Institute

Santa Fe Art Institute exterior entrance view.

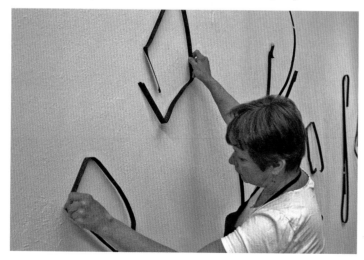

Image of artists working in studio during *RE – Connection*, a 2004 SFAI Artist-in-Residence program that brought together six artists from the former Yugoslavian Republic who now live and work in countries claiming differing cultural heritages and political conditions. The residency culminated in an exhibition at the University of New Mexico Art Museum in Albuquerque.

Artist-In-Residence Patricia Goodrich working in her studio, 2003.

The Santa Fe Art Institute (SFAI) was founded in 1985 by Pony Ault and the noted architect and artist William Lumpkins, both of whom sought to provide a unique opportunity for emerging artists to pursue a brief, intense period of study with critically acclaimed visiting artists. Richard Diebenkorn was SFAI's first Visiting Artist, and he became a major force in the establishment of SFAI, helping to attract both students and other Visiting Artists, among whom are such renowned contemporary artists as John Baldessari, Elizabeth Murray, Susan Rothenberg, Donald Sultan, and Joel-Peter Witkin.

Today, the Institute remains, as it was founded, an independent, educational, nonprofit organization. In 1999, the Institute moved to its extraordinary new facility. Designed by renowned Mexican architect Ricardo Legorreta, the nearly 17,000 square-foot facility has permitted SFAI to expand its mission and programming significantly. SFAI takes as its mission an exploration of the intersections of contemporary art and society. By bringing together prominent individuals and institutions in the arts, sciences, and humanities, SFAI enlivens local, national, and international discourse through residencies, lectures, workshops, publications, exhibitions, and educational and outreach programming. Nurturing artists and providing a stimulating, creative atmosphere for their work serves society in an essential way and gives artists the support necessary to take risks and explore possibilities. For young people, the arts allow creativity and innovation to be valued along with the traditional skills for learning.

In support of this mission, SFAI has developed a wide range of programs aimed at serving artists at various stages of their careers and diverse audiences. SFAI has evolved the original Visiting Artist Program into the Artists Lecture & Workshop Series—concept-based, multidisciplinary programs that run for eight months each year and include lectures, studio workshops, and exhibitions. The Institute offers artist and writer residencies of one to three months duration, as well as emergency residency programs such as the New York City Emergency Artists Relief Program, which provided respite for 130 artists displaced by the tragic events of September 11th. SFAI has initiated ongoing education and outreach programs that bring the arts and arts education to underserved audiences in the greater Santa Fe area. Collaborations with institutions and organizations such as the Palace of the Governors, Museum of International Folk Art, PhotoArts Santa Fe, The New Mexico School for the Deaf, and SITE Santa Fe, as well as with individuals representing a wide range of disciplines, further enhance programming and provide opportunities to engage the arts from a variety of perspectives. SFAI's Membership Program offers members at all levels a range of exciting benefits.

Photographer/Filmmaker Shirin Neshat (center left) and Filmmaker Shoja Azari (center right) instruct an Artist Workshop with artist Munson Hunt (left) and photographer Wendy Young (right), the first workshop in the *Transmit+Transform 2004* series exploring sound and light in the contemporary arts.

Each Santa Fe Art Institute room for visiting artists, workshop participants, or artists-in-residence comes with a private bath and bed, furniture, courtyard, access to laundry room, communal kitchen, and lounge. Thoughout the year artist residencies are offered, each from one three months in duration.

Peter Sarkisian

LINDA DURHAM CONTEMPORARY ART, SANTA FE

The artist with *Dusted*, 1998.
Mixed media and video projection, 33" x
33" x 29.5". Collection of The Museum
of Modern Art, San Francisco.
Photograph by Bill Wade.

Some critics interpret Peter Sarkisian's work as renouncing the mass culture of TV. Perhaps. But it seems more to the point that his work is about the different ways we see time. Setting aside the cultural keystones of our era and its monuments, Sarkisian's work suggests that time isn't about objects, it's about issues. When we look at a sculpture or photograph or painting, we usually think of it as looking at objects. But if we see past the medium the way that Sarkisian sees past it, his work no longer depicts a thing, it becomes a container consecrated by geometry.

Sarkisian's work is visual poetry, true enough, but much more so is it a philosophy of a visual, rather than a spiritual, attitude toward continuity. One comes away from his work sensing that, except for where the dates are placed on a calendar, the past and future are really the same thing. At our deepest and most irreducible still point, around which all the rest of our existence turns, we are time's equivalent of optical illusions. Sarkisian chases after what we *are* at that still point. It is our good fortune to behold what happens when he gets there.

Comments and captions written by the editor at the artist's request.

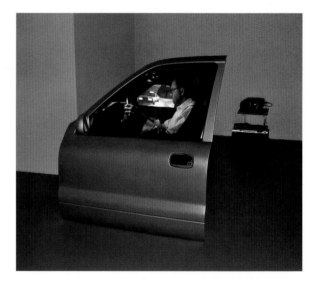

Top
Waters 2003
Installation view, mixed media and video projection, 32" x 23" x 17.5".
All three photographs by the artist.

Center
Registered Driver 2004
Installation view, mixed media and video projection, 30" x 36" x 9".

Bottom
Blue Boiling In Pail 2003
Installation view, mixed media and video projection, 12" x 12" x 9".

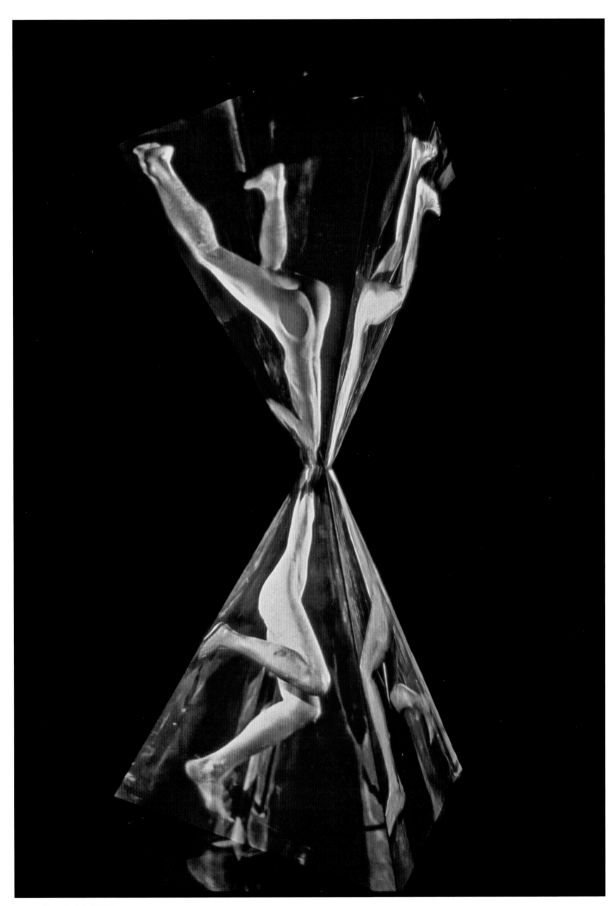

Manifold 2002
Installation view, mixed media and video projection, 11' x 6' x 6'.
Commissioned by The Duam Museum of Art, Sedalia, MO, and Rodney and Rebecca Hartman.
Photograph by Kevin Sisemore.

Jane Sauer
THIRTEEN MOONS GALLERY, SANTA FE

Most of my work concerns the unseen but ever-present and powerful world of human emotions and how they interrelate. When I see or feel something that really strikes me viscerally and intellectually, I roll it around in my mind's eye for a while. An idea eventually percolates into three-dimensional forms. Not very many of these inspirations end up being completed work. Because it takes so long to make a piece, I always have many more ideas than I have time to actualize.

My ideas tend to be more complex than what I like to experience visually. I have to look at what I plan to construct and decide if the idea can portray an entire thought process in a few simple shapes and forms. A mix of confusion and distillation repeats over and over again. Labor-intensive construction, such as building one knot after another to create a cohesive structure, is a meditative process. I become completely absorbed with the piece and feel almost at one with it as it becomes art.

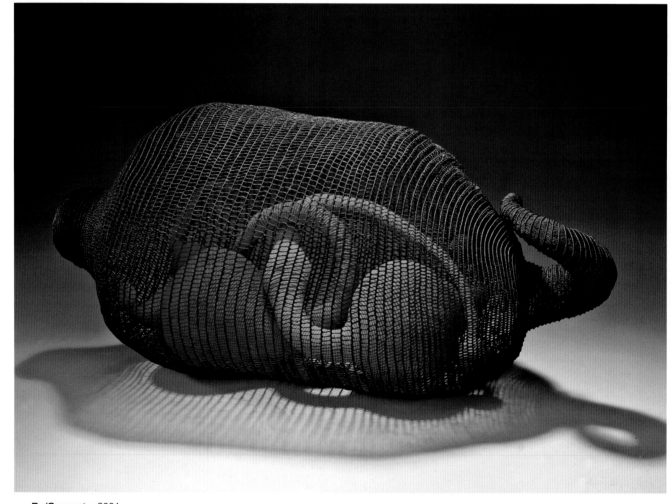

Re/Generate 2001
Waxed linen, pigment, wire; 39" x 18" x 17".
Collection of Barbara & Eric Dobkin.
Photo by Wendy McEahern.
The theme of people and relationships has run through the thirty-five years of my professional art career. My passion is constructing with linear elements, and has been since 1972.

168

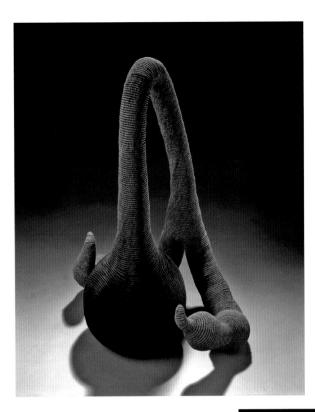

Chamisa 2001
Knotted waxed linen thread and paint; 22" x 16" x 17".
Collection of Museum of Arts & Design, New York, NY.
Photo by Wendy McEahern.

From the time I was in grade school I obsessively made art. When I was in junior high, I was making realistic portraits. By high school I knew I was going to be an artist.

Not So Independent 2001
Knotted waxed linen thread and paint; 22" x 14" x 13".
Collection of the artist. Photo by Wendy McEahern.

At Washington University I deeply desired to be taken seriously, so I declared myself a painter. But in reality I was a closet materials-based artist. Jack Lenor Larsen's book *Beyond Craft: The Art of Fabric* revolutionized the way I viewed my first love, fibers.

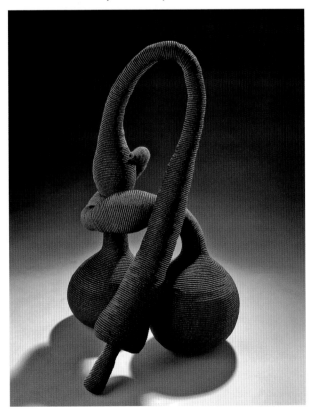

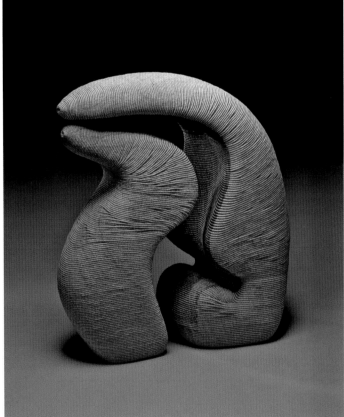

Tender Moments 1998
Waxed linen thread and paint; 24" x 22" x 11".
Collection of Laura and James Hageman.
Photo by David Kingsbury.

169

Arlene Cisneros Sena

MEDICINE MAN GALLERY, SANTA FE
BLUE SAGE GALLERY, SCOTTSDALE

I grew up in a traditional New Mexico Catholic home. The first art I was exposed to was devotional art.

My parents were from northern New Mexico and southern Colorado, where the *santero* and religious icon traditions originated. I remember seeing *santo*s many times, but not really paying much attention to them.

As an adult I began volunteering for Spanish Market and the Spanish Colonial Arts Society. My husband said, "You really should be showing in the market." Frankly, I was pretty intimidated by it and wasn't sure I knew enough.

Then I took a workshop at the Folk Art Museum conducted by Charlie Carrillo. The second day we were to complete a traditional *retablo*. So I was introduced to the traditions and the traditional way of working early on.

A saint is a saint and each has its personal iconography. Hence there are certain things you must do with a particular saint's imagery. In New Mexican history only about thirty saints were traditionally done. The early *santero*s were not artists. They were holy men taught to use specific materials to make an image. Technique and "art" as we know it are less important than the saint as an image to behold.

I don't view the saints as superhuman or place them on a pedestal. I view them as extraordinary people who led very special lives. I form a personal bond with some pieces and it is difficult to let go. The bond grows from both the subject I have chosen to work with and the piece itself as it gradually takes form and shape. I love the process of making an image. I'm uncomfortable about talk that I have a "gift." I was chosen to do this because it is what I was meant to do. I am happy to share; that is enough.

There are two sides to this art, the spiritual and the traditional. I am very proud of New Mexican religious traditions. My mother taught me how to pray, and I know that she was very proud that I went in this direction; I hope that my son and daughter pass that on to their children.

A *santo* image reminds us to emulate the life of that saint, and embrace him or her as a role model. We ask the saints for their help. The *santero* tradition is rooted in faith and family. I do the work to pass on a spiritual tradition.

Nacimiento de Jesucristo 2004
Natural pigments, homemade gesso, pine sap, varnish, and 23K gold leaf on sugar pine; 10" x 10".
All artwork photos by Chris Corrie.

La Divina Pastora 2004
Natural pigments, homemade gesso, pine sap varnish and 23K gold leaf on sugar pine; 20" x 34". Collection of Luis Armijo.

Los Tres Reyes Magos 2004
Natural pigments, homemade gesso, pine sap varnish and 23K gold leaf on sugar pine; 11" x 19". Collection of Brian Hackethal.

La Sagrada Familia, 2001
Natural pigments, homemade gesso, pine sap varnish and 23K gold leaf on sugar pine; 14" x 26". Private collection.

Los Protectores 2004. An altarscreen dedicated to protectors of the home and family. Natural pigments, homemade gesso, pine sap varnish and 23K gold leaf on sugar pine panels; 4' x 6'. Private collection. *Left top*: **Santa Ana**, patron of mothers and grandmothers, family needs, women in labor, housewives, horsemen. *Left center*: **La Conquistadora**, acceptance of death, help in danger, protection against accidents. *Left bottom*: **San Francisco de Asís** (Patron of Santa Fe), peace and reconciliation within the family. *Middle top*: **La Santísima Trinidad**, favors of immediate need, harmony and peace; protection against enemies. *Middle center*: **La Sagrada Familia**, patron of the family. *Middle bottom*: **Los Arcángeles**, **San Rafael**, patron of travelers; **San Miguel**, guardian of small children, patron against evil. **San Gabriel**, protector of children, parents and teachers. *Right top*: **Santa Bárbara**, patroness of the home, against fire and lightning. *Right center*: **Nuestra Señora de la Luz**, protection against storms, reliever of all ills. *Right bottom*: **San Antonio de Padua**, finder of lost articles, lost animals, those in peril, against fire, patron of the home.

Sherri Silverman

TRANSCENDENCE DESIGN, SANTA FE

Subtle levels of the mechanics of creation and various forms of symbolism spontaneously dance across all these pieces of paper. My art explores my inner images and the images I see in nature, books, and art. My inspiration comes from quiet interior states, meditation, and contemplative creative time. My intention is to create work that expands and enlivens consciousness, that nourishes and is a wonder to others and myself. Like Matisse, I wish my art to heal people and evoke greater happiness and wholeness in the world.

Ladders of Light #3: Kali Yantra
1990
Pastels on paper, 42" x 31".
Ladders symbolize the pathway to communion with the divine: Jacob's ladder in the Judeo-Christian tradition, Horus' ladder in Egyptian mythology, the seven-runged Mithraic ladder, the shamanic pole. Kali represents time and transformation. Downward pointing triangles are an archetypal symbol of the Feminine Divine; concentric triangles are a traditional way of expressing how the Unmanifest emerges into the physical world in ever-increasing waves of manifestation from the bindu point, the junction between the unseen and the seen.

Ladders to the Moon 2002
Pastels and pencil on paper, 24.5" x 24.5".
The chair in the sky represents an experience I had in meditation where I was clearly in the chair with my feet on the ground but also up in the sky with the stars all around me. These ladders provide a pathway to the full moon, which represents inner spiritual fullness.

BMoCA #18: Earth Goddess 2001
Pastels and pencil on paper, 5" x 5". Private collection, Colorado.

BMoCA #22: Intersection of Time and the Timeless 2001
Pastels and pencil on paper, 5" x 5". Private collection, California. Exhibited and sold 2002, "Western States Small Works," Sonoma Museum of Visual Art, Santa Rosa, CA.

Two weeks after 9/11, I was Artist in Residence at the Boulder Museum of Contemporary Art. I could only think of depicting what is really important in this life: joy, the divine, subtle levels of the creative process, healing and service to the world. BMoCA was noisy and active with deliveries, museum visitors asking questions, and staff hanging a show. Working much smaller than usual allowed me to maintain composition and focus on development of these little icons.

173

Marsha Skinner
PARKS GALLERY, TAOS

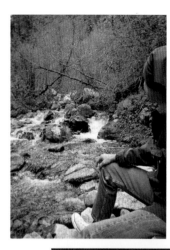

My paintings are about the reconciliation and
integration of opposites.
 Form / formlessness;
 Darkness / light;
 Movement / stillness;
 Hard / soft;
 Change / changelessness.

In these are everything I have loved to draw—
 dance,
 the earth and sky,
 clouds,
 rocks,
 water,
 fire,
 growing
 things.

Changes I 2004
Oil on canvas, 36" x 36". All photos by Pat Pollard.
To make the paintings it is first necessary for me
to sit a lot by falling streams, drawing water.

Winter Painting 8/2004
Oil on canvas, 36" x 36".
My paintings are not finished until they seem to
breathe, until—seen indirectly from the corner of my
eye—they appear to have become living creatures.

Jaune Quick-to-See Smith

LewAllen Contemporary, Santa Fe

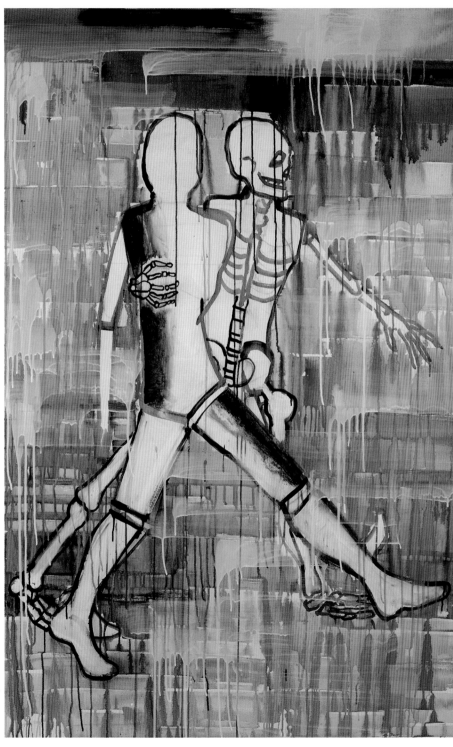

Waltz 2004
Mixed media on canvas, 72" x 48".
All photos by Dick Ruddy.
Everyone moves through life
in an inevitable waltz with death.

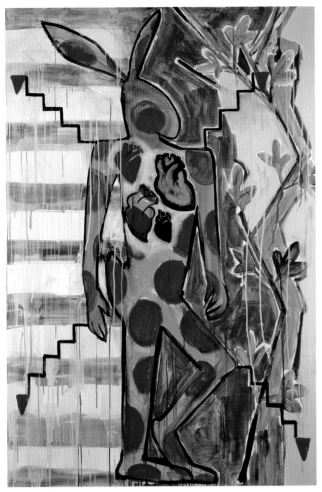

Mixed Blood 2004
Mixed media on canvas, 72" x 48".
Rabbit, often a trickster, acts as a stand-in for a mixed-blood,
whose four hearts represent being an emissary between cultures.

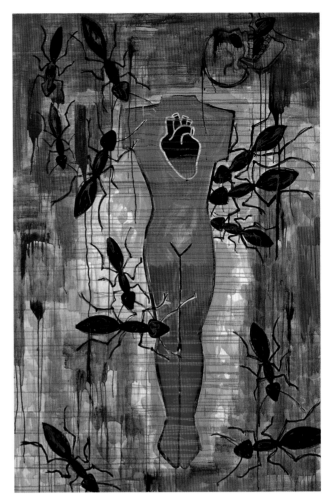

Which Comes First 2004
Mixed media on canvas, 72" x 48".
No death is permanent because all life is recycled so that
eventually the human becomes molecularly part of the ant
and vice versa.

Jaune Quick-To-See Smith is considered one of the most
outstanding artists of her generation and one of the most
acclaimed American Indian artists today. Smith melds the
Native American aesthetic traditions of the past with modern
and contemporary art ideals and conceptual concerns. Her
paintings and printmaking meld text, symbols, figuration,
and abstraction to make statements about American Indian
history and culture, American politics and society, and
nature and the cycle of life.

Smith is an artist, activist, independent curator, teacher,
and lecturer. An enrolled member of the Confederated Salish
and Kootenai Tribes of the Flathead Nation, Montana, her
heritage includes Flathead Salish, Metis (French-Cree), and
Shoshone. Smith's works express issues of personal identity
and Indian life today through the depiction of icons
meaningful to her tribe. She consciously adopts and com-
bines the visual languages of Native American traditions
and twentieth-century European and American art.

The celebration of birth, life and death is the focus of
Waltz (2004), in which a skeleton dances with a stylized fig-
ure reminiscent of a segmented Iroquois sculpture. Rather
than being fearful of the skeleton, obviously representing

death, the figure accepts the dance and makes the transi-
tion from one world to another.

The whimsical painting, *Mixed Blood*, 2004 relates to
Smith's observations of nature, and the strengths in the peo-
ple she admires. In particular, the painting honors her
cousin, Gerald Slater, the founder of the Two Eagle River
School and the Salish Kootenai College. Through this work,
Smith expresses her belief that understanding and peace
comes about when people work together as one people with
many hearts, dispensing with notions of hierarchy, warfare,
and conquest.

In *Which Comes First*? (2004) Smith speaks about the
cycles and sources of life. The central figure is a headless,
armless body floating in an abstract background, painted
in a manner to indicate the body is slowly losing its life,
while large ants feed on it. Another ant emerges from the
jaws of a skeleton at the upper right of the composition. To
Smith, this is not a gruesome or fearful scene, but a reflection
of life. Viewed through the perspective of Native religious
ideology, Smith's art celebrates life and our precious earth.

Contributed at the artist's request by Julie Sasse,
Curator of Modern and Contemporary Art,
Tucson Museum of Art.

Richard Zane Smith
BLUE RAIN GALLERY, TAOS AND SANTA FE

Richard Zane Smith, *Yusé ata* (earthenvessel)
enrolled member of the Wyandot Nation of Kansas
and of the greater Huron (Wendat) Confederacy.
Photo by Scott Plunkett.

ho'wahi tsatrihute, Sondaichichia!
(come listen Earth Maker!)
i know why i was born

when i hold earthclay in my hand
vast secrets open their petals
When YOU embrace the earth mother
in warm mutual rythmic passion
your earth/spirit children are born

i'm a spitting image of you and mom
my hands hold this soft yielding clay
with tenderness and sparks flying
we collaborate we scheme together
pulling and pushing wrestling tumbling
till another child breaks forth

a laughing scraped-knee child
born of love and sweaty tears
as i also was born and raised
and in this clay soft and trembling
i see the faces of my ancestors
and children yet to come

i know why i'm here!
Tizhamé tuh skénön'
Yusé ata

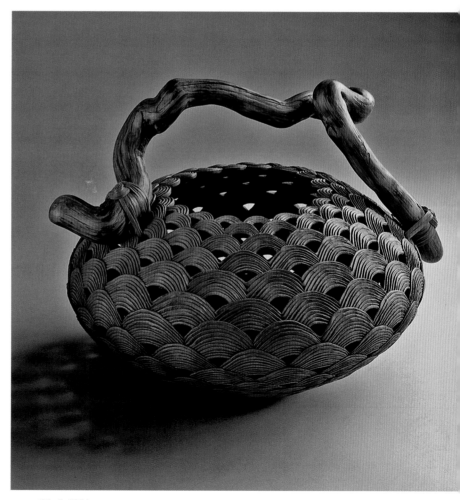

untitled 2004
Natural clay with spruce root and leather handle, 12" x 14" dia.
All photos courtesy of Blue Rain Gallery.

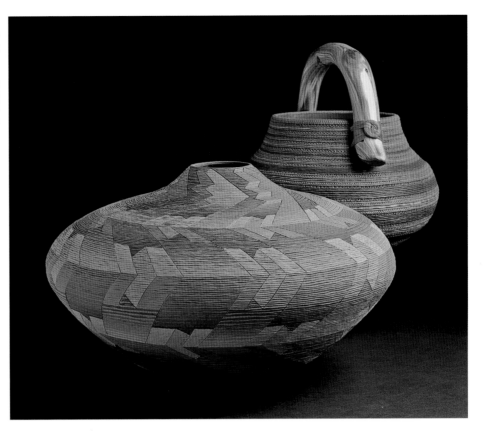

foreground piece
untitled 2002
Natural clay, 16" x 20" dia.

background piece
untitled 2002
Natural clay with juniper and
leather handle, 10" x 11" dia.

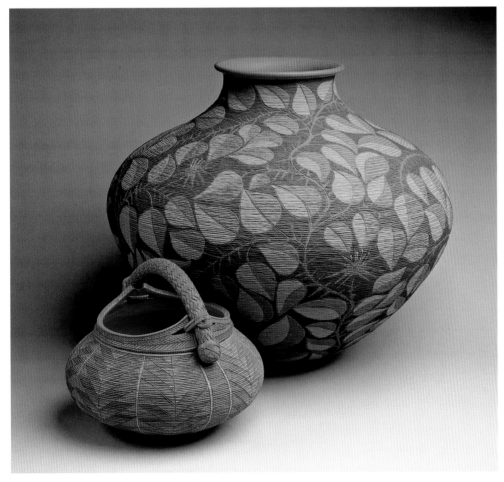

foreground piece
untitled 2004
Natural clay and leather, 6" x 8.5" dia.

background piece
untitled 2004
Natural clay, 18.5" x 14.5" dia.

Mark Spencer

STUDIO GALLERY, SANTA FE

My art is about the ineffable mystery underlying what we take for granted. It's about the constant, unrelenting change and growth of our time. It is about the Divine in the mundane.

Central to my art is my obsession with the forces of nature and history. They demonstrate to me the relationship between the personal and the universal. I wrestle with our culture's gross contradictions, turmoil, and trouble. I seek relevant metaphors that I hope resolve these tensions. By looking beyond the face value of an experience, I discover the image of a timeless event. Each picture is a stage upon which the event is articulated. If I'm lucky, the viewer will feel a little closer to the passion and beauty of life.

Tempest 2003
Oil on canvas, 48" x 48".
Collection of Michael Hurlocker, Santa Fe.
All photos by Wendy McEahern.

Inner Circle 2001
Oil on canvas, 48" x 48".
Collection of Billy Baldwin, Albuquerque.

Requiem 2000
Oil on canvas, 78" x 90".
Collection of Dr. Robert Bell.

Mind Altar 1999
Oil on canvas, 44" x 48".
Collection of Valerie Fairchild, Santa Fe.

Earl Stroh

FENIX GALLERY, TAOS

Jennifer Lynch

I paint pictures because I need to. Have been since I was a kid. Most of my paintings originate in quick line drawings. I call them "shorthand sketches." Then when it comes to translating the drawings into a painting, I am very exacting. It usually takes a long time before I am completely happy with a piece. Taking time to get it exactly right has been my method since I started doing serious art at the age of thirteen.

When I lived in Paris in the late 1940s I would make quick pencil sketches on the spot, then develop them into a more elaborate work later. During what I call my Texture Period, when I used a lot of impasto, the rhythm of the act of painting generated the shapes, forms, and colors. I'm never so productive as when I'm going to have a show.

My advice to people who look at art is, Look!–Look!–Look! And after the first three looks, look *carefully*. There are two words, to look and to see. Chicken or egg, it's hard to say which comes first, so I say, Both!–Both!–Both!

When I was thirteen I ran into a really good art teacher in public school in Buffalo, which in those days was *really* rare. It's rare now, but in those days it was unheard of. She worked at the Albright Museum and sometimes volunteered to teach at the public school. She decided I had, quote–unquote "talent," and sent me out to a children's class. For two hours a week after school we would sit around on stools at the Museum of Natural History and draw the stuffed animals. The teacher at the Museum was a student at the Art Institute of Buffalo. She decided I should join the Saturday morning high-school class taught by one of her own teachers. After a couple of weeks he arranged for me to come to the Art Institute. I was thirteen at the time, the only kid in a room full of adults. That experience was it! Going back to regular high-school day classes bored the hell out of me.

When I got to high school I'd go to school all day, go home for supper, then go back to the Art Institute for evening classes. They gave homework, which I couldn't do in the evening. So I'd do it in the one study hall period of the day. Instead of shooting spitballs like the other kids, I'd do my homework.

By the time I was nineteen, I was teaching at that Art Institute. I went to Europe in the very early Fifties. Spent a couple of months in Madrid, across Southern France into Italy, up to Switzerland, Paris, London, and back here.

In 1948, I had my first show, in Taos. Artists like myself who had graduated with Master's Degrees couldn't get jobs. So I thought, "Give up that, you're going to be a painter." I'd come back from Europe with a certain Cezanne way of seeing things. When I got back to Taos to work as a tutor, it took a couple of years for me to find my own path.

Allegro Ma Non Troppo 2004
Intaglio solar plate etching, 12" x 12".
No matter how I start a work, the work itself tells me when to stop.

Quiet Scherzo 1980
Lithograph, 18" x 25".
I am fascinated with the ambiguities of light and space—Sung Period Chinese scrolls, for example—although less so with the Japanese. They can't quite seem to get over decoration. The most interesting works for me were when Japanese paintings closely resembled their woodcuts.

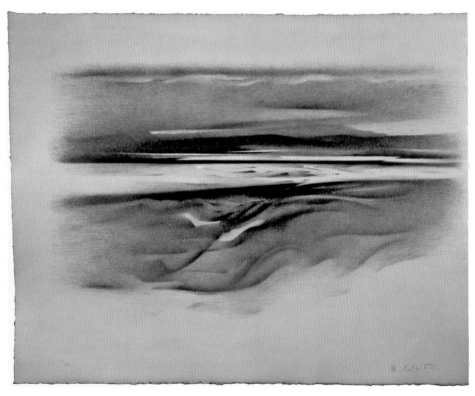

Opposite
Celebration ca. 1984
Oil on canvas, 25" x 30".
All photos courtesy Fenix Gallery, Taos.
I call my working process "Ingres"-ing the subject. Ingres once said, "Talent does what it wants. Genius does what it can." I don't pay much attention to what people think of what I do. I just do it.

Mary Sweet
DARTMOUTH STREET GALLERY, ALBUQUERQUE

I am interested in the effects of light upon the land, the patterns of sunlight and shadow, the nuances of color and distance, clouds and moods, on the landscapes of the West's mountains, canyons, rivers, deserts.

People tell me, "You can't be a serious artist and paint landscapes anymore." The art world and society have become so thoroughly urban they seem to consider the land irrelevant, though we still depend on it for everything. I have done other subjects but always come back to the landscape. Even so, I have no interest in painting it traditionally.

I always drew and painted. I was born and raised in Ohio, went to Stanford University in California and have lived many years in New Mexico. I have never been to Europe or Asia but I have been to many of the remote areas of the West. I have hiked, backpacked, camped, skiied, and been down rivers. These are the places I love and paint. I have seen the downside of Nature—been flash-flooded, snowed-in in the back country, and at times very scared. But I've also seen how these places expand the spirit and inspire us to be better than we are, to appreciate the wonders of the earth we live on. This is what I paint.

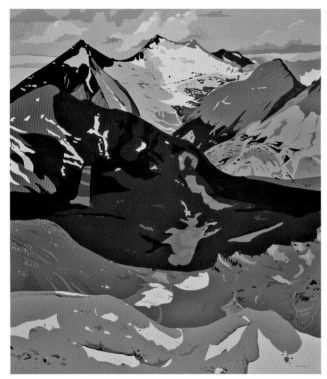

Snowmass Mountain 1997
Acrylic on canvas, 54" x 48".
Collection of the artist. All photos by Pat Berrett.
This is the view of Snowmass Mountain from the top of Buckskin Pass in the Maroon Bells – Snowmass Wilderness Area.

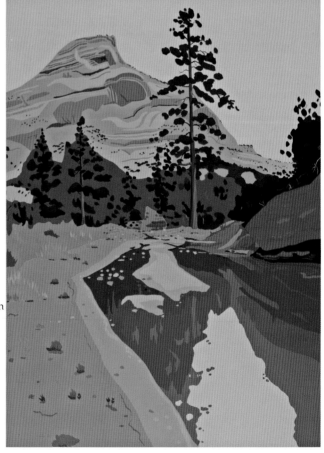

Woodenshoe Canyon 1997
Acrylic on paper, 30" x 22". Collection of the artist.
This is a very pretty high-altitude canyon in the very remote Dark Canyon Wilderness Area.

Cathedral Lake Summer 2004
Acrylic on Canvas, 48" x 60".
Collection of the artist.
Cathedral Lake, in the Maroon
Bells – Snowmass Wilderness is
one of my favorite places on
earth.

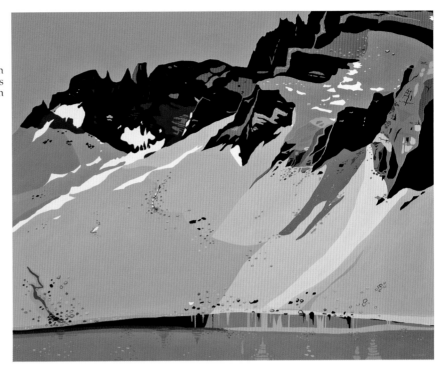

Coyote Natural Bridge 1997
Acrylic on Canvas, 36" x 48".
Collection of the artist.
Coyote Natural Bridge is in a tributary canyon
of the Escalante River in southern Utah. Over
the last fifteen years I have hiked almost the
entire Escalante.

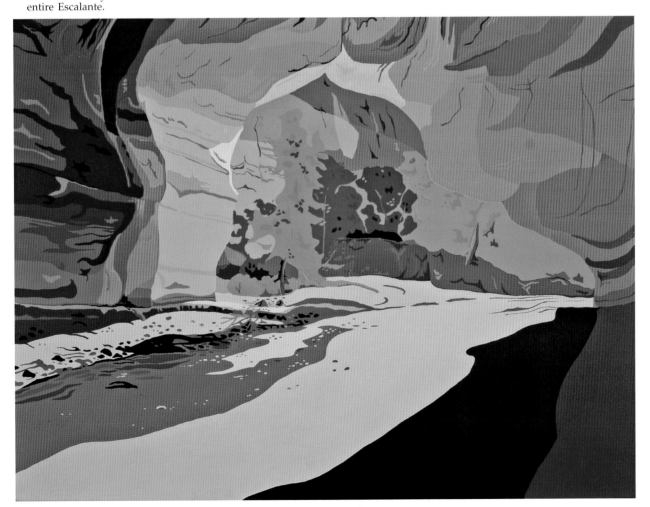

Roxanne Swentzell

Hahn-Ross Gallery, Santa Fe

My art is about the emotion of being human. I feel the world around me very strongly and need to tell people about it. I want my art to bridge the gaps between the "inside" and the "outside"—between individuals, races, sexes, between humans, and the rest of the world. Even though I make a given piece at a particular point in time, it is made of human emotions and by that it is timeless.

My mom potted so I was around clay all the time. I had a speech impediment so I had to communicate in other ways. I started making figures that depicted what I meant. One time I made a clay figure of a little girl crying to communicate that I hated going to school. I made hundreds of these figures. At first they were tiny, but as I learned how to pinch them in the clay better, they got more elaborate. By junior high school they had grown so large that I began to hollow-build them. I am still communicating with figures—communicating women, my culture, humanity. I try to say things to the world by crossing cultural boundaries. People from all over the world see this in my work. They are my ultimate communication.

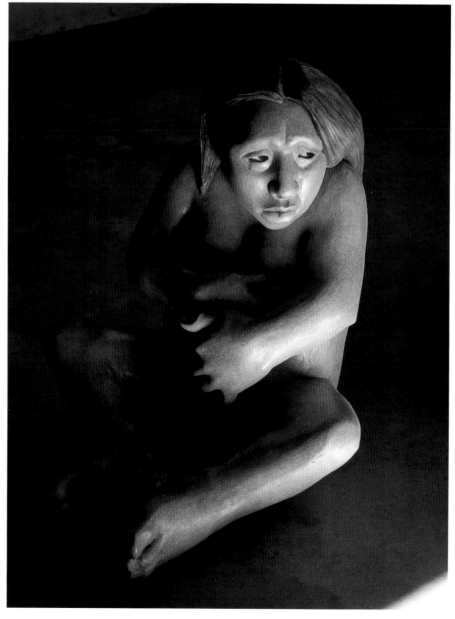

Loss 2002
Ceramic, 15.5" x 11" x 15".
All photos courtesy Hahn-Ross Gallery.
I sculpt emotions. Emotions put us in touch with our own centers. I put into my work what I hope others will understand about how I see and feel.

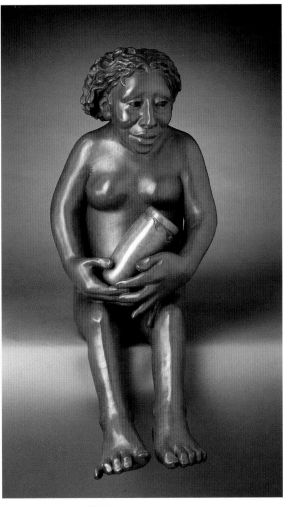

The Occasion 2003
Bronze, edition of 20, 23" x 10.5" x 14.5".
Remembering is important. Tradition imparts the spiritual in us. We develop a special way of thinking and being.

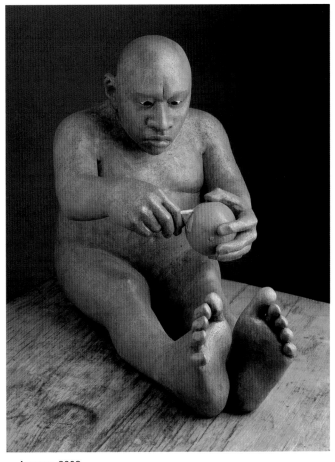

Layers 2002
Ceramic, 17" x 10" x 23".
In the pueblo we have a different way of living. We have a close sense of ourselves and our environment. There is much to study in the old Indian ruins around us. We try to hold our culture together in a modern world. We keep alive old traditional crafts and ways of using plants. American Indian peoples come here from all over the country to learn from us. When I am with my people, a whole philosophy spreads over my life.

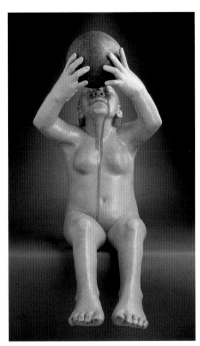

Spilt 2002
Ceramic, 23" x 11" x 14.5".

Luis Tapia

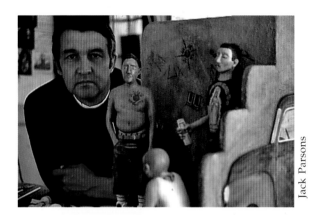

Jack Parsons

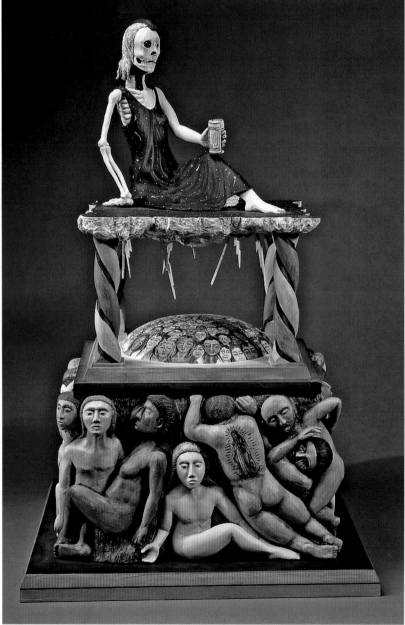

above right
**Northern New Mexican Woody
(Penasco Truck)** 2002
Carved and painted wood,
11.75" x 30.5" x 12.75".
All photos by Dan Morse,
Firefly Studios, Santa Fe.
I learned a long time ago that I can't satisfy
everyone. Even rejection can be positive
because I know that I inspired a reaction
to my work.

below left
**Dona Sebastiana Relaxes After
a Hard Day at the Office** 2003
Carved and painted wood, 35" x 22" x 20".

188

My art is rooted in a tradition of Hispanic folk art that dates to 17th century New Mexico. I want to bring that tradition up to date to both reflect and comment on important contemporary religious, political, and social issues.

I discovered traditional Hispanic folk art during the 1960s and 1970s civil rights movement after learning about the attempts of Reyes Lûpez Tijerina to reclaim Spanish land grants in northern New Mexico, and the plight of Chicano farm workers in California. Their activism motivated me to learn what my culture was really about. I knew we had our own art and music because I had lived with them all of my life. But I was never fully aware of their true cultural context.

I began to carve small-scale nude sculptures at first. Then, after studying the traditional art of my culture, I turned to religious art. Eventually my work began to address social and political issues as well.

I am lucky that most people seem to understand the combination of craftsmanship, history, and culture that makes my work unique.

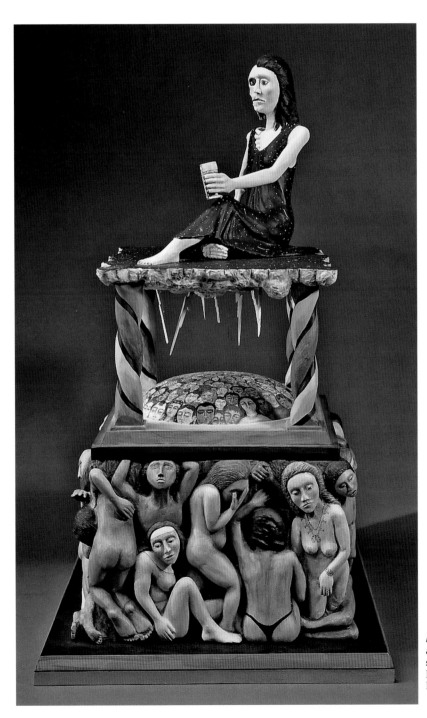

Dona Sebastiana Relaxes After a Hard Day at the Office (obverse side of page to left)
I want my work to speak for itself. In doing so, it also speaks for me.

189

Sergio Tapia

OWINGS-DEWEY FINE ART, SANTA FE

Jennifer Esperanza

Tezcatlipoca Brings Doom 2003
Carved and painted wood, 23.25" x 13.75" x 13.75".
My father has been my main artistic influence. I first
entered his studio at the age of five and began to learn
the traditional New Mexican methods of saint-making. I
was inspired early on by books he gave to me about
the Renaissance masters, Goya, and Dalí. Later I became
interested in the contemporary art I saw with friends of
my father—the constructions of Rudy Fernandez, soft
sculptures of Gary Mauro, the seemingly effortless and
free stylings of Gilbert "Magu" Lujan, and the precisely
researched and detailed paintings of Paul Pletka.

El Corazon Mande 2002
Carved and painted wood, 35" x 30.5" x 7.5".
All photos by Dan Morse, courtesy of Owings-Dewey Fine Art.
My work transforms and extends the three-hundred-year old
New Mexican *santero* tradition, using modem and bold imagery
to express religious and social commentary deeply rooted in
our cutural history. I seek narratives that speak to far-reaching
issues in society today.

Tezcatlipoca Brings Doom (interior)
My pieces begin randomly. Something I see or read—even
a conversation—brings an idea to light. At this point I often
do several drawings, jotting in notes about dimensions, colors,
engineering (a single image might contain thirty or more
pieces of wood), and assembly. Then the carving. I use a
large variety of hand and power tools—chisels, grinders,
dremels, and so on. Then come several stages of sanding and
priming with gesso. I paint with acrylics, often enhancing
details with gold and silver leaf.

Super Chicano 2003
Carved and painted wood,
18.5" x 13.875" x 13.875".

This piece was inspired by a Chicana/Chicano, Latina/ Latino art symposium. I noticed how so many people invent and rely on labels to define themselves. Instead of relying on their own personal experiences they turn to general and rather simplistic symbols of their heritage.

In the American Hispanic community there are a multitude of different backgrounds and cultures— Mexican, Spanish, Cuban, Boriqua (Puerto Rico), Chicano (Mexican-American), Centro-Americano (Guatemala, Panama, etc.), and so on. After awhile the profusion of identities can get ridiculous—people call themselves "Latino" even though they aren't from Rome and don't speak Latin.

Within any one of these word-geographies there are even narrower social, economic, and racial distinctions. The term "Chicano" used in this work can mean "Mexican-American," "migrant farm worker," "*Mojado*" (Wetback)," or "*Patitos*" ("little feet" or illegal immigrant).

To me distinctions like these seek identity going the wrong way on the highway. They have homogenized their own histories to the point where they forget that they are all part of a great unity—we all speak Spanish. That's why I use "Hispanic," meaning "from Spanish descent."

Many identify with the word Chicano because they look to the 1960s social movement for guidance. Not a bad place to start, but too brief a historical sample. A complete sense of history has roots going back further than our parents, grandparents, and great grandparents, even though they have the most traceable effect on who we are.

Each generation is made of stories passed down within families. My own family came to what is now New Mexico four hundred years ago with the explorers and *conquistadores*. Although it is an ugly history to the peoples they conquered, it remains my history. The same will be true for my own great grandchildren, and they will probably have as great a sense for me as I do for my own grandfathers.

What has this got to do with the work in this picture, *Super Chicano*?

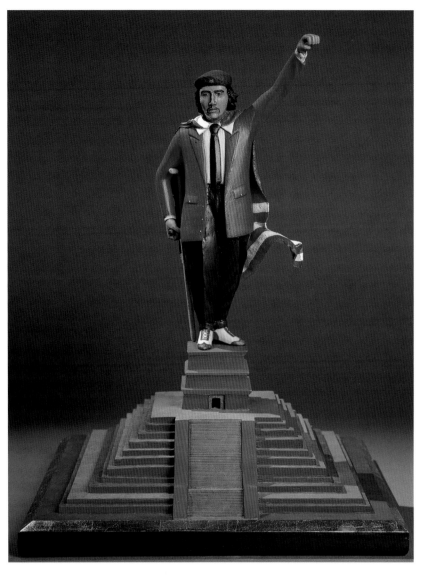

For years I have watched the repetitive use of a small image vocabulary construct a homogenous, commercialized version of Chicano identity. The vocabulary inspires countless paintings of Ché Guevarra, Frida Kahlo, Emiliano Zapata, and so on. Yet not every woman painter is a Frida nor every male painter a revolutionary. What use, then, is the vocabulary?

Super Chicano is meant to make the user of stock Chicano icons stop and compare the icon versus the realities of their own experience. This icon wears a Zoot Suit in the red, black, and white colors of the Royal Chicano Air Force and the United Farm Workers. He wears their symbolic brown beret. His face is Ché Guevarra's. He holds the uplifted arm and fist of brown pride. He stands atop an Aztec temple (the mythic cultural root of the Chicano—an ironic reference to siding with the native ancestors rather then the Chicano's actual *conquistadores* ancestry.) He wears a cape of the Mexican and American flags to show his present bicultural history—another irony considering the amazing number of third or fourth generation Chicanos identify themselves as "Mexican" even though they have never been to Mexico.

The sum of all this is *Super Chicano*, a glorious, idealized character that has a mythic life but not a real one. From the looks of him and his stance, he will stand through adversity as a savior to all Chicanos, thus elevating all of them mentally, spiritually, culturally, and socially.

That's the surface I painted on the work. Now let's give *Super Chicano* a deeper look.

Notice the crutch and the chip on his shoulder. These represent blaming "the Establishment," "the Man," or "Society" in general for the quality of their lives. It is easy to blame others for what we won't do ourselves, and that mentality goes against everything that I observed growing up in New Mexico, with its long line of successful Hispanic politicians, businessmen, teachers, and artists. Such people know we build our lives with deeds, not complaints.

Super Chicano says that you cannot dwell on the differences while ignoring the commonalities, cannot extol a separatist attitude and then complain when excluded. *Super Chicano*'s message is for people who pick and choose the stereotypes they wish to reinforce. That is *Super Chicano*'s crutch. I intended this piece to be a red light, a jolt to people to get them to really think about their rhetoric, search for their personal truth, and not be bought off with less than the whole truth. In short—toss the crutch, brush off the chip, and get to work with the rest of us.

191

Mayé Torres

MAYÉ TORRES STUDIOS, CARSON, NM

Miguel Gandert

Our Lady of the Un-Holy Bomb 2004
Drawing, 60" x 40".
Collection of the artist. Photo by the artist.
Art is not bound to verbal language and allows the
expression of sacredness to unfold.

Peltier & Papillion 2004
Drawing, 40" x 54".
Collection of the artist. Photo by the artist.
I began making mud pies at an early age
and continued from there.

Losing Marbles I 1998
Drawing, 40" x 60".
Collection of Amon Carter III, TX. Photo by Pat Pollard.
I like to synthesize ideas, thought, and form; create
illusions to ignite a conundrum within the self.

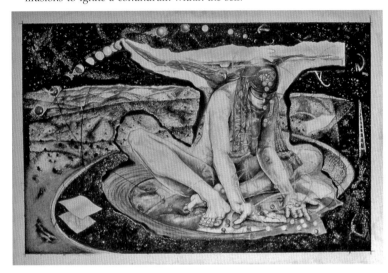

ART is:

a remembrance of the soul,
an oasis for the mind,
a voice for the people,
a voice for the quiet,
an answer before the question,
a union of idea and form,
an exquisite expression of self,
a mindful-ness and mindless-ness,
a discipline, a meditation,
a prayer,
an unfolding of consequence,
imagination meeting skill,
an utmost focusing of heart and hand,
a process of infinite evolution.

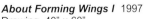

Silent Speech 1998
Drawing, 40" x 60".
Collection of Capitol Arts Foundation,
Santa Fe, gift of Frank & Cecilia Torres,
NM. Photo by Pat Pollard.
A work of art is not complete until the
viewer stands before it. It opens a door
into the space occupied by heart, body,
and mind.

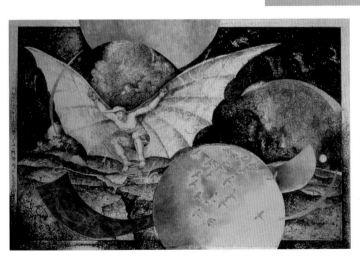

About Forming Wings I 1997
Drawing, 40" x 60".
Collection of The National Hispanic Cultural Center,
gift of Pamela & Hunter Boll, MA. Photo by John Rudiak.

Robert Dale Tsosie

JOHN YAEGER GALLERY, SCOTTSDALE

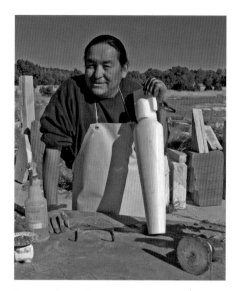

Stone is alive. It chooses me. Stone commands the utmost respect, honor, and love. I cannot touch it if I am out of balance in some manner.

Stone takes me wherever I want to go internally. I usually get my ideas from passing glimpses of whatever goes by in my daily life, whether it is a shadow or a shard of glass. These sparks ignite a flame of artistic passion that leads me to my studio.

My content is about the mysteries of birds, animals, ancient spirits, female human beings, and whatever else comes around my mind. These divine creations all help me to get through life feeling connected to a spiritual energy. My thoughts lead to inventive imagination. Only through stone can I create a successful interpretation.

My work reflects change in a modern world. When I go back to what I have done before, I refine my early ideas into a new distillation that has deeper meaning and a living soul.

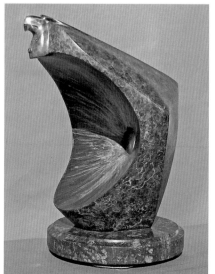

Messenger 2003
Bronze, edition of 12, 13" x 8" x 8".
Photo by the artist.
Sometimes I refine and distill early work into a new piece that has a deeper meaning.

Mountain Kiva Priest 2004
Colorado Marble, 48" x 11" x 11". Photo by the artist.
Line is one of the hardest ingredients to work with. Not every piece is great, but with each one I learn a little more about my style and technique, and from this, that I must continue to study until I am satisfied.

Midnight Maiden 2004
Belgian Marble, 20" x 6" x 6".
Photo by Martin Perea.
Sometimes a piece may change dramatically
from start to finish. Stone becomes what it wants
to be. I do not control it. I go with the flow;
otherwise it will not work.

Winter Spirit 2004
Colorado Marble, 21" x 5" x 5".
Photo by Martin Perea.
I use my female qualities, modernism, simple
elegance, and a touch of minimalism to form a
unique piece that I can call my own.

Theresa Villegas

CHIAROSCURO, SCOTTSDALE

My work is inspired by the light of the Southwest and the beauty of the Sonoran desert. I'm influenced by language, literature, and poetry. A large part of my work stems from my long-lived love affair with Mexico—the culture in general, and the spiritual faith held in the hearts of the people.

Painters who have played a decisive role in my style are the American regionalists Grant Woods and Thomas Hart Benton, Mexican muralist Diego Rivera, and French surrealist Renée Magritte.

I paint because I want to "see" in a tangible form, timeless images, thoughts, and feelings from life. I hope for my work to inspire thought, humor, irony, peace, and love. But mostly I aspire for my work to contribute beauty to our world.

Yo Me He Convertido En Un Paraíso (I Have Become Like Paradise) 2002
Oil on stretched canvas, 66" x 68".
Private collection.
All photos by Deb Whalen.

Translation:

My heart was split, and
A flower appeared;
And grace sprang up;
And it bore fruit for my God.
And my drunkenness was
Insight, intimacy with your spirit.
And you have made
All things shining.
You have granted me
Perfect ease;
I have become
Like paradise.

- adapted from *The Song of Solomon*

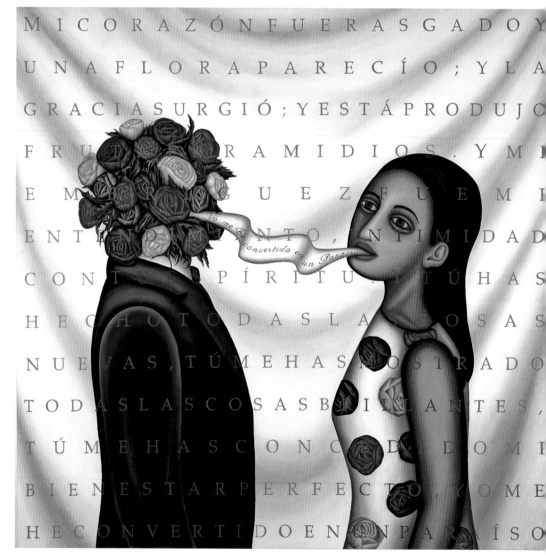

1 El Corazón

2 Desear

21 Lujuria

22 La Paleta

37 El Sireno

46 El Faro

La Lotería: An Exploration of Mexico 2001
Oil on wood, 54 panels each 14.25" x 9.5" x 2", total installation size 10' x 27'. Collection of the artist.

The inspiration for this installation was based on the traditional Mexican game of chance called "La Lotería". The phrase for the image on each painting is a literal or ironic description of the image. La Lotería was a perfect format to base my installation on because it brings the rich culture of Mexico to the U.S. in a fun and exciting way.

The installation was conceived while on sabbatical, living in San Miguel de Allende, Guanajuato. A full year of research on the historical and social importance of the game went into the piece. Its large scale contrasts with the exacting minute detail of each painting. This draws in, even seduces, the viewer with the color, language, and humor that celebrates the Mexican culture.

Individual panels from **La Lotería: An Exploration of Mexico**
Within the Mexican culture, icons are often used to convey humor, irony, and faith that can soften the harsh realities of life. This enables people to maintain their sanity in surroundings that sometimes appear to be controlled by the irrational. This way of thinking can be both inspirational and hopeful.

Escuche (Listen) 2002
Oil on canvas, 48" x 48". Private collection.
The banner coming from the mouth says, "God will find a mouth to tell you what you need to hear." Clockwise, the small banners read, "Forgive," "To Give is to Receive," "Persevere," "Be Honest," and "Love Yourself."

El Juego De Vida (The Game of Life) 2001
Oil on canvas, 71" x 76". Collection of the artist.

197

Tom Waldron

LINDA DURHAM CONTEMPORARY ART, SANTA FE

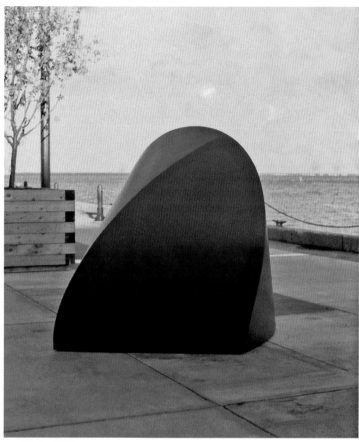

I make a lot of small sculptures out of cardboard, which is similar to steel in that it comes in sheets and can be curved in one dimension. Lately I've been drawn again and again to a few simple shapes. A wedge with a curved back, a symmetrical winged shape, a low three-sided mound, and a few other forms seem to keep suggesting new interpretations. I think this is because these forms have a certain logic that lends itself to the process of cutting, fitting, and welding steel plate.

Pitch 1997
Steel, 66" x 70" x 52". Collection of Allene Lapides.
This picture was taken on the Navy Pier in Chicago.

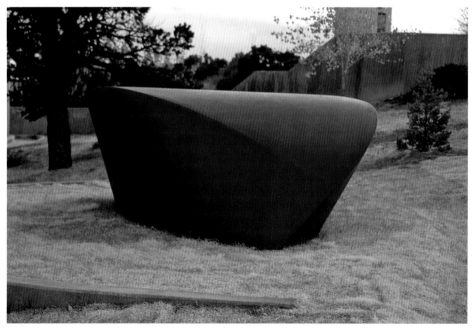

Saddle 1997
Steel, 50" x 140" x 74".
Installallation at the Gallup campus of the University of New Mexico.

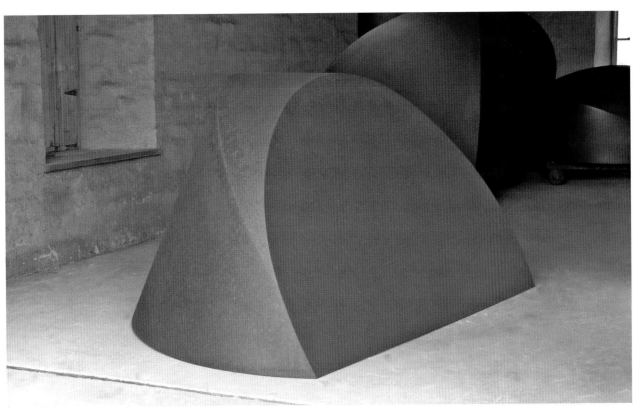

Skid 2002
Steel, 43" x 82" x 57". Collection of the artist.
Two other sculptures from this series of four-sided forms are visible in the background.

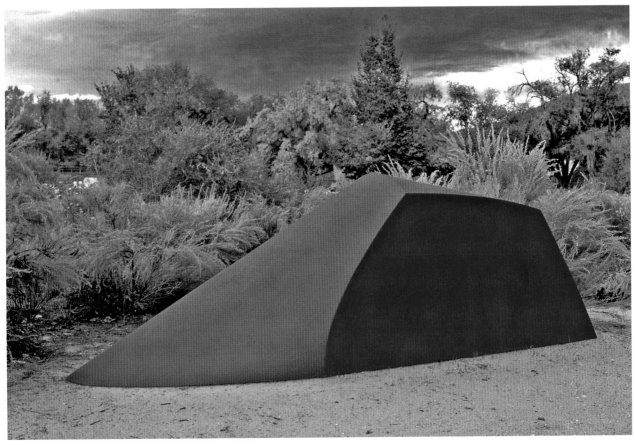

Bevel 2004
Steel, 36" x 120" x 40". Collection of the artist.
This is the most recent of an ongoing series.

Joan Watts
CHARLOTTE JACKSON FINE ARTS, SANTA FE

Series Zero refers to zero as a primordial symbol full of infinite potential. The void is expressed as fields of colored light emptied of forms.

Presence is in absence.

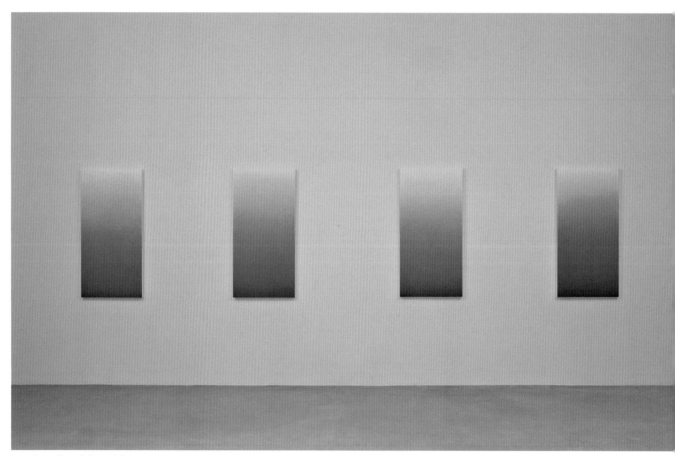

above, from left to right
0-7, 0-8, 0-9, 0-10 2003
Oil on Canvas, 44" x 22" each.
All photos by the artist.

opposite page
0-22 2002
Oil on canvas, 44" x 22".

Emmi Whitehorse

LewAllen Contemporary, Santa Fe

In accordance with Navajo philosophy, I have chosen to focus on nature, or landscape. My paintings tell the story of knowing land over time—of being completely, microcosmically, within a place. I am defining a particular space, describing a particular place. They are purposefully meditative and meant to be seen slowly. The intricate language of symbols refers to specific plants, people, and experiences.

These images float in and out of my awareness. My childhood was spent playing and tending sheep in a landscape that seemed magical and endless, passing days amid the land's vastness—days spent noticing the subtle fluctuations of light, the perpetual changes in color, and the fleeting shift of elements from prominence one moment to obscurity the next.

Beginning in 1999, my paintings have become more non-referential in imagery, instead relying more heavily on pure sensory response.

My new works are about water, about a sense of surfacing from the water, about capturing an elusive ethereal vapor, about capturing liquid mass.

Vernal Bloom 2003
Oil on paper on canvas, 51" x 39.5".
I had trouble making up my mind whether this painting was going to be water- or land-related.

above
Undulation 2002
Oil on paper on canvas, 39.5" x 51".
This painting had to be reworked after it had been out in the
world for a year. Now it is in my own collection.

below
Water Front 2003
Oil on paper on canvas, 28.75" x 40.5".
This painting was such a happy painting
that I got carried away with it.

Suzanne Wiggin

FENIX GALLERY, TAOS
MEYER-MUNSON GALLERY, SANTA FE

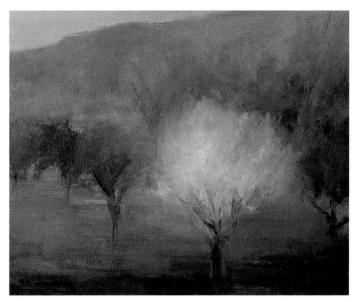

Glow Tree 2003
Oil on panel, 9" x 11".
All photos by Pat Pollard.

Our home sits on the eastern edge of a bowl perched upon the side of a mountain. On a clear day you can see nearly a hundred miles. The weather comes from the west. Clouds move across this vast space towards us, piling against the mountains behind. There is time to study an approaching storm. Light is the variable element. It is the verb, revealing and concealing endless detail. This direct observation of the landscape provides the primary motif for my paintings and monoprints. My intention is to hold a moment.

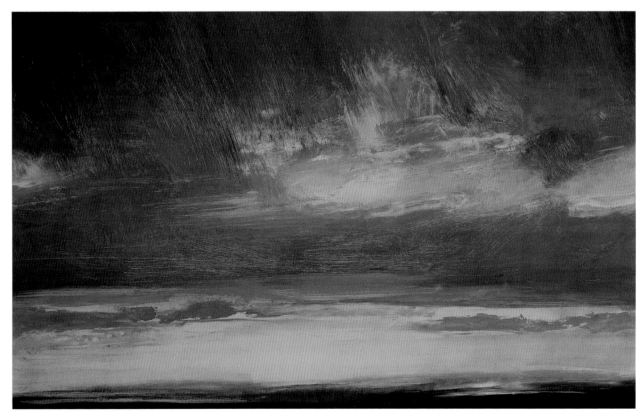

West Sky 2004. Monoprint, 24" x 24".

Light Rain 2004. Monoprint, 24" x 24".

Yellow Light 2003. Monoprint, 33" x 44".

Joel-Peter Witkin
LINDA DURHAM GALLERY, SANTA FE

Portrait Reminiscent of Portrait As A Vanité
1995
Tone silver gelatin print.
All photos by the artist.

I cannot image love nor the atoms which make up all things, nor can I image God. I am overwhelmed by existence and the splendor and misery we call history.

All these things are natural to man. I can hold these things like sand between my hands and be comforted because, although the reason and purpose of life is beyond comprehension, it is within us. It is in stones and flowers, too. In the Natural Law. What is within us, I believe, is the reality that Someone, Something created all things. That the very passion of life, of love and hatred, is the acceptance or negation of God.

Which is more sensible—to believe that there is purpose to life and that we are part of it, or to believe that life has no purpose?

The poet e.e. cummings described a lost soul as, "a man falling on all sides." William Blake, a believer, was overwhelmed by creation. He once wrote, "I can look at a knot in a tree until it frightens me."

Both these statements are radiant with intelligence. They have become art because they have the power to affect our reality, even our souls.

Great art is about transcendence. It elevates life. This is why I try to make great art. It is my vocation, my prayer. Like the clown before the altar, his "prayer," his art, was to perform. Some thought this was blasphemy. The aware knew it was the most sublime act of love of which he was capable.

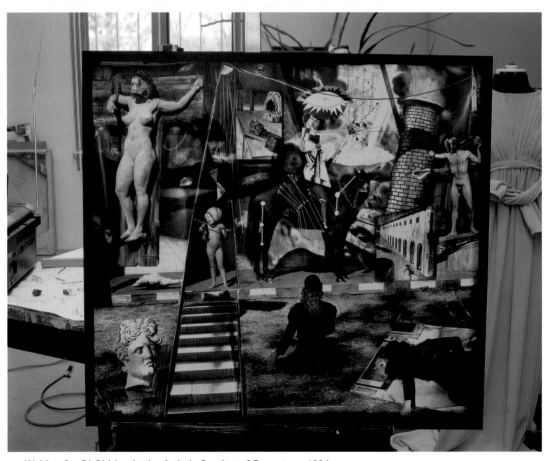

Waiting for Di Chirico in the Artist's Section of Purgatory 1994
Tone silver gelatin print with wax, encaustic, 30" x 34".

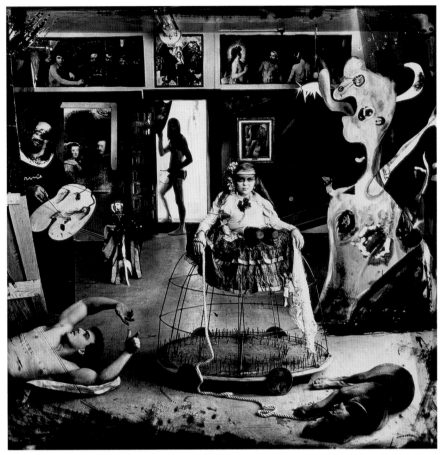

Las Meniñas 1987
Tone silver gelatin print, 30" x 30".

Woman on a Table 1987
Tone silver gelatin print, 30" x 30".

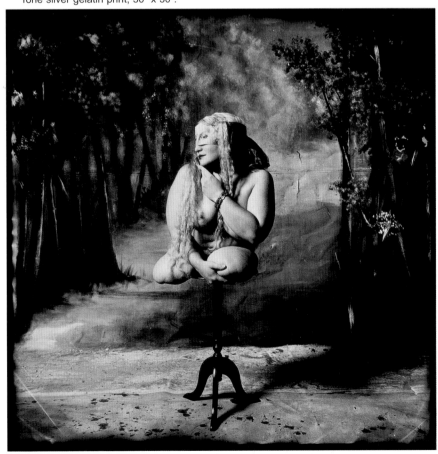

Karen Yank

CHIAROSCURO, SANTA FE AND SCOTTSDALE
LEMMONS CONTEMPORARY, NEW YORK

Photo by Charles Rushton

My father is a sculptor. Very early on I took a keen interest in his creative work. Knowing that I was an artist from the very beginning always felt so natural. There was never a turning-point decision.

My creativity comes from the center of me, the place that makes me alive. I feel healthiest in my mind, body, and spirit when I am working on a sculpture. I am constantly searching to find something deeper in myself to express.

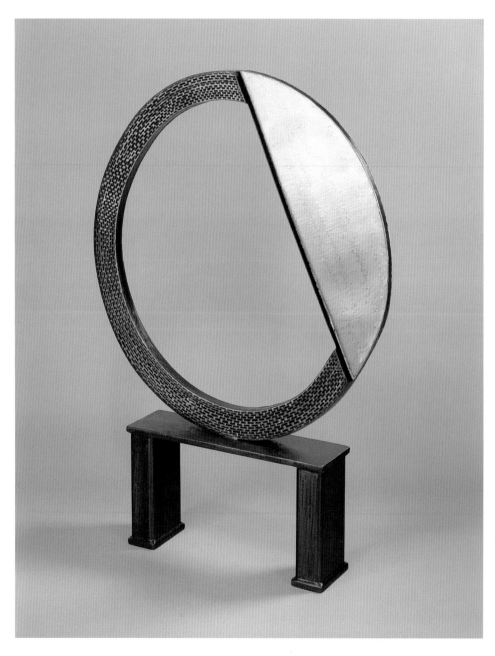

In the Course of Continuous Experience 2002
Steel, stainless Corten,
50" x 36" x 6.5".
Photo by Herbert Lotz.
My work expresses abstract emotional content which is a direct reflection of my life. Each sculpture is a notation of something important going on in my life at a given time.

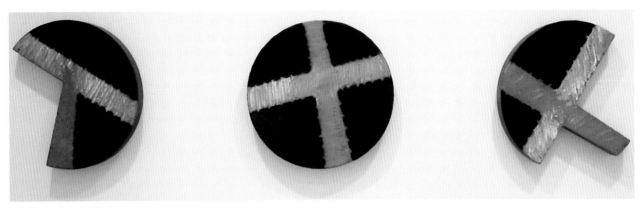

O – X # 1–3 2004
Steel, stainless, 12" x 48" x 1.5".
Photo courtesy of Lemmons Contemporary, New York.
What I try to express and what the viewer gets from my work don't always match. Why should they?

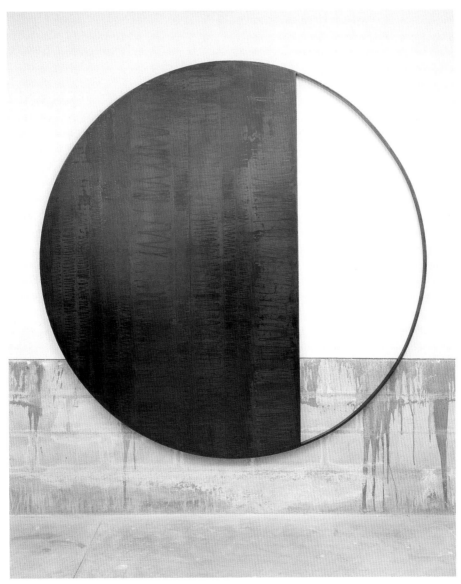

Unequal Halves 2003
Steel, 84" x 84" x 1.5". Photo by Herbert Lotz.
Each person comes to a given work with an entirely different set of life experiences. Why would we expect intent and perception to match? That is what makes art so interesting.

Susan York
CHARLOTTE JACKSON FINE ART, SANTA FE

Even more than the influence of Minimalism, growing up in New Mexico beneath wide mesas, mud buildings, and a large sky is at the heart of my work. The distillation of space has become my magnetic north.

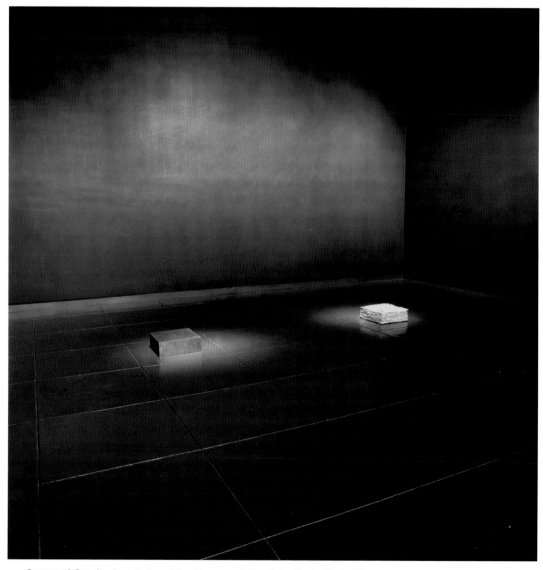

Center of Gravity Installation at the Museum of Fine Arts, Santa Fe, 2002
Graphite, porcelain, and steel; 20' x 14' x 15'.

The Color of Wind 2003
Porcelain and steel, 6.75" x 18.5" x 4.75".
Collection of Christopher Rocca & David Rosen. Photo by Herb Lotz.
The opposite experiences of infinite calm and profound tension are at the heart of my work.

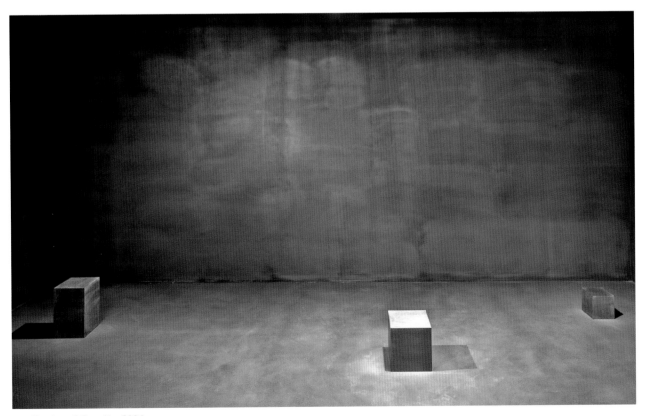

Center of Gravity 2004
Graphite, 21' x 15' x 14'.
Installation at the School of the Art Institute of Chicago (with sound by Steve Peters).

Melissa Zink
Parks Gallery, Taos

Robbie Steinbach

The task during my art-making years has been to find a form which would allow me to express and explore an internal world created from an obsessive love of books.

The explorations have included the alphabet, metaphors, narrative, actual book materials, and ideas about dimensionality, repetition, and association.

Layers of Meaning 2003
Mixed media/plexiglass, 17" x 20" x 2".
All photos by Pat Pollard.

I discovered along the way that although I was wedded to only one internal world, it could take many visible forms. Those infinite possibilities and the continuous revelations of the miracle of literacy continue to make each new project an adventure.

I hope that I am leaving a record documenting a love affair that grows more intense and compelling with each discovery.

Lifetime of Papers 2004
Mixed media, 22" x 18" x 4".

The Guardians 2004
Bronze, editions of 10; from left: ***Chamberlain of Letters*** (72"
tall), ***Minister of Words*** (66" tall), ***Book Warden*** (72" tall)

Barbara Zusman

LINDA DURHAM CONTEMPORARY ART, SANTA FE

Although my sculptures have a formal, post-minimal quality, they a
full of life. In them, people often see elements of landscape and the huma
body, and themes of containment and flow, growth and rebirth. Howeve
I do not consciously reference a particular subject. I am more concerne
with substance and form—with turning a straight line into a graceful curve
making layered pieces in subtle earth tones, with saying as much as I ca
in the simplest possible way.

My artistic influences include Eva Hesse, who made sculptures bo
minimal and personal; Louise Bourgeois' anthropomorphic three-dime
sional pieces charged with sexuality and innocence; and the architect Fran
Gehry, who, like me, bends the rectangle.

I shape my work with foam rubber and wrap it in endless strata
crisp muslin. Often I begin with a piece of antique wood, which provid
the stimulus and starting point. Once a utilitarian object, the wood
transformed into a container for my sculpture. Old wood has been a
inspiration ever since my childhood in the Pacific Northwest.

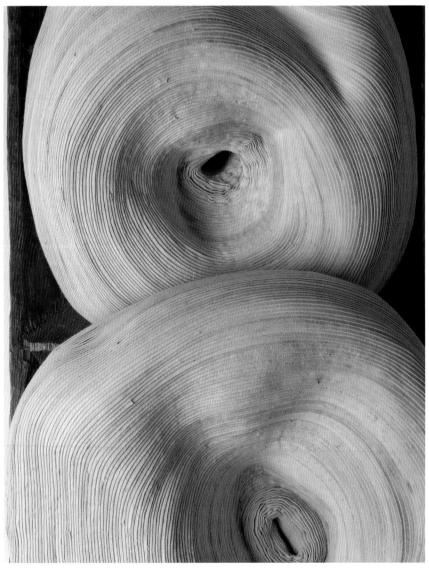

detail from **Multiple Nests** (opposite page, left)

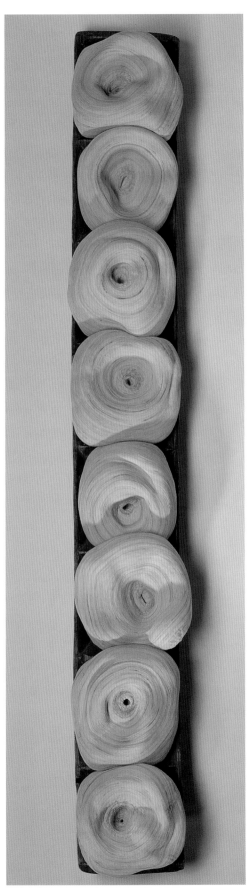

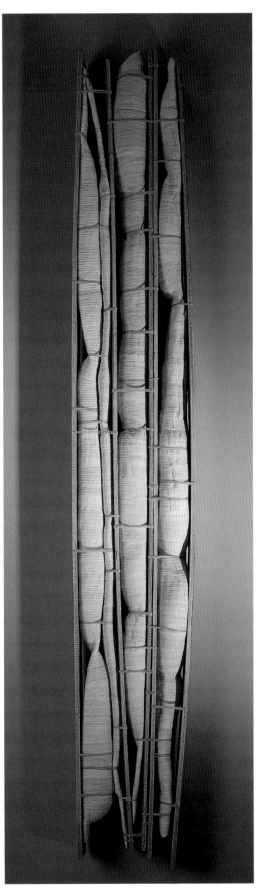

Multiple Nests (front view) 2001
Coffee on muslin, on foam, on wood,
80.5" x 8" x 10".

Family Tree (front view) 1998–99
Acrylic, graphite, and oxides on redwood; coffee
and starch on muslin; wire; 66.5" x 10.5" x 5.5".

215

Where to find these artists

Tony Abeyta
Shipley Gallery
122 Kit Carson Road
Taos, NM 87571
505-751-6820
arttone@yahoo.com

Blue Rain Gallery
130 Lincoln Avenue
Santa Fe, NM 87501
505-954-9902
117 South Plaza
Taos, NM 87571
505-751-0066, 800-414-4893
www.blueraingallery.com

Ron Adams
LewAllen Contemporary
129 West Palace Avenue
Santa Fe, NM 87501
505-988-8997, fax 505-989-8702
gallery@LewAllenArt.com
www.lewallenart.com

Elizabeth Alderman
Art Department
New Mexico State University
P. O. Box 30001
Las Cruces, NM 88003-8001
505-523-9339
elizabeth@glasshaus.org
alderman@nmsu.edu
www.glasshaus.org

Page Allen
Owings-Dewey Fine Art
76 East San Francisco St.
Santa Fe, New Mexico 87501
505-982-6244, fax 505-983-4215
lwidmar@owingsdewey.com
www.owingsdewey.com

Carol Anthony
Gerald Peters Gallery
1011 Paseo de Peralta
Santa Fe, NM 87501
505-954-5700, fax 505-954-5754
www.gpgallery.com

Diane Armitage
P. O. Box 2812
Santa Fe, NM 87504
505-988-4130
diananemi@msn.com
www.diananemi.com

Cathy Aten
www.cathyaten.com
sfcaten@aol.com
tadu downtown
110 West San Francisco
Santa Fe, NM 97501
505-992-0100
tadu@comcast.net
www.andersoncontemporaryart.com

Jim Bagley
bbinc@lobo.net
Dartmouth Street Gallery
3011 Monte Vista NE
Albuquerque, NM
505-266-7751
www.dsg-art.com

Forgive Me Son For I Have Sinned by Arthur López

Charlene Cody Gallery
130 W. Palace Ave.
Santa Fe, NM
1-800-752-1343
www.charlenecodygallery.com

Rice Gallery of Fine Art
7060 W. 135th
Overland Park, KS
913-685-888
thericegallery@sbcglobal.com

Billye Turner
Art Consultant
739 NW Ogden
Bend, Oregon
541-382-9398

Barbara Barkley
HC 32, Box 534
Quemado, NM 87829
infinity@gilanet.com

Jane Barthès
jane@barthes.de
www.barthes.de/jane
tadu downtown
110 West San Francisco
Santa Fe, NM 97501
505-992-0100
tadu@comcast.net
www.andersoncontemporaryart.com

Larry Bell
Larry Bell Studio
4101 NDCBU
Taos, NM 87571
505-758-3062
bell@larrybell.com
www.larrybell.com

Rebecca Bluestone
www.rebeccabluestone.com
Gerald Peters Gallery
1011 Paseo de Peralta
Santa Fe, NM 87501
505-954-5700
info.sfgallery@gpgallery.com
www.gpgallery.com

Erika Blumenfeld
Charlotte Jackson Fine Art, Inc.
200 West Marcy St, Suite 101
Santa Fe, NM 87501
505-989-8688
info@charlottejackson.com
www.charlottejackson.com/

Kevin Cannon
James Kelly Contemporary
616-1/2 Canyon Road
Santa Fe, NM 87501
505-989-1601
info@jameskelly.com
www.jameskelly.com

Capitol Art Collection
411 State Capitol
Santa Fe, NM 87503
505-986-4614
Cynthia.Sanchez@state.nm.us

Charles M. Carrillo
Santos of New Mexico
2712 Paseo de Tularosa
Santa Fe, NM 87505
505-473-7941
CCarr1810@aol.com

Carol Coates
ccphotowrk@aol.com
tadu downtown
110 West San Francisco
Santa Fe, NM 97501
505-992-0100
tadu@comcast.net
www.andersoncontemporaryart.com

Erin Currier
erincurrierfineart@yahoo.com
www.erincurrierfineart.com
Parks Gallery
127 A Bent Street
Taos, NM 87571
505-751-0343
parksgallery@newmex.com
www.parksgallery.com

Eddie Dominguez
deerheaven@mac.com
Allene Lapides Gallery
558 Canyon Road
Santa Fe, NM 87501
505-984-0191
www.lapidesgallery.com/

Carol Eckert
4cae@cox.net
Thirteen Moons Gallery
652 Canyon Road
Santa Fe, NM 87501
505-995-8513
www.thirteenmoonsgallery.com

Tom Eckert
tom.eckert@asu.edu
4cae@cox.net
Thirteen Moons Gallery
652 Canyon Road
Santa Fe, NM 87501
505-995-8513
www.thirteenmoonsgallery.com

Richard Faller
rfphoto@cybermesa.com
Ernesto Mayans Gallery
601 Canyon Road
Santa Fe, NM 87501
505-983-8068
arte2@aol.com
www.artnet.com/mayans.html

Alexandra Eldridge
ae8848@msn.com
Turner-Carroll Gallery
725 Canyon Road
Santa Fe, NM 87501
505-986-9800
www.turnercarrollgallery.com

George Billis Gallery
2716 SW La Cienaga blvd
Los Angeles, CA 90034
310-838-3685
la@georgebillis.com
www.georgebillis.com

Julie Baker Fine Art
120 N. Auburn St., Suite 100
Grass Valley, CA 95945
530-273-0910
julie@juliebakerfineart.com
www.juliebakerfineart.com

Weber Fine Arts
17 Boniface Circle
Scarsdale, NY 10583

John Fincher
jhfincher@aol.com
Gerald Peters Gallery
1011 Paseo de Peralta
Santa Fe, NM 87501
505-954-5700
www.gpgallery.com

Jody Forster
jodyforster@earthlink.net
Andrew Smith Gallery, Inc.
203 W. San Francisco St.
Santa Fe, NM 87501
505-984-1234
www.andrewsmithgallery.com

Miguel Gandert
mgandert@unm.edu
Andrew Smith Gallery, Inc.
203 W. San Francisco St.
Santa Fe, NM 87501
505-984-1234
www.andrewsmithgallery.com

Joe Ramiro Garcia
joeramirogarcia@yahoo.com
www.joeramirogarcia.com
LewAllen Contemporary
129 West Palace Avenue
Santa Fe, NM 87501
505-988-8997
www.lewallenart.com

Tammy Garcia
Blue Rain Gallery
117 South Plaza
Taos, NM 87571
505-751-0066

130 Lincoln Ave., Suite D
Santa Fe, NM 87501
505-954-9902
www.blueraingallery.com

Sandy Goins
Hand Graphics
2312 W. Alameda
Santa Fe, NM 87505
sander@cape.com

Canyon Road Contemporary Art
403 Canyon Road
Santa Fe, NM 87501
505-983-0433
CRcontart@aol.com

Teri Greeves
Kiowa Beadwork
P. O. Box 28804
Santa Fe, NM 87592
nahmoos@msn.com

Thirteen Moons Gallery
652 Canyon Road
Santa Fe, NM 87501
505-995-8513
www.thirteenmoonsgallery.com

Woody Gwyn
dgwyn@earthlink.net
Gerald Peters Gallery
1011 Paseo de Peralta
Santa Fe, NM 87501
505-954-5700
www.gpgallery.com

Siegfried Halus
307 Lomita Street
Santa Fe, NM 87501
shalus@sfccnm.edu

Frederick Hammersley
Charlotte Jackson Fine Art, Inc.
200 West Marcy St, Suite 101
Santa Fe, NM 87501
505-989-8688
www.charlottejackson.com

Harmony Hammond
lalanera@aol.com
www.harmonyhammond.com
Dwight Hackett projects
2879 All Trades Road
Santa Fe, NM 87507
505-474-4043
info@dwighthackett.com
www.dwighthackett.com

Rodney Hamon
P. O. Box 870
Sandia Park, NM 87047
hamonyank@newmexico.com
rhamon@unm.edu

Bob Haozous
32 Calle Francisca
Santa Fe, NM 87505
bobhaozous@cs.com

Zonnie and Jaymes Henio
P. O. Box 155
Ramah, NM 87321
jesslahoot@yahoo.com

Dartmouth Street Gallery
3011 Monte Vista NE
Albuquerque, NM 87106
800-474-7751
www.dsg-art.com

Eaten by Coyotes by Bob Haozous

Richard Hogan
Linda Durham Contemporary Art
1101 Paseo de Peralta
Santa Fe, NM 87501
505-466-6600
ldca@earthlink.net
www.lindadurham.com

Colette Hosmer
colettehosmer@aol.com
Addison/Parks Gallery
209 Galisteo Street
Santa Fe, NM 87501
505-992-0704
www.addisonparksgallery.com

Frank Buffalo Hyde
Cline Fine Art
4200 North Marshall Way
Scottsdale, AZ 85251
480-941-1811
131 West San Francisco Street
Santa Fe, NM 87501
505-982-5328
www.clinefineart.com

Luis Jiménez
jimenez@pvtnetworks.net
Moody Gallery
2815 Colquitt
Houston, TX 77098
713-526-9911
http://moodygallery.com/

Approaching Fall by Carolyn Lamuniere

Tom Joyce
wtjoyce@earthlink.net
EVO Gallery
725 Canyon Road
Santa Fe, NM 87501
505 982 4610
director@evogallery.org.
www.evogallery.org

Mark Klett
Lisa Sette Gallery
4142 N Marshall Way
Scottsdale, AZ 85251
480-990-7342
www.lisasettegallery.com

Nancy Kozikowski
nancyk@dsg-art.com
Dartmouth Street Gallery
3011 Monte Vista NE
Albuquerque NM 87106
800-474-7751, 505 266-7751
www.dsg-art.com

Carolyn Lamuniere
clamuniere@newmexico.com
Hand Artes Gallery
P. O. Box 417
Truchas, NM 87578
505-689-2443, 800 689 2441

Elaine Beckwith Gallery
P. O. Box 179
Route 30
Jamaica, VT 05343
802-874-7234

Carm Little Turtle
1325 West Bosque Loop
Bosque Farms NM 87068
little_turtle9@msn.com

Arthur López
artplopez@aol.com
Parks Gallery
127-A Bent Street
Taos, NM 87571
505-751-0343
parksgallery@newmex.com
www.parksgallery.com

Félix López, Santero
P. O. Box 3691
Fairview Station
Española, NM 87533
505-753-2785
felixlopez@cybermesa.com

Estella Loretto
36 Wildflower Way
Santa Fe, NM 87506
info@estellaloretto.com
www.estellaloretto.com

Jennifer Lynch
Lynch Press
P. O. Box 2997
Ranchos de Taos, NM 87557
505-737-0131
lynchpress@newmex.com

Fenix Gallery
228-B Paseo de Pueblo Road
Taos, NM 87571
505-758-9120
http://fenixgallery.com/index.html

Chadwick Dean Manley
www.chadmanleydesign.com
info@chadmanleydesign.com
tadu downtown
110 W. San Francisco
Santa Fe, NM 87501
505-992-0100
www.taducontemporary.com

View at Muley Point by Mark Klett

Boyd & Dreith
(for designers and architects only)
595 S. Broadway, Suite 103-S
Denver, CO 80209
303-777-4600
www.boyd-dreith.com

Diane Marsh
deerheaven@mac.com
Addison/Parks Gallery
209 Galisteo Street
Santa Fe, NM 87501
505-992-0704
john@addisonparksgallery.com
www.addisonparksgallery.com

Sylvia Martínez Johnson
P. O. Box 386
Regina, NM 87046
505-289-3523
pita95@hotmail.com

Ada Medina
530 Garcia St., No. 2
Santa Fe, NM 87505
alchymi@att.net
Studio
3888 Highway 14 (South)
Santa Fe, NM 87505

Klaudia Marr Gallery
668 Canyon Road
Santa Fe, NM 87501
505-988-2100
art@klaudiamarrgallery.com
www.vandegriffmarr.com

Delilah Montoya
dmontoy2@mail.uh.edu
Andrew Smith Gallery, Inc.
203 W. San Francisco St.
Santa Fe, NM 87501
505-984-1234
www.andrewsmithgallery.com

Jesús Moroles
jmoroles@sbcglobal.net
www.moroles.com
LewAllen Contemporary
129 West Palace Avenue
Santa Fe, NM 87501
505-988-8997
gallery@LewAllenArt.com
www.lewallenart.com

Forrest Moses
flmoses@earthlink.net
www.kenshoeditions.com
LewAllen Contemporary
129 West Palace Avenue
Santa Fe, NM 87501
505-988-8997
gallery@LewAllenArt.com
www.lewallenart.com

Carol Mothner
Gerald Peters Gallery
1011 Paseo de Peralta
Santa Fe, NM 87501
505-954-5700
info.sfgallery@gpgallery.com
www.gpgallery.com

Patrick Nagatani
2933 Monte Vista
Albuquerque, NM 87106
pnagatani@earthlink.net
pn19@unm.edu

Arlo Namingha
Niman Fine Art
125 Lincoln Ave-Suite 116
Santa Fe, NM 87501
505-988-5091
www.namingha.com

Dan Namingha
Niman Fine Art
125 Lincoln Ave-Suite 116
Santa Fe, NM 87501
505-988-5091
www.namingha.com

Les Namingha
Blue Rain Gallery
117 South Plaza
Taos, NM 87571
505-751-0066
130 Lincoln Avenue
Santa Fe, NM 87501
505-954-9902
www.blueraingallery.com

Margaret Nes
nesaldo@yahoo.com
Hahn Ross Gallery
409 Canyon Rd.
Santa Fe, NM 87501
505-984-8434
hahnross@rt66.com
www.hahnross.com

P. A. Nisbet
Studio
314-1/2 Garcia Street
Santa Fe, NM 87501
505-988-1322
panisbet@mindspring.com
The Meyer-Munson Gallery
225 Canyon Road
Santa Fe, NM 87501
505-983-1657
art@munsongallery.com
www.munsongallery.com

Dino Paravano
dinoparavano@att.net
Gerald Peters Gallery
1011 Paseo de Peralta
Santa Fe, NM 87501
505-954-5700
www.gpgallery.com

Florence Pierce
Charlotte Jackson Fine Art
200 W. Marcy Street, Suite 101
Corner of Marcy and Grant
Santa Fe, NM 87501
505-989-8688
cgjart@aol.com
www.charlottejackson.com

Ron Pokrasso
pokrasso@shaening.com
Deloney Newkirk Fine Art
634 and 669 Canyon Road
Santa Fe, NM 87501
info@deloneynewkirk.com
www.deloneynewkirk.com

Ken Price
Fenix Gallery
228-B North Pueblo Road
Taos, NM 87571
505-758-9120
jkendall@fenixgallery.com
http://fenixgallery.com

James Kelly Contemporary
616-1/2 Canyon Road
Santa Fe, NM 87501
505-989-1601
info@jameskelly.com
www.jameskelly.com

Al Qöyawayma
alqoy@cableone.net
www.alqpottery.com
Blue Rain Gallery
117 South Plaza
Taos, NM 87571
505-751-0066
130 Lincoln Avenue
Santa Fe, NM 87501
505-954-9902
www.blueraingallery.com

Kim Rawdin
krawdin@cox.net
Patina Gallery
131 West Palace Avenue
Santa Fe, NM 87501
505-986-3432
ivan@patina-gallery.com
www.patina-gallery.com

Cervini Haas Gallery
4200 N. Marshall Way
Scottsdale, AZ 85251
480-429-6116
info@cervinihaas.com
www.cervinihaas.com

Bette Ridgeway
bridgesfnm@aol.com
www.ridgewaystudio.com
tadu downtown
110 West San Francisco
Santa Fe, NM 97501
505-992-0100
tadu@comcast.net
www.andersoncontemporaryart.com

Johnnie Winona Ross
Dry Creek Studio, Inc.
P. O. Box 414
Arroyo Seco, NM 87514
505-776-0094
jcross@laplaza.org

James Kelly Contemporary
616-1/2 Canyon Road
Santa Fe, NM 87501
505-989-1601
info@jameskelly.com
www.jameskelly.com

Richard Levy Gallery
514 Central Ave. SW
Albuquerque, NM 87102
505-766-9888
info@levygallery.com
www.levygallery.com

Parks Gallery
127 A Bent Street
Taos, NM 87571
505-751-0343
parksgallery@newmex.com
www.parksgallery.com

Roswell Artist-in-Residence Program
1404 West Berrendo
Roswell, NM 88201
505-622-6037
rswelair@dfn.com
www.rair.org

Meridel Rubenstein
meridel@nets.com
www.meridelrubenstein.com
LewAllen Contemporary
129 West Palace Avenue
Santa Fe, NM 87501
505-988-8997
gallery@lewallenart.com
www.lewallenart.com

Ramona Sakiestewa
LewAllen Contemporary
129 West Palace Avenue
Santa Fe, NM 87501
505-988-8997
gallery@lewallenart.com
www.lewallenart.com

Santa Fe Art Institute
1600 Saint Michaels Drive
Santa Fe, NM 87505
505-424-5050
info@sfai.org
www.sfai.org

Peter Sarkisian
sarkmachine@yahoo.com
Linda Durham Contemporary Art
1101 Paseo de Peralta
Santa Fe, NM 87501
505-466-6600
ldca@earthlink.net
www.lindadurham.com

Jane Sauer
jsauer@cybermesa.com
Thirteen Moons Gallery
652 Canyon Road
Santa Fe, NM 87501
505-995-8513
jsauer@thirteenmoonsgallery.com
www.thirteenmoonsgallery.com

Gulf of Tonkin Coral Sutra by Meridel Rubenstein

Arlene Cisneros Sena
30 Calle el Gancho
Santa Fe, NM 87507
505-438-0163
fred@cisnerosdesign.com

Sherri Silverman
Transcendence Design
P. O. Box 2461
Santa Fe, NM 87504
505-984-0108, 505-660-9333
sherri@transcendencedesign.com
www.transcendencedesign.com

Marsha Skinner
Parks Gallery
127 A Bent Street
Taos, NM 87571
505-751-0343
parksgallery@newmex.com
www.parksgallery.com

Jaune Quick-To-See Smith
jqtss@aol.com
LewAllen Contemporary
129 West Palace Avenue
Santa Fe, NM 87501
505-988-8997
gallery@lewallenart.com
www.lewallenart.com

Richard Zane Smith
coils@cybermesa.com
Blue Rain Gallery
117 South Plaza
Taos, NM 87571
505-751-0066
130 Lincoln Avenue
Santa Fe, NM 87501
505-954-9902
www.blueraingallery.com

Mark Spencer
1010 Camino Redondo
Santa Fe, NM 87507
505-982-5815, 505-699-7570

Earl Stroh
Fenix Gallery
228-B North Pueblo Road
Taos, NM 87571
505-758-9120
jkendall@fenixgallery.com
http://fenixgallery.com

Mary Sweet
Mfsweet@aol.com
Dartmouth Street Gallery
3011 Monte Vista NE
Albuquerque NM 87106
800-474-7751, 505-266-7751
www.dsg-art.com

Roxanne Swentzell
Hahn Ross Gallery
409 Canyon Rd.
Santa Fe, NM 87501
505-984-8434
hahnross@rt66.com
www.hahnross.com

Luis Tapia
Owings-Dewey Fine Art
76 East San Francisco St.
Santa Fe, NM 87501
505-982-6244
lwidmar@owingsdewey.com
www.owingsdewey.com

Sergio Tapia
Owings-Dewey Fine Art
76 East San Francisco St.
Santa Fe, New Mexico 87501
505-982-6244, fax 505-983-4215
lwidmar@owingsdewey.com
www.owingsdewey.com

Mayé Torres
13 Ravens Dance Rd.
Carson, NM 87517
P.O. Box 2333
Taos, NM 87571
505-776-3931

Robert Dale Tsosie
P. O. Box 88
San Jose, NM 87565
505-421-2986
rdtsosie@plateautel.net

Teresa Villegas
teresa@teresavillegas.com
www.teresavillegas.com
Chiaroscuro
7160 Main Street
Scottsdale, AZ 85251
480-429-0711, fax 480-429-0713
gallery@chiaroscuroaz.com
www.chiaroscurogallery.com

Tom Waldron
tomwaldron3@earthlink.net
Linda Durham Contemporary Art
1101 Paseo de Peralta
Santa Fe, NM 87501
505-466-6600
ldca@earthlink.net
www.lindadurham.com

Joan Watts
Charlotte Jackson Fine Art, Inc.
200 West Marcy St, Suite 101
Santa Fe, NM 87501
505-989-8688
info@charlottejackson.com
www.charlottejackson.com

Emmi Whitehorse
whitehorse@zia.com
LewAllen Contemporary
129 West Palace Avenue
Santa Fe, NM 87501
505-988-8997
gallery@lewallenart.com
www.lewallenart.com

Suzanne Wiggin
swiggin@zianet.com
The Meyer-Munson Gallery
225 Canyon Road
Santa Fe, NM 97501
505-983-1657
www.munsongallery.com

Fenix Gallery
228-B North Pueblo Road
Taos, NM 87571
505-758-9120
jkendall@fenixgallery.com
http://fenixgallery.com

Sandy Carson Gallery
760 Santa Fe Drive
Denver, CO 80204
303-573-8585
sandycarsongallery.com

Joel-Peter Witkin
1701 Five Points Road, SW
Albuquerque, NM 87105-3017
505-843-6682
jwitkin1@comcast.net
Linda Durham Contemporary Art
1101 Paseo de Peralta
Santa Fe, NM 87501
505-466-6600
ldca@earthlink.net
www.lindadurham.com

Karen Yank
hamonyank@newmexico.com
Chiaroscuro
439 Camino Del Monte Sol
Santa Fe, NM 87505
505-992-0711
info@chiaroscurosantafe.com
www.chiaroscurosantafe.com

Susan York
syork5@earthlink.net
www.susanyork.com
Charlotte Jackson Fine Art
200 W. Marcy St., Suite 101
Santa Fe, NM 87501
505-989-8688
cgjart@aol.com
www.charlottejackson.com

Braunstein/Quay
430 Clementina
San Francisco, CA 94103
415.278.9850
bquayg@pacbell.net
www.bquayartgallery.com

Exhibitions2d
400 S. Highland
Marfa, Texas
432-729-1910
exhibitions2d@aol.com
www.exhibitions2d.com

Melissa Zink
zink@newmex.com
Parks Gallery
140 Kit Carson Road
Taos, NM 87571
505-751-0343
parksgallery@newmex.com
www.parksgallery.com/

Barbara Zusman
Linda Durham Contemporary Art
1101 Paseo de Peralta
Santa Fe, NM 87501
505-466-6600
ldca@earthlink.net
www.lindadurham.com

Coil-built pots by Richard Zane Smith